For Caroline

Tim Benton

LC
FOTO

Le Corbusier
Secret Photographer

LARS MÜLLER PUBLISHERS

Behind the QR code patches are seven montages of film sequences shot by Le Corbusier on his Siemens B camera, interspersed with some of the still photographs he took using the single-frame feature. They were originally shown in the exhibition *Construire l'image: Le Corbusier et la photographie*, Musée des Beaux-Arts, La Chaux-de-Fonds, October–December 2012.

Abbreviations
BV Bibliothèque de la Ville, La Chaux-de-Fonds
FLC Fondation Le Corbusier, Paris
CCA Centre Canadien d'Architecture / Canadian Centre for Architecture
LoC Library of Congress, Washington, D.C.
NGA National Gallery of Art, Washington, D.C.

Introduction

8

Charles-Édouard Jeanneret (1887–1965), who adopted the nom de plume Le Corbusier in 1920, was not afraid to advertise his achievements in a wide range of media: painting, drawing, lithography, collage, sculpture, and tapestry, not to mention architecture and urbanism. But about one branch of his activity he was always strangely silent. Between 1906 and 1916, and again from 1936 to 1938, Le Corbusier took hundreds of photographs. He published very few of these, and always maintained that photography was a stultifying activity, good only for lazy people.[1] Le Corbusier never let himself be photographed holding a camera. To see and to understand was to draw. To take a photograph was to allow the subject to be impressed on the negative without passing through the brain. Nevertheless, Le Corbusier's photographic output deserves attention, not only as a commentary on his state of mind at various moments but also in terms of the quality of the pictures he took. It can be argued from the evidence of those photographs that he did have a "photographer's eye," that is to say, he could frame and compose what he saw in ways quite different to how he saw as an architect or as a draftsman, and that he imposed a distinctive and often highly satisfying aesthetic on the image. The photographer who strives to achieve aesthetically satisfying results—who does not merely take "snaps"—is not a passive extension of the machine. He or she actively selects, analyzes, shapes, and renders into graphic form what the lens offers as countless opportunities. Among the young Jeanneret's and the middle-aged Le Corbusier's photographs there certainly are many "snaps," taken to record something of interest, but there are also many good photographs. So, there is a judgment to be made about the quality and meaning of Le Corbusier's photographs. Consequently, we have organized this book into text and "albums," in which a selection of photographs can be examined outside the discourse of the text.

1 Le Corbusier, *L'Atelier de la recherche patiente* (Paris: Vincent, 1960), 37, 203.

I will follow the convention of referring to our man as Jeanneret before 1920 and Le Corbusier subsequently. From 1906 to 1911, Jeanneret made a serious effort to master the technique and art of photography, purchasing at least three cameras, a tripod, and filters and learning to print and develop his negatives. Over 500 of these photographs survive, and some of them were intended for publication. He continued to take photographs of more personal interest until at least 1919. Later he acquired a 16 mm movie camera and, in addition to shooting sequences of film, took over 6,000 still photographs between 1936 and 1938. Although only a handful of these were ever printed, this corpus includes some extraordinary pictures and opens up a quite new insight into the architect's imagination.

This book divides into two quite distinct parts. Part One deals with Jeanneret's photographs of 1911–19. These have already been thoroughly discussed since Giuliano Gresleri discovered the negatives and contact prints in the city library in La Chaux-de-Fonds. The reader interested in this material must turn to Gresleri's book, which reproduces 600 of the photographs.[2] My contribution in this part of the book is to reconsider the evidence, looking closely at the cameras Jeanneret used and correcting some errors of attribution and dating. By identifying the types of camera that Jeanneret used, and their technical limitations, I hope to have set the discussion of the authorship of these photographs on a firmer footing. More importantly, I have reconstructed the material culture of photography at the time, allowing the reader to share more closely Jeanneret's photographic aims and experience. My hypothesis is that Jeanneret made a serious effort to take professional architectural photographs in Germany and Prague (April–May 1911) but that he soon gave this up for a more personal style, one closer to his approach to sketching. By October 1911, Jeanneret had abandoned the effort to take good-quality photographs and turned to the camera to take visual notes.

2 Le Corbusier and G. Gresleri, *Le Corbusier, viaggio in Oriente: gli inediti di Charles Edouard Jeanneret, fotografo e scrittore* (Venice: Marsilio/Paris: Fondation Le Corbusier, 1985).

The 1936–38 photographs discussed in Part Two have only begun to receive attention.[3] Some segments of film have been exhibited in recent exhibitions, and Claude Prelorenzo has written about Le Corbusier's cinematic technique.[4] But most of the still photographs discussed in this book have never been seen before and represent a completely new body of work by Le Corbusier at the height of his powers. They constitute a significant body of photographs, reflecting an understanding and taste for the "New Photography" of the 1920s and 1930s that could not have been expected from Le Corbusier's other work. The exhaustive study of different formal configurations (machinery on an ocean liner, stacks of wood and tiles, fishing nets spread out on a quay, shadows from palm trees projected onto a white wall) demonstrate his excitement at the potentital for near abstraction of the photographic image. Some of the pictures are primarily of anecdotal interest, providing an insight into the architect's mind at a low ebb in his professional career. Others illustrate his sympathy for the slum dwellers of Rio de Janeiro, the fishermen of the Bassin d'Arcachon, or the nostalgia for dying traditions. Many of the images are of natural forms, following the path already trodden by his paintings since 1928. But some of the sequences of his pictures reach out for explanations of the "cosmic" forces of sun and moon and their action on sea, wind, and rain, forming tiny expanses of sand, as they formed the vast landscapes Le Corbusier viewed from the air on several occasions between 1929 and 1938. This concentrated labor of visualizing, composing, capturing images appears to have been completely disinterested: very few were published and it is probable that Le Corbusier never even saw them properly projected or printed.

The literature has made various untested assumptions about the cameras Jeanneret used. If it is difficult to attribute authorship to a photograph, it is often possible to know precisely what camera took a picture. This knowledge sets certain limits to the possible. For example, Giuliano Gresleri

3 T. Benton, J.-C. Blaser, et al., *Le Corbusier and the Power of Photography* (London: Thames and Hudson, 2012).
4 C. Prelorenzo, "Quand Corbu faisait son cinéma," *Le Visiteur* 17 (November 2011): 67–75.

attributes a number of Jeanneret's photographs of the Orangery at Potsdam to his visit in June 1910.[5] But only two pictures taken with the camera he owned at this time portray the Orangery or its gardens.[6] The glass plate view BV LC-108-82, in the Bibliothèque de la Ville in La Chaux-de-Fonds (BV), must have been taken during the visit in April 1911, after the purchase of the plate camera in that month. Without knowing what the capacities of these cameras were, little of value can be said about the technical limitations of the photographs. Many of Jeanneret's photographs have been misattributed and misdated in the literature, and although this is not always significant, it can lead to serious misunderstandings. For example, a number of photographs of subjects in France have been attributed to Jeanneret's stay between 1908 and 1909, although they were in fact taken with a camera he purchased in October 1911. Photographs of classical and Rococo architecture at Versailles, Nancy, and Dijon, for example, make much more sense when correctly dated to the period after 1912, by which time Jeanneret had been fully weaned off his early enthusiasm for Gothic. As is often the case when you look into something carefully, fondly cherished beliefs have to be discarded. For example, I will show that the ICA Cupido 80 camera, conserved in the Fondation Le Corbusier, could not have taken a significant number of the photographs attributed to its use. Either these were taken by someone else or Le Corbusier must have owned a different camera.

The interest of the young Charles-Édouard Jeanneret in photography is well known and has been well documented. Giuliano Gresleri wrote the pioneering work on the photographs of the "voyage d'orient" (1910–11), putting together the journal entries and articles Jeanneret wrote about the trip, some of the drawings, and 300 of the photographs alongside each other.[7] The "voyage d'orient" (Journey to the East) is the term given to a six-month trip that Jeanneret made from May to November 1911, starting in Dresden and continuing via Prague and Vienna before descending the Danube, via various

5 G. Gresleri (ed.), *Les voyages d'Allemagne, Carnets; Voyage d'Orient, Carnets*, vol. 1 (Milan: Electa, 2000), 67.
6 BV LC-108-340, BV LC-108-334.
7 See also G. Gresleri, *Viaggio in Oriente. Charles-Edouard Jeanneret fotografo e scrittore* (Venice: Marsilio / Paris: Fondation Le Corbusier, 1995). Allen Brooks's review of this book offered some significant factual corrections but left the basic argument unchallenged.

deviations, to Budapest, Belgrade, Bucharest, Adrianopolis (Edirne), Istanbul, Mount Athos, and Athens, returning by way of Brindisi, Naples, Rome, Pisa, and Florence.[8] Between Dresden and Athens, Jeanneret was accompanied by a German art history student, August Klipstein, from whom Jeanneret learned a great deal. Klipstein was working on the Cretan artist El Greco, and his interest in Byzantine art and architecture influenced part of the itinerary. Gresleri makes an excellent job of setting this material into the intellectual context of the young Jeanneret, as he struggled to develop confidence in his judgment and taste. The subsequent discovery and publication of the notebooks in which Jeanneret wrote and sketched his reactions to what he saw on these travels has further deepened and complicated our understanding of this important stage in the architect's development.[9] One function of these little notebooks was to assist Jeanneret in writing a series of articles for the newspaper *La Feuille d'Avis de La Chaux-de-Fonds*. Jeanneret prepared a manuscript of his essays and some of these were indeed published, in part "improved" by his father and by the editor of the newspaper, Georges Dubois, a family friend.[10] At the end of his life, Le Corbusier prepared an edition of his manuscript, with a number of changes, which was published posthumously by Jean Petit, in 1966.[11] Gresleri included the chapters from the original manuscript in his book, noting the changes between these and the *Feuille d'Avis* articles on the one hand and Le Corbusier's 1966 edition on the other. Gresleri also included selected letters from Jeanneret's correspondence with his parents, his master Charles L'Éplattenier, his friend and mentor William Ritter, and, after the voyage, his travel companion August Klipstein.[12] All this adds up to a considerable documentation of an event that Le Corbusier himself considered very important in the development of his confidence as an architect. He published sketches and a few of his photographs from the voyage d'orient in a number of his articles and books in the 1920s and continued to do so throughout his life.[13]

8 Le Corbusier and I. Zaknic, *Journey to the East* (Cambridge, MA: MIT Press, 2007). See also the conference devoted to the voyage d'orient: G. Gresleri "L'Oriente di Jeanneret," in *Parametro*, 1, 6-64, 0031-1731, and an interesting article by G. Gresleri: "Viaggio e scoperta, descrizione e trascrizione," in *Casabella* 51 (1987): 116, in which he speculates about the impact of the voyage d'orient on Le Corbusier's later career.

9 Le Corbusier, *Voyage d'Orient*, (6 carnets in 5 vols. with transcriptions) (Milan: Electa, 1987) and Le Corbusier and G. Gresleri, *Le Corbusier: les voyages d'Allemagne: carnets.* (Milan: Electa / Paris: Fondation Le Corbusier, 1994).

10 These articles, which cover only the first half of the manuscript, appeared between July and November 1911. The manuscript is held at the Fondation Le Corbusier.

11 Le Corbusier, *Le Voyage d'Orient* (Paris: Minuit, 1966). Later editions include Le Corbusier and I. Zaknic, *Journey to the East* (Cambridge, MA: MIT Press, 1987).

12 Most of these have now been extensively published: M.-J. Dumont, *Lettres à ses maîtres 2 L'Éplattenier* (Paris: Linteau, 2002) and Le Corbusier, R. Baudouï, and A. Dercelles, *Correspondance Tome I, Lettres à la famille, 1900–1925 édition établie, annotée et présentée par Rémi Baudouï et Arnaud Dercelles* (Paris: InFolio / Fondation Le Corbusier, 2011). The second volume, covering 1926–1949, was published in January 2013.

13 Sketches from the voyage d'orient were published in *Vers une Architecture, Urbanisme,*

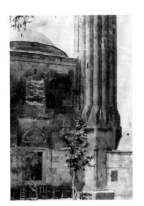

L'Art décoratif d'aujourd'hui, Alma-
nach de l'architecture moderne
and Une Maison – Un Palais,
but his photographs appear
in only a few: Urbanisme, p. 29;
L'Art décoratif d'aujourd'hui, p. 121
(this may be a museum photo);
Almanach de l'Architecture
moderne, pp. 65, 116; Une Maison –
Un Palais, pp. 17, 25; and La Ville
Radieuse, pp. 139, 155, 322.
14 Italo Zannier, "Le Corbusier
fotografo," in Le Corbusier,
Le Corbusier, viaggio in oriente:
gli inediti di Charles Edouard
Jeanneret fotografo e scrittore:
2a ed. (Venice: Marsilio, 1985),
69–73.
15 B. Mazza, Le Corbusier
e la fotografia: la vérité blanche
(Florence: Florence University
Press, 2002).
16 A. Rabaça, "Documental
language and abstraction in the
photographs of Le Corbusier,"
Jornal dos Arquitectos. I would
like to thank Armando Rabaça
for an advance view of an English
draft of this piece.
17 Allen Brooks notes that
Klipstein, a protégé of Worringer,
quoted from Abstraction and
Empathy in the journal he made
during the trip. H. A. Brooks,
Le Corbusier's Formative Years:
Charles-Edouard Jeanneret at La
Chaux-de-Fonds (Chicago: Univer-
sity of Chicago Press, 1997), 235.
18 The negative, whose image
measures 7.8 × 9.7 cm, is a sheet of
celluloid from a pack film. Contact
prints demonstrate that this was
not a glass plate (BV LC-108-341).
19 D. Naegele, "Object, Image,
Aura: Le Corbusier and the Archi-
tecture of Photography," in Harvard
Design Journal 6 (fall 1998): 1–6.
For Naegele's PhD thesis, see
D. Naegele, "Le Corbusier seeing
things: ambiguity and illusion
in the representation of modern

In all this work, the role of photographs in the processes of learning and understanding of the future Le Corbusier was afforded only a marginal role. The Italian photographic historian Italo Zannier wrote a short chapter in Gresleri's book outlining some of the facts of life with cameras of the type used by Jeanneret.[14] He distinguished between some of the earlier, prosaic photographs intended to capture information and some of the later ones in which can be seen the real photographic art of how to bring out the meaning of a subject by eliminating the inessential and using the composition to highlight what is important. More recently, Barbara Mazza wrote a book on Le Corbusier and photography that went more closely into the photographic quality of Jeanneret's early pictures[15] and discussed Le Corbusier's later use of professional photographers to document his buildings. The relationship between his own experience as a photographer and his use of photographic images is extremely important.

Armando Rabaça has contributed an interesting essay on the subject, in which he emphasizes the importance of Wilhelm Worringer's *Abstraction and Empathy* on Jeanneret during the voyage d'orient.[16] Jeanneret's friend and travel companion August Klipstein seems to have had the book with him during the journey and encouraged Jeanneret to read it.[17] For Rabaça, this is confirmation that Jeanneret was interested in extracting abstract formal configurations from his photographs and not just cognitive information. Rabaça's analysis of a photograph of the wall of a mausoleum and the base of a minaret insists on this process of abstraction FIG. 1.[18]

For Daniel Naegele, however, this photograph has another meaning. Naegele wrote a fundamental PhD thesis on Le Corbusier's work with the professional photographers who illustrated his buildings. His later research focused more on finding anthropomorphic references in the photographs that Jeanneret took or those that Le Corbusier selected for publication.[19] He sees a grotesque face and a part of a body embedded in the rough stone

FIG. 1 **Charles-Édouard Jeanneret, minaret and tomb of Uc Serefeli Camii, contact print, 7.8 × 9.7 cm, pack-film negative**
BV LC-108-341 → p. 96

work of the wall FIG.1. I am sure that Rabaça is right in thinking that this photograph represents an effort by Jeanneret to create an abstract, rectilinear composition, rather than to simply record the building. This photograph is quite different from the sketches Jeanneret made of mosques, which usually explore the structure and the sequence of spaces.

Leo Schubert contributed a chapter to the book *Le Corbusier before Le Corbusier*, looking specifically at the photographs that inspired Jeanneret's view of Germany.[20] Schubert's work has the great value of putting together Jeanneret's acquisition of postcards and professional prints with the photographs he took himself. Noting the importance of Paul Schultze-Naumburg's *Kulturarbeiten* (1902–08) as a model for the use of photographs both to praise and criticize urban configurations, Schubert suggests that many of the photographs made during the German trips were taken to make points relating to Camillo Sitte's *City Planning According to Artistic Principles*.[21]

Zannier and Rabaça insist on the fact that Jeanneret's photographs focus on the essential:

> *Following the tradition of traveling photography, the documental purpose of Jeanneret's photographs during the journey to the East led to a realist tone and a simple compositional principle that essentially consists in centering the subject of analysis in the frame.*[22]

For Zannier, this focusing on the essential was a measure of photographic quality; for Rabaça, it is more a question of documentary concision, a "realist tone." Neither analysis gets to the bottom of the problem, since Jeanneret's photographs are neither consistently concise, as images, nor do they do a good job of documenting the things that seem to be of interest, even to him, judging from the extensive documentation we now have. The fact that he chose to use postcards or professional photographs in his publications,

architecture," in *Dissertation in Architecture,1996*, (Pennsylvania, 1996).

20 See L. Schubert, "Jeanneret, the City, and Photography," in Von Moos and Ruegg, *Le Corbusier before Le Corbusier* (New Haven: Yale University Press, 2002), 55–68. See also L. Schubert and Centro internazionale di studi di architettura Andrea Palladio di Vicenza, *La villa Jeanneret-Perret di Le Corbusier, 1912: la prima opera autonoma* (Venice: Marsilio, 2006), in which Schubert discusses some of the photographs Jeanneret took of the Jeanneret-Perret villa.

21 C. Sitte, *City Planning According to Artistic Principles [Der Städtebau nach seinen künstlerischen Grundsätzen vermehrt um "Grossstadtgrün"]*, originally published in 1889 (New York: Rizzoli, 1965).

22 See also Hildegard Frübis, "Images du sphinx: La conquête de l'Orient par la photographie, à mi-chemin entre archéologie et beaux-arts," in *A la recherche de l'Orient: Paul Klee. Tapis du souvenir* (Bern: Zentrum Paul Klee/Ostfildern: Hatje Cantz Verlag, 2009), 106–29.

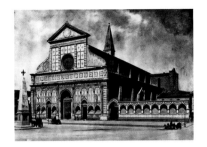

FIG. 2 **Alinari brothers, Santa Maria Novella, Florence** NGA 1900149271

23 O. Schwindrazheim, "Die Poesie der alten deutschen Stadt," in *Deutsche Camera-Almanach. Ein Jahrbuch* VIII (1912): 133–142, p. 135.

rather than his own photographs, underlines the fact that he realized that it took a certain photographic talent to give forms their greatest impact or communicate the important features of a building. Furthermore, the approach to travel photography in the period 1900–10 was far from being typically "realist." Professor Schwindrazheim, writing in 1912 to advise the readers of the *Deutscher Camera-Almanach* on how to take travel pictures, began by evoking Sleeping Beauty awakened by the kiss of the Prince, along with the people, animals, and fire in her palace. The traveler should seek out just such villages and nooks and crannies of the German countryside, apparently unchanged over centuries and needing only the perceptive lens of the cameraman to bring them to life.

Just like city dwellers of today, we who live in an era of modern marvels, radio telegraphy, airships, etc., are once again extraordinarily receptive to the poetry of old German towns—traveling or wandering from afar to savor them—and this reawakened inclination is gaining currency in ever wider circles![23]

The *Heimatschutz* movement in Germany and Switzerland, like the Arts and Crafts Movement in Britain, had led to great enthusiasm to discover, restore, and paint or photograph the charm of old towns and villages. Jeanneret was himself sensitive to this movement, although he was developing a more independent approach to vernacular architecture during the period of his photographic activity, one in which he sought the pure and authentic primitive not in Europe but in the Balkans and in Turkey.

The documentary model of the professional agencies—Alinari, Broggi, or Marburg—was challenged by the new pictorial school of photography. In fact, well before 1900, a gulf had opened up between the professional photographic agencies and the pictorial photographers. The professionals had developed methods that included the use of large wooden cameras taking

glass plates of 8 × 10 inches (ca. 20 × 25 cm), 10 × 12 inches (ca. 25 × 30 cm), or 15 × 12 inches (ca. 38 × 30 cm), the latter described by the English photographic authority R. Child Bayley as "the most popular of the 'large' sizes."[24] This allowed for the easy production of contact prints of publishable and exhibitable size. Their aim was to represent famous buildings as completely as possible, for sale to tourists or publishers. To achieve this, they would often find advantageous viewpoints, from houses or towers, or use tall stepladders, to get the view they needed. They would pose figures in strategic locations to give a sense of scale and would wait for the best available lighting. Wide-angle lenses would be used to "get in" as much as possible. Yellow or orange filters would make the skies darker and accentuate cloud effect, and sometimes special cloud effects would be added to the image. Very long exposures offered a way to remove the bustle of people and traffic. In interiors, exposures of up to half an hour might be used, along with elaborate methods, to cut down the glare from windows in dark interiors. On occasion, electric lighting or multiple magnesium flash would be used to illuminate dark corners. None of this, however, was practicable for the travel photographer.

Jeanneret's photographs have to be inserted between the professional architectural photograph and the pictorial travel picture. His aim, generally, is neither to "get everything in" nor to produce a print that could, by the conventions of the time, be displayed on the wall in an exhibition. Instead, it belongs to the genre of specialist photographs—those of geographers, engineers, archaeologists, and architects, who took photographs for particular reasons. It is unproductive to treat them as art, although several are of a fine quality, and unhelpful to compare them with professional architectural photographs.

A quite different approach is taken by Andrzej Piotrowski in an essay in which he sees a transformation, in Jeanneret's photographs between 1907

24 R. Child Bayley, *The complete photographer* (London: Methuen & Co., 1907), 39.

and 1911, from conventional stereotypes to a more interpretative mode. He identifies a certain nominalism in his early photographs, which often foreground a famous object—fountain, statue, monument—at the expense of an overall understanding of space and place. In part this can be explained very simply: Jeanneret was charged by L'Éplattenier to take photographs in particular categories—including cemeteries, gardens, bridges—and Jeanneret confessed to his friend August Klipstein that he was having difficulty following this guidance.[25] He refers to reading the manuscript of his book *La Construction des Villes* to L'Éplattenier:

> *I read it to my master, who considered the aim admirable. But the joker advised me, reasonably enough, to complete the work with a study of cemeteries, bridges, gardens, parks, and garden cities. It's a lot of research to do and I don't really know where to start. Aren't there some wonderful gardens in Spain? I dug out a photograph of the courtyard of the Generalife, which I propose to publish: do you know anything better? And what about bridges? I'm really short on these. All the time I was visiting beautiful countries I never looked at the bridges, and it's a shame. If only I had done as you did, sketching the bridge at Toledo! If you have any ideas of beautiful bridges, in any style of architecture, let me know.*[26]

He made a similar point to L'Éplattenier in a letter of October 1, 1910.[27] Public fountains were just one of the categories of things Jeanneret was collecting for his book. L'Éplattenier also owned a camera and lent it to Jeanneret for one of these photographic expeditions. Jeanneret complained that none of the twelve pictures taken with L'Éplattenier's camera had come out.[28]

As Jeanneret developed as a photographer, Piotrowski argues, effects of light and shade and asymmetrical framing are used to interpret the subject in new ways.

25 Letter to Klipstein, September 2, 1910 (FLC E2(12)74).
26 FLC E2(6)128.
27 FLC E2(12)74.
28 Letter to L'Éplattenier from Munich on October 1, 1910 (FLC E2 E2(12)74).

No longer relying on preexisting narratives in his form-making processes, and disregarding expectations concerning descriptive realism, he sought forms that escape verbal descriptions…. Consequently, the photographs and drawings he produced at the end of that voyage would almost eliminate the distinction between an observational depiction and a conceptual drawing.[29]

29 A. Piotrowski, "Le Corbusier and the Representational Function of Photography," in Higgott and Wray, *Camera constructs; Photography, architecture and the modern city* (Farnham: Ashgate, 2012), 35–45, p. 38.

There is something in this. There certainly is an evolution in the way Jeanneret perceived the subject and the techniques he used to interpret it, but it is too simplistic to see this as a single evolution. Many factors come into play, not least the conventions of travel, architectural, and pictorial photography of the period. For example, in several of the early photographs, strong effects of light and shade are used to create graphic effects FIG. 4. Furthermore, once Jeanneret had abandoned his more sophisticated camera in October 1911, his photographs generally revert to a simpler and cruder style of pictorial note-taking. I will argue that you have to understand the cameras Jeanneret used at each stage in order to understand the pictures he took.

The photographs showing fountains in the center of the frame, which Piotrowski interprets as a "textual" stereotype, can be more simply explained. The photograph of the fountain in the Basse Ville, Fribourg FIG. 3, was taken in March 1910, when Jeanneret had three years' experience of taking photographs with this camera, and it shows some sophistication in its composition. Jeanneret has found a raised viewpoint around two meters above the level of the fountain in order to take his photograph and this, combined with a slight tilting of the camera, has enabled him to get in the top of the statue. Tilting the camera upward is revealed in the slight convergence toward the top of the vertical lines of the buildings in the background. It is important that the column and statue are central in the composition, because otherwise they too would lean to the right or to the left. In fact,

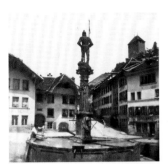

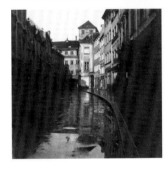

FIG. 3 **Jeanneret, Fontaine de la Fidélité,
Fribourg, Switzerland, March 1910**
BV LC-108-296 → p. 58

FIG. 4 **Jeanneret, photograph of a rainy street
in Munich, March 1910**
BV LC-108-293 → p. 61

the whole picture is tilted slightly to the right, but apart from this slight carelessness, the photograph shows careful composition and planning. 30 FLC R3(18)161.

The photograph of a rainy street is plausibly identified as being of Nuremberg by Gresleri. If so, it must have been taken either in March 1908 or June 1910. It is a typical example of a "pictorial" photograph. No building of importance is shown in the photograph, nor is there an obvious point of urban planning to be made. It is simply a "nice photo" made by the effects of light and shade and the surprising impact of slick black asphalt after rain. In a letter to his friend William Ritter of February 2, 1912, Jeanneret says that he put on one side for him the "Photo of Munich as a Venetian Canal."[30] No other surviving photograph so perfectly matches this description, which helps to explain why the photograph was taken. It is likely, therefore, that this photograph was taken in Munich on one of the many occasions that Jeanneret was there between 1908 and 1910. Given the difficulty of dating photographs when it is known that Jeanneret visited a place on more than one occasion, it is hard to substantiate the hypothesis that Jeanneret developed from a "textual" to a "pictorial" form of representation. More important was the motivation for each shot—accumulating images for his book, making a visual note, or taking a photograph for the pleasure of it.

I will return to the question of photographic style; suffice it to say that the dominant mode of travel photography was precisely of this kind, in which the artist endeavors to make a "picture" out of an urban scene by choosing a moment when heavy shadows forming dramatic shapes give the composition formal interest. Furthermore, it is misleading to treat the photographs and drawings as if they shared the same evolution. The development of Jeanneret's drawing style during the six months of the voyage d'orient marked a fundamental shift from a pictorial to an architectural mode of analysis and expression. Drawing became a means not only of

memorizing a formal and spatial configuration but interpreting it, and often changing it, in the light of architectural concerns.[31] But before considering all this, it is necessary to note both how Jeanneret's aims changed during the period and how his different cameras determined what he could do at any one time.

31 G. Gresleri (ed.), *Les voyages d'Allemagne, Carnets; Voyage d'Orient, Carnets* (Milan: Electa, 2000).

Jeanneret's First Photographic Campaign 1907–17

A corpus of photographs exists from the period 1907–17, with apparently impeccable provenance, which has always suggested to scholars that Jeanneret was their author. The 610 prints and photographs in the Fondation Le Corbusier from the period 1906–21 consist mostly of prints and contact prints. They were in Le Corbusier's possession at his death, along with a very large collection of postcards and prints by professional photographers and a significant number of photographs of unknown origin, some of which may have been taken by Jeanneret. The collection of 638 photographs in the Bibliothèque de la Ville in La Chaux-de-Fonds taken between 1906 and 1921 were in the house of his mother at Corseaux, on Lake Geneva, at the time of the death of Le Corbusier's brother, Albert (1973). They formed part of a collection of over a thousand miscellaneous family photos and pictures of buildings and landscapes. The niece of Le Corbusier's cousin and architectural partner Pierre Jeanneret, Jacqueline Jeanneret, visited the house and removed a large quantity of material. Part of this she donated to the library in La Chaux-de-Fonds. A collection of copy prints of some of the voyage d'orient negatives remained in her possession until recently, when they were acquired by the Canadian Centre for Architecture (CCA) in Montreal, as part of a collection of the work of Pierre Jeanneret. I have made a complete concordance of these three collections.[32] We must nevertheless ask, who took the photographs, when, and with what cameras? These questions are linked. Unless a photographer has developed a strong personal style, or adopts very particular technical methods, it is not easy to attribute authorship. But it is sometimes possible to connect photographic negatives to particular cameras, because some cameras leave a "fingerprint" on the border of the negative, produced by irregularities in the masking frame. We can also make certain deductions about negative size and type, quality of image, and characteristics produced by particular features of a camera. So we can make a first attempt at identifying the author of these photographs by attaching them to particular cameras.

32 This concordance will be published on the site of the Fondation Le Corbusier.

First we must establish the basics: what cameras did Jeanneret own, what were their limitations, and what does this tell us about the photographs and their authorship?

Le Corbusier himself claimed, much later, that the first camera he bought was a cheap Kodak:

> *I bought myself a little Kodak camera, which Kodak sold for six francs in order to sell film to all those idiots who use it, and I was one of them, and I noticed that by entrusting my emotions to a lens I was forgetting to have them pass by me—which was serious. So I abandoned the Kodak and picked up my pencil, and ever since then I have always drawn everything, wherever I am.*[33]

And in January 1936, just before embarking on an intensive campaign of photography, he gave the journalist Philippe Diolé a similarly dismissive judgment:

> *I have always made drawings, since I do not believe in cameras, which are instruments for the idle. We expect them to make a record, but they fix nothing in your own brain. The drawing, on the other hand, enables you to remember and to understand.*[34]

Jeanneret's Cameras

A set of approximately 236 pictures on celluloid film with an unusually large square format (ca. 9 × 9 cm) have survived, which I date to between 1906 and 1921. By "picture" I mean here the image(s) produced from a single negative. The negative and/or any contact prints or enlargements that survive here count as one "picture." The precise dimensions of the images

33　From an interview in the 1960s with Jacques Barsac, *Le Corbusier un Film de Jacques Barsac*, part 1 (1887–1929), prod. Christian Archambeaud and Jacques Barsac, Ciné Service Technique, Paris, 1987, cited by Leo Schubert in "Jeanneret, the City and Photography," in *Le Corbusier before Le Corbusier*, see note 20, p. 14.
34　Philip Diolé, "Leurs raisons de vivre: Le Corbusier," *Beaux-Arts* 31 (January 1936): 1 (FLC X1(13)1).

are 8.32 × 8.32 cm, on film 8.8 cm wide. These exist in the form of 162 negatives and contact prints at the Bibliothèque de la Ville in La Chaux-de-Fonds (BV) and sixty-five contact prints in the Fondation Le Corbusier, Paris (FLC). Of the 162 in the library in La Chaux-de-Fonds, seventy-six do not exist in either the FLC or CCA collections. Of the sixty-five in the Fondation Le Corbusier, forty-seven are unique to that collection. In addition, 123 contact prints of the 9 × 9 cm negatives exist also as copy prints in the collection of the Canadian Centre for Architecture (CCA), of which thirty do not exist in either of the other collections. I will speculate later about how and when these various prints were produced. Most of these photographs were taken between June 1906 and May 1911, either in La Chaux-de-Fonds or during Jeanneret's travels in Switzerland, Germany, Austria, and Italy. All of them were taken in places Jeanneret was known to have visited. Some, of Swiss landscape and family scenes, may precede 1906 while around forty-five postdate May 1911; some were taken as late as 1921. Zannier seems to believe that some of the 9 × 9 cm negatives were taken with the camera that is now in the collection of the Fondation Le Corbusier, but this is excluded by the dates, as will be shown below. It is even possible that the camera had been in Jeanneret's family before 1906, since several negatives taken with it depict Alpine scenery and family scenes that cannot be dated.

At some point in March or April 1911 Jeanneret bought a new and expensive camera and began taking 9 × 12 cm glass plate negatives with it between April 1911 and the end of September 1911. Sixteen plate photographs of Potsdam, Stuttgart, Karlsruhe, Frankfurt, and Hamburg were taken between April 4 and May 11, 1911. Jeanneret also visited Potsdam on June 20, 1910 and made notes about the Orangery and the open-air staircase and gardens in his Carnet II.[35] He refers to having taken a photograph of the avenue lined with hornbeams (p. 132) and this may be BV LC-108-330 (square negative). He took another photograph with his first camera on this occasion,

35 G. Gresleri (ed.), *Les voyages d'Allemagne, Carnets; Voyage d'Orient, Carnets*, vols. 1 and 2 (Milan: Electa, 2000), 66–67 and 129–36 respectively.

of the steps leading up to the Orangery.[36] Of the 9 × 12 cm glass plates, 172 have survived in negative and/or contact print form (159 in the BV, 80 in the FLC, and 87 in the CCA collections). Fifty-two are unique to the BV and twelve to the FLC collections. There are also fifteen 9 × 12 cm celluloid pack-film negatives, mostly taken in Istanbul, of which eight are held in the BV, fourteen copies in the FLC, and eleven in the CCA. There are also around 163 negatives from the period May-October 1911 measuring 6 × 9 cm, perhaps using the same camera with a roll-film holder. of which 130 are in the BV, 140 in the FLC, and 115 in the CCA collections. Jeanneret did not throw his first camera away on buying the new one. Between April and May 1911, he seems to have continued using his first camera alongside the new one; there are 9 × 9 cm negative pictures of the Hohenzollern Bridge, Cologne (visited May 5–6, 1911), the Wesaplatz in Hagen (visited May 9, 1911; FIG. 41), and two photographs of Prague (May 25–27, 1911; FIG. 5) and a picture of the Charles Bridge; FLC L5(1)131.

These photographs, taken in places he visited only in May 1911, demonstrate a sophisticated use of his simple camera. Neither FIG. 5 nor FIG. 47 is tilted upward, with the consequent "drunken verticals." Both are carefully exposed to make picturesque use of the foreground and effects of light and shade. I suggest that with these photographs he is putting lessons he learned with his plate camera to good use with his modest 3½ × 3½ inch negative camera.

From this point on Jeanneret abandoned the square-format camera but returned to it occasionally after 1911, using it to take some 40 views of the house and garden he had designed for his parents in La Chaux-de-Fonds, between 1912 and 1919, and some family snaps.[37] As late as October 1920, he could still get it out to take three photographs of his parents, his brother, Albert, and his new friend Amédée Ozenfant, on the balcony of their rented chalet at Châbles. Ozenfant visited La Chaux-de-Fonds with Jeanneret

FIG. 5 **Jeanneret, photograph of Staré zámecké schody, near the castle, Prague, May 1911**
BV LC-108-257 → p. 59

36 BV LC-108-340.
37 See Leo Schubert and Centro internazionale di studi di architettura Andrea Palladio di Vicenza, *La villa Jeanneret-Perret di Le Corbusier, 1912: la prima opera autonoma* (Venice, Marsilio, 2006); Centro internazionale di studi di architettura Andrea Palladio, K. Spechtenhauser, and A. Rüegg, *Maison Blanche: Charles-Edouard Jeanneret/ Le Corbusier* (Basel: Birkhäuser/London: Springer, 2007), in which there is also a detailed discussion of the restoration of the villa.
38 See H. A. Brooks, *Le Corbusier's formative years: Charles-Edouard Jeanneret at La Chaux-de-Fonds* (Chicago: University of Chicago Press, 1997), 502.

FIG. 6 **Jeanneret, 6 × 9 cm negative of peasant women in Baja, Hungary, probably shot with a roll-film holder on his plate camera**
BV LC-108-029 → p. 125, top right

FIG. 7 **Jeanneret, close-up of the bottom right corner of 6 × 9 cm negatives shot with a roll-film holder**

between August 23 and September 4, 1919, and visited the house at Châbles on that occasion, but his parents had yet to move in. The photographs on the balcony probably date from the summer of 1920, when Ozenfant and Jeanneret made a repeat visit and Albert was also present.[38] It seems that Ozenfant also paid Jeanneret's parents a visit, alone this time, in September 1922, when Jeanneret was in Venice with their patron Raoul La Roche.[39] Similarly, although he stopped taking plate negatives regularly in October 1911 for the rest of the voyage d'orient, he seems to have taken a number of glass plates, perhaps as many as fifty, in subsequent years to document the construction of the house for his parents and life in the house and garden between 1913 and 1919. Some of these may have been professional photographs but the majority seem to have been taken by Jeanneret with his first camera, his plate camera, and his third camera, a Kodak Brownie.

It appears that there was some sort of malfunction with his plate camera in Athens (September 1911), for not only did he stop taking glass plates with it, the 6 × 9 cm negatives he had been taking up until then also stopped. We know this because they had a characteristic "fingerprint"—a strip of felt along the right-hand edge, which pulled out at the bottom into a distinctive wedge and which left a small indent at the top right. Some of the most interesting pictures, of vernacular architecture, mosques, and tombstones, were taken on these negatives.

Jeanneret purchased his third, cheaper camera, the Kodak Brownie, in Naples in October 1911, and used this for the remainder of the trip, taking only five more glass plates in Italy and no more of the distinctive 6 × 9 cm negatives with the felt strip along the edge. This third camera was probably a folding Brownie, which could be bought for $5 (ca. 26 Swiss francs). Although the negatives taken with the folding Brownie are also 6 × 9 cm in format, their quality is quite different from the "felt strip" negatives: much less sharp and with less contrast.

39 Ozenfant letter to Jeanneret, September 14, 1922, FLC E2(17)427.

First Steps

We cannot be certain what make or model Jeanneret's first camera was. When he told Jacques Barsac that his "Kodak" had cost six francs, he may have been thinking of the Kodak Brownie, manufactured in Rochester, USA, from 1900 on. This sold for $1 in the USA (around 5 francs in France or in Switzerland). The film format that Jeanneret used, however, excludes this possibility. It is the type of film, taking $3\frac{1}{2} \times 3\frac{1}{2}$ inch pictures (ca. 9×9 cm), that Kodak called 101 and which Agfa produced as H6. It was the first celluloid film to be manufactured in quantity by the George Eastman company, from 1895 on, and although it apparently remained in production until 1951, very few new cameras were made to use it after 1900. No Kodak Brownie cameras were made to take this kind of film.

In 1895, the Boston Camera Company invented a celluloid roll film backed with black paper and an inspection window in the back of the camera that could be used to advance the film precisely from frame to frame. This enabled photographers to buy rolls of film separately from the camera and load and unload them in subdued daylight. This went against the principle on which George Eastman had founded his company, with its slogan: "You press the button we do the rest." The first roll-film Kodak cameras were supplied with a long roll of film inside. Once the 100 pictures had been taken, the whole box was sent back to Rochester, processed, and a new camera returned, loaded with film, along with the prints. The problem was that the camera, loaded with film, was expensive at $25, whereas plate cameras were on the market for much less. Eastman realized that the Bull's-Eye threatened his Kodak cameras and began making the Bull's-Eye under license. In 1895, Eastman began manufacturing its own version of the Bull's-Eye camera, in various film-size formats.

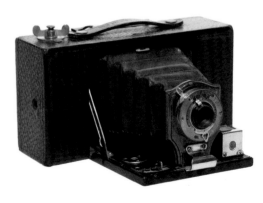

FIG. 8 Bull's-Eye camera produced by the Boston Camera Company from 1895 on (advertisement in *Century*, June 1894, in George Gilbert, *Collecting Photographica*, Hawthorn Books, p. 41)

FIGS. 9, 10, 11 No. 2 Flexo (or Plico) Kodak camera, taking 3½ × 3½ inch No. 101 film, marketed by Kodak between 1900 and 1914

FIG. 12 Kodak Flexo camera, showing front and sides hinged open to provide access to the interior to load film

FIG. 13 No. 2 Folding Pocket Kodak, made by Kodak between 1905 and 1910

Collection of Jos Erdkamp

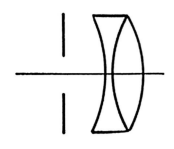

The standard method for making prints from negatives at this time was the contact print; the bigger the negative, the bigger the print. Professional photographers used negatives as large as 18 × 24 cm or larger, and popular cameras typically took negatives of 6 × 9 cm or 5 × 7 cm. The 9 × 9 cm negatives matched the standard size of European lantern slides at the time and it simplified the arrangement of the camera, since it was always used the same way up. The first Bull's-Eye cameras took circular pictures (as did the first Kodak cameras), which also partly explains the square format of the negative. Photographers had long used circular or oval vignettes to frame portraits, thus focusing attention on the sitter. A circular format also conveniently disguised the defects of the very simple meniscus lenses used in these cameras FIG. 14,[42] which tended to become unsharp and slightly dark in the corners.[40] The meniscus lens is defined as "a single disc of glass, thicker in the center than at the edges, with one face convex and the other concave." Provided a small aperture was used (ca. f16), a reasonable picture could be obtained. The better box cameras were fitted with simple achromatic lenses, which cured some of the aberrations of the meniscus lens and could be used at a wider aperture. In the words of an authority on these early cameras, "Well-designed lenses of this type produce sharper images and cover larger fields than the single [meniscus] lens at apertures of f12.5 to f16."[41]

The Kodak Bull's-Eye cameras and all later models took square photographs. Kodak's No. 2 Bullet camera, very similar to the Bull's-Eye, was manufactured from 1895 to 1903 and an improved model was produced up until 1913. The Bull's-Eye and Bullet cameras were extremely successful in the USA, making the company more money in one year (1897) than in five years of selling the previous Kodak models.[43] The Falcon was another Kodak model and there were other cameras of a similar kind made in Europe.

So, what model did Jeanneret buy? Anyone in Europe seeking to buy a camera using the 101 film had the following candidates to choose from:[44]

40 *The Focal Encyclopedia of Photography* (New York: Macmillan, 1960), 720.
41 C. B. Neblette, F. W. Brehm, and E. L. Priest, *Elementary Photography for Club and Home Use* (New York: Macmillan, 1936), 51.
42 Ibid., p. 50.
43 C. Ford, *The Story of Popular Photography* (London: Century, 1989), 63, in association with the National Museum of Photography Film and Television.
44 Eastman Kodak Company, *History of Kodak Cameras*, Publication AA-13, minor revision 3/99. Currency conversion to French francs based on data from Global Price and Income History Group.

FIG. 14 **Simple meniscus lens**
FIG. 15 **Simple achromatic lens**

No. 2 Falcon Kodak Box camera	1897–1899	$5	26 francs	Replaced in 1899 by No. 2 Flexo camera, known in Europe as No. 2 Plico (same price)
No. 2 Bull's-Eye Kodak camera	1895–1913	$8	42 francs	Various models (1896, 1897, 1898, C, and D) Simple meniscus lens, I and B speeds, three apertures
No. 2 Bullet camera	1895–1896	$8	42 francs	Very similar to the Bull's-Eye
No. 2 Folding Bull's-Eye	1899–1901	$10	52 francs	Superior version of the Bull's-Eye with a better achromatic lens. As a folding camera, it was more convenient to carry around.
No. 2 Bullet Improved	1896–1900	$10	52 francs	Could take single plates as well as the 101 roll film.
No. 2 Bull's-Eye Special Kodak camera	1898–1904	$15	78 francs	Superior version, with Bausch and Lomb rectilinear lens, iris diaphragm, and triple action shutter (slow, medium, or fast)
No. 2 Folding Pocket Kodak	1905–1910	$15	78 francs	Aluminum body covered in leather with nickeled fittings F.P.K. automatic shutter, double combination rapid rectilinear lens
No. 2 Bullet Special	1898–1904	$18	94 francs	Rapid rectilinear lens, triple action shutter, choice of six apertures. Could also take glass plates. Discontinued in 1904

Of these cameras, the most readily available were the Bull's-Eye and Flexo cameras (sold in Europe as Plico), which were produced in large quantities. The Folding Pocket Kodak was also widely available. For example, an admiring announcement in *La Photo-Revue Suisse* in 1897 stressed that "[i]ts briefcase shape makes it especially suitable for cyclists and tourists."[45] The announcement went on to promote the Folding Bull's-Eye camera, pointing out that it had all the refinements of the Folding Pocket Kodak, but was made of wood, not aluminum. These two cameras and the No. 2 Bullet Special had superior, sharper lenses, offering less distortion and a slightly wider aperture, which meant that that they could be used handheld in a wider variety of lighting conditions. Clearly, all these cameras were much more expensive than the six francs cited by Jeanneret. It would be extremely interesting to know whether he purchased one of the cheapest box cameras

45 "Les nouveaux appareils Eastman," *La Photo-Revue Suisse* 1(1) (January 1897): 32.

FIG. 16 **Jeanneret, photograph taken in Italy, 1907, with his first camera** BV LC-108-476

FIG. 17 **Jeanneret, detail of the top right corner of the negative** BV LC-108-476

(priced between 26 and 42 francs), with their simple meniscus lenses or one of the superior versions, with their sharper and better, corrected lenses costing between 50 and 95 francs. A meniscus lens can deliver a sharp image at the center of the picture, provided that a very small aperture is used, but the quality tends to fall off slightly at the corners, both in sharpness and in the intensity of light. The small aperture, combined with the slow films in use at that time, meant that long exposures had to be given in all but strong sunlight. Many of the photographs taken by Jeanneret with this camera are not very sharp, and this is probably due to the slow shutter speed. The cheaper cameras only had one "instantaneous" speed, which would be the equivalent of around 1/30 second—slow enough to quite likely make the camera shake when taking pictures handheld. Anything moving close to the camera would be blurred. In interiors or in shade, the "instantaneous" exposure would give an underexposed picture, and so the camera would have to be placed on a tripod and a "guesstimate" exposure given by opening and closing the shutter by hand.

 Although we cannot know who took any of these photographs, we can be confident that this group of 236 pictures was taken with the same camera used on Jeanneret's travels to Germany and Italy between 1907 and 1911. This is because the contact prints, and in many cases the original negatives, have survived. This means that we know not only the exact dimensions of the negatives but also some telltale details of the camera. The giveaway is a slight nick in the camera's mask, on the top right-hand edge of the negative, and this can be found on all the pictures taken with this camera where the contact print has not been cropped. There is also a slight gap in the mask at the top corners, indicating that the side mask did not make a light-tight join to the top.[46]

 The detail of one of Jeanneret's 9 × 9 cm negatives illustrates both these points FIGS. 16–17.[47] The corner of the negative becomes quite unsharp and

46 I would like to thank Jos Erdkamp for his generous help in analyzing these negatives. Erdkamp has a unique collection of early Kodak roll-film box cameras.
47 No one has yet been able to identify this picture. The back of the copy of the print in the CCA is marked only "1907".

you can see the little "blip" along the top edge and the tiny gap in the corner (white on the negative and black on the contact print).

If we assume that the first camera Jeanneret acquired was a simple Flexo (or Plico) camera, we can describe it and how it worked. The camera was made of wood covered in seal grain leather, weighing 19 ounces (539 grams), had a very simple meniscus lens with fixed focus, and a shutter offering a single "instantaneous" speed (roughly 1/30 second), as well as Time and Bulb settings that allowed for longer exposures. The lens had a focal length of 4½ inches, slightly less than the diagonal of the 3½ × 3½ inch negatives; the angle of view would be very slightly wider than "normal" vision. To make access to the roll films easier, the side panels of the Flexo opened out, as did the front panel FIG. 12. The shutter was a rotating disk that could be interrupted by the T or B lever projecting from the top of the camera in order to make a time exposure. Another lever controlled the aperture, which covered the lens with one of three holes of diminishing size. When both these levers were pushed in, the camera was ready for snapshots. The widest aperture and the "instantaneous" shutter speed would be selected, producing images that were less sharp than the smallest aperture with a time exposure on the tripod.

The basic aperture, allowing for the "instantaneous" handheld views, was around f16 and the film had a speed of around 30 ISO, ten times slower than the slowest films still manufactured today.[48] Most models offered two other "stops" (apertures), which allowed less light to enter and increasing sharpness across the whole negative. These would be equivalent to about f22 and f32.

The film was orthochromatic, with poor sensitivity to red, which was why the inspection window in the back of the camera, from which the film markings could be read, was colored red. It is also why Jeanneret bought himself a yellow filter, which was one of the ways of balancing the tones in

48 The f number is defined by the ratio of the aperture to the focal length of the lens. An f16 stop on a 4½ inch (114 mm) lens would measure a little over ¼ inch across. I would like to gratefully acknowledge the technical expertise of Jos Erdkamp, collector of early Kodak cameras, in verifying these details with the help of the Kodak Bull's-Eye and Bullet cameras in his possession.

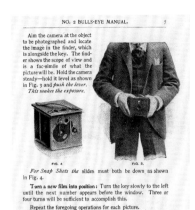

a picture.[49] Without a yellow filter, blue skies would come out white, and anything slightly yellow or red would register as dark grey or black. The viewfinder consisted of a small circular window in the top of the camera connected to a lens in the front by a prism, giving a reasonable but very small image. Precise framing of the picture was impossible, but the camera was relatively simple to use.

It is worth reflecting on Jeanneret's choice of camera. Many artists seized on the new Kodak cameras when they became available in the 1890s.[50] Edgar Degas was prepared to purchase a professional plate camera and take interior photographs with exposures lasting several minutes. A famous photograph of Pierre Auguste Renoir and Stéphane Mallarmé (1895), now in the Museum of Modern Art, shows Degas with his large plate camera and tripod reflected in the mirror. An inscription on the photograph by Paul Valéry, who apparently witnessed this session, explained that the exposure took fifteen minutes. Cameras like the No. 2 Bullet camera, the Bull's-Eye, and the Folding Pocket Brownie, however, could be used handheld, provided that a certain amount of blurring was accepted. It is interesting that it was the colorists, Nabis painters like Édouard Vuillard, Pierre Bonnard, Félix Vallotton, and Maurice Denis, who turned to the portable Kodak cameras, perhaps because they accepted the slightly blurred quality of the pictures. Many of them were associated with the journal *La Revue Blanche*, published by Alexandre, Alfred, and Thadée Natanson. Vuillard, for example, had a Kodak camera taking $3\frac{1}{2} \times 3\frac{1}{2}$ inch photographs, which he bought around 1897 and kept throughout his life.[51] Two photographs of Vuillard with his camera taken by Pierre Bonnard in 1899 and 1900 demonstrate that it was a box camera, probably a Kodak Bull's-Eye or No. 2 Bullet, the same as one of Maurice Denis's cameras.[52] The situation is confused by the memories of Jacques Salomon and Annette Vaillant, daughter of Vuillard's close friend Alfred Natanson.[53] Natanson was an expert photographer

49 Letter to his parents, February 11, 1908 (R1(4)87).
50 Elizabeth W. Easton, Introduction, in E. W. Easton (ed.), *Snapshot: Painters and Photography, Bonnard to Vuillard* (New Haven: Yale University Press, 2012), 1–11.
51 Félix Vallotton had a similar camera, a Kodak No. 2 Bullet, which survives in a private collection (ibid., p. 181, note 6).
52 Ibid., cat. 1, p. 65, and cat. 2, p. 107. Maurice Denis also owned the rather superior Folding Pocket Kodak, as did the Belgian painter Henri Evenepoel.
53 According to Jacques Salomon, "Vuillard owned a Kodak. It was an ordinary model, one of the bellows type." Lefevre Gallery and E. Vuillard, *Vuillard et son Kodak* (London, 1972), 2.

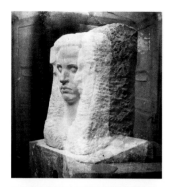

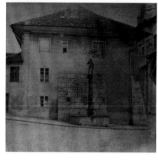

FIG. 19 **Jeanneret, view of a portrait bust, double exposure** BV LC-108-0227

FIG. 20 **Jeanneret, contact print made on printing-out paper** CCA Folio La Chaux-de-Fonds, Envelope 16 No. 26

and had a large plate camera like the one Degas used. Annette Vaillant must have been confused when she recalled that her father's plate camera was the same as Vuillard's.[54] Vuillard's photographs are similar to Jeanneret's in their degree of sharpness, depth of field, and contrast. He had his films professionally developed but made the prints at home, often with the help of his mother, using printing-out paper.

It seems that artists who were confident about their artistic integrity and independence from verisimilitude found it easier to accept the camera as a daily companion. None of them referred publicly to their photographs. As Maurice Denis said, "Art is not simply a visual sensation that we receive, a photograph, however sophisticated, of nature. No, it is a creation of the mind, for which nature is the springboard."[55] Jeanneret was to become a great admirer of Maurice Denis and the Nabis through his connection with the Perret brothers in 1909, and his attitude to the camera may have changed during his stay in Paris from 1908 to 1909. At any rate, the fact that Jeanneret was reticent about the purchase of his cameras and his photographic activity, hardly ever mentioning it in his correspondence and never in print, was absolutely consistent with contemporary artists and their use of photography.

A mistake frequently made by Jeanneret was to forget to wind on the film between exposures. There are a number of double exposures, and we must imagine that others were thrown away as failures. These mistakes are understandable: cameras of this kind had nothing to stop multiple exposures being made on one frame. They also had no system for calculating correct exposure; the instruction books offered tables describing different lighting conditions inside and out, and the photographer had to guess which one was appropriate. As a consequence, many of Jeanneret's negatives are over- or underexposed. The one saving grace was that the large negatives had a greater tolerance than the small negatives of modern photography. Adjustment could also be made in development.

54 See note 53, p. 16.
55 M. Denis, "De Gauguin et de Van Gogh au Classicisme," *L'Occident* 90 (May 1909), cited in E. W. Easton, C. Chéroux, Van Gogh Museum Amsterdam, Phillips Collection, and Indianapolis Museum of Art, *Snapshot: Painters and Photography, Bonnard to Vuillard* (New Haven: Yale University Press, 2012), 7–8.

THE KODAK FILM TANK

THE Kodak Film Tank can be carried and used anywhere; it eliminates the dark-room entirely, developing film in broad daylight. It is very simple to use and it produces better results than the old hand development way. Every roll of film put into the tank will come out developed as well or better than that roll of film could have been developed in the dark-room, by the most experienced photographer.

It consists of a winding box, light-proof apron and solution cup with cover. All articles can be packed in the box, making the outfit self contained.

THE PRICE

Brownie Kodak Film Tank, For No. 1, No. 2, and No. 3 Folding $2.00
Pocket Brownie Cartridges.
3½-inch Kodak Film Tank, For Kodak or Brownie Cartridges 5.00
having a film width of 3¼ inches or less.

KODAK FILM TANK SUPPLIES

Kodak Film Developer Powders, Brownie, per package of ¼ $.10
Dozen.
Ditto, for 3¼-inch Tank, per package, ½ dozen. .20
Kodak Acid Fixing Powder, per ¼ pound package. .10
Ditto, per ½-pound package. .15
Ditto, per 1-pound package. .25

14

56 Letter to Klipstein, December 18, 1911 (E2(6)144).
57 FLC E2(6)145.
58 H. A. Brooks, *Le Corbusier's formative years: Charles-Edouard Jeanneret at La Chaux-de-Fonds* (Chicago: University of Chicago Press, 1997), 71.

The Kodak manuals encouraged purchasers to develop their own film and make their own prints. Contact prints could be made in daylight using Kodak Solio or Velux daylight printing-out paper. The negative was sandwiched with a sheet of this paper in a printing-out frame and placed in bright sunlight. The image would slowly appear; when sufficiently dense, the process could be stopped by passing the print through a bath of fixer and then washing it. The prints in the Canadian Centre for Architecture collection were made using daylight printing-out paper.

These contact prints were probably made by placing several negatives on one sheet of paper and cutting out the individual pictures afterward. It is not clear why they were made. Perhaps they were intended for Klipstein but were never sent, or perhaps they were made as a spare set. Either way, they are witness to a considerable investment in time and money, at a time when Jeanneret was very busy designing the house for his parents in the winter of 1911–12. There does not seem to be any principle of selection. Higher-quality contact prints could be made using bromide paper, which required the use of a darkroom for developing and fixing the paper. Most of the contact prints in the Fondation Le Corbusier and the library in La Chaux-de-Fonds are bromide prints. Jeanneret told Klipstein he was making bromide prints of the negatives.[56] On February 8, he tells Klipstein "I have also finished the plans for a photographic studio ..." but this may have been an unexecuted project for a client rather than a laboratory for his own use.[57]

The first photographs taken with this camera that we can date with some confidence are four views of successive stages in laying the foundations for the Villa Fallet, in June 1906 FIG. 22. Jeanneret's father records in his diary that the ground was broken for the Villa Fallet on June 17, 1906.[58] Another photograph showing the first stage of digging foundations is BV LC-108-228. A slightly later stage, with the building of the retaining wall, is shown in BV LC-108-285 and another, later still, is in the Canadian Centre for Architec-

FIG. 21 **Kodak film tank, as advertised in a Canadian Kodak catalog of 1921**

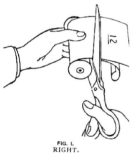

FIG. I.
RIGHT.

FIG. 22 **Jeanneret, view of the foundations being laid for the Villa Fallet, June 1906**
BV LC-108-319

FIG. 23 **Page from the Bull's-Eye manual showing the technique of cutting up negatives for development**

ture (2-15B-38). Leo Schubert identifies BV LC-108-319 as being connected with the Villa Jeanneret-Perret (1912) but this does not match the image.[59]

The next views that can be confidently dated are from the Italian trip to Rome, Florence, Ferrara, Venice, and then Vienna (beginning in September 1907).

We know, from a letter to his parents on February 11, 1908 that Jeanneret bought a developing tank and some extra items for his camera when in Vienna. He wrote: "I went mad again: I shelled out for the developing machine I so much wanted; tried it out; delighted with the results rather than with the price, which was 30 francs. Be quiet, please, Mr. budget! I also bought a tripod for the camera and two filters, a yellow one and a close-up lens: 15 francs!"[60] In other words, he spent 30 francs on the developing machine, and a further fifteen francs on a tripod, a yellow filter, and a portrait lens. Kodak developing tanks were advertised at $5 in the USA, which equates to around 26 francs. Close-up lenses were listed in the USA at 50 cents (ca. 2.60 francs) while the standard Kodak tripod cost $2 (10.40 francs). The close-up, or "portrait" lens was a simple meniscus lens attached to the camera lens and was intended for photographing subjects between one and two meters away. The stone portrait bust in FIG. 19 would have required the close-up lens.

The purchase of this developing tank early in 1908 makes some sense. He had already taken nearly fifty photographs by then, judging only by what has survived, including the pictures in Italy and several in and around La Chaux-de-Fonds. He had probably discovered that developing the individual frames one by one in a darkroom using open dishes was both time-consuming, difficult to set up, and prone to error. The method described in the Bull's-Eye manual was to cut up the film, in the subdued light of an orange, candlelit safelight, using the markings on the back of the black backing paper FIG. 23. Then each frame of celluloid could be dipped

59 Leo Schubert and Centro internazionale di studi di architettura Andrea Palladio di Vicenza, *La villa Jeanneret-Perret di Le Corbusier, 1912: la prima opera autonoma* (Venice: Marsilio, 2006).
60 Letter to his parents, February 11, 1908 (FLC R1(4)87).

Time Exposures in the Open Air.

When the smallest stop is in the lens the light admitted is so much reduced that time exposures out of doors may be made the same as interiors but the exposure must be much shorter.

With Sunshine—The shutter can hardly be opened and closed quickly enough to avoid over-exposure.

With Light Clouds—From ½ to 1 second will be sufficient.

With Heavy Clouds—From 2 to 5 seconds will be required.

The above is calculated for the same hours as mentioned above and for objects in the open air. For other hours or for objects in the shadow, under porches or under trees, no accurate directions can be given; experience only can teach the proper exposure to give.

Time exposures cannot be made while the camera is held in the hand. Always place it upon some firm support, such as a tripod, chair or table.

FIG. 24 **Jeanneret, decorative urn, Versailles, probably December 1908** BV LC-108-264

FIG. 25 **Instructions for outdoor time exposures with the Bull's-Eye camera**

61 See Appendix 1 → p. 408

into the developing dish using fingers or tweezers and agitated gently until the image appeared, before washing and fixing. This worked only if the film had been wound on in the camera to the precise point marked by the arrows in the inspection window. The film had to be kept tightly wound so that the marks on the backing paper would line up properly with the exposures made on the film. Developing each frame one by one allowed for adjustments to be made to mistakes in exposure. The frame could be held up to the orange glow of the safelight and a decision made. A longer or shorter development time would make the negative denser, resulting in a lighter print, or vice versa. Too long an exposure to the safelight would cause fogging (making the negative gray overall), a phenomenon visible on several of Jeanneret's negatives. Attempting to develop several frames at once required patience and skill and could easily lead to scratches or uneven development. The purchase of a developing tank speeded up this process considerably and avoided long periods in near total darkness. Once the film had been inserted into the developing tank, the process could be continued in daylight. The developing tank allowed for the even development of an entire film, safe from fogging, but the ability to make adjustments for each frame was reduced. In extreme cases, if the negative was too black, a single negative could be "reduced" (bleached) after developing and fixing, and there are signs that Jeanneret did this too.

The overexposed negative for this contact print FIG. 24 shows signs of rough grain produced by chemical reduction. Despite his investment in the developing tank, Jeanneret soon turned to professional development of his negatives. There is documentary evidence that most, if not all, of his negatives taken during the voyage d'orient were professionally developed.[61]

The manuals all insist that the best results are obtained by developing the film soon after exposure. The latent image tends to gradually lose contrast if left too long undeveloped. Jeanneret says that he and Perrin

developed the pictures taken during the 1907–08 trip to Italy together in Vienna, several months after they had been shot, but he may have meant that this is when he made contact prints from the negatives. This is what he wrote to his parents: "Yesterday evening Perrin and I developed the Italian photographs. Very successful, I think. The great pity of it is that we haven't any of our escapades, for example "Perrin braving the pigeons at St. Mark's" or "Cagot, purple-faced, leaving the Albergo della Campana at Chioggia, waving a napkin and crying 'si, si, signor, voi estere una voleur'!" or again the full-length portrait of the official guide in Siena or the divine effigy of Marianne de La Scala (or, to be strictly accurate, the 'domestic servant' who looked like Marianne, which didn't stop her having a nice smile …)."[62]

A camera of this kind could be used for handheld photography in bright natural daylight using the widest aperture. A series of beautiful views of Alpine scenery confirms this →pp. 56–57. The image bottom left was probably taken with the camera resting on a stone near the water's edge. These photographs demonstrate a real interest in the selection of viewpoint, well-balanced composition, and effective use of the square format.

Setting the camera on a tripod or other support allowed for pictures to be taken in overcast conditions, in the shade, or indoors. Notice that opening and closing the shutter quickly by hand invariably produced a blurred picture through camera shake. The most difficult conditions therefore were overcast daylight, when the "snapshot" would almost certainly be underexposed, but a time exposure of around half or one second difficult to control. In this case, a problem arises if there is any movement in the subject. An example is a picture taken of Jeanneret with his father and mother in their rented summer house in Switzerland FIG. 26.

In this picture, the background and middle foreground are sharp, but the three figures are blurred, because of slight movement. When taking static subjects on a tripod, long exposures could be taken with good results.

FIG. 26 **Photograph of Charles-Édouard Jeanneret, his father, and mother, probably taken by his brother, Albert, on the balcony of a rented house in Châbles, Switzerland** BV LC-108-308

FIG. 27 **Jeanneret, photograph of Khmer reliefs in the Trocadero museum, November 1909** BV LC-108-236

62 Jeanneret, letter from Vienna to his parents (FLC R1(4)63).

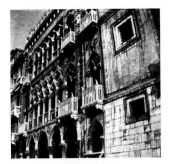

63 Among the photographs in the Fondation Le Corbusier are some that were clearly bought in Venice (e.g. FLC L4-19-154).
64 FLC E2(12)4.
65 For example, in the six notebooks for the voyage d'orient, there are references to photographs that have not survived: Carnet 1, p. 37, Carnet 2, p. 12, Carnet 4, pp. 24, 26, Carnet 5, p. 17, although there are also references to photos that have survived: Carnet 2, p. 119, Carnet 4, pp. 24, 26, 114, 124.
66 FLC R1(4)63.
67 Letter to Albert, February 2, 1908 (FLC R1(10)393).

For example, he took a number of photographs in the Trocadero museum in Paris, of Khmer sculptural reliefs, using a tripod and probably quite long exposures FIG. 27.

Although these show the characteristic vignetting (darkening at the corners) of a meniscus lens, they are quite respectable images.

Only ten of the photographs that Jeanneret took on his first trip to Italy and Vienna, from September to November 1907, have survived.[63] Whether this small number supports his later claim that the photographer Moser had lost many of his negatives is unknowable. On March 21, 1911, he wrote to L'Éplattenier: "In July 1910 I gave Moser over 80 negatives for him to make some good prints, which were intended for my book. They were all my pictures of Germany and the best ones of Paris and Italy. I don't know how many times I have written to Moser. My mother and brother have both visited him several times. And Moser always promising to deliver the pictures next day. The last time I wrote was ten days ago, still without a reply."[64] It is certainly true that there are a number of references to photographs he claims to have taken where the photos seem to have been lost.[65] At any rate, Jeanneret was himself dissatisfied with his Italian pictures. In a letter to his parents on January 11, 1908, he at first declared himself pleased with the results;[66] but only a few days later he described them to his brother, Albert, as disappointing, compared with his drawings. "I have a number of photographs of my beautiful trip but, curiously, I don't look at them very much. For a start, I'm too busy, but I prefer to recall those beautiful days looking at my sketches, my miserable drawings. It is these that take me back so precisely to those wonderful places where Beauty has left her mark [1 parcelle de sa robe]."[67] In other words, his sketches took him vividly back in memory to the experience of the Italian trip, but his photographs did not. In a letter to his master Charles L'Éplattenier on February 26, 1908, he commented on the poor quality of the photographs taken of the Villa

FIG. 28 **Jeanneret, photograph of the Ca d'Oro, October 1907** BV LC-108-0254

FIG. 29 **John Hobbes (for John Ruskin), daguerreotype of Ca Barbaro, Venice, 1849**

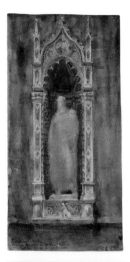

FIG. 30 **Jeanneret, sketch of St. Mark in a niche on Orsanmichele, Florence, 1907** FLC 2162

FIG. 31 **Postcard of Orsanmichele in Le Corbusier's collection** FLC L58382

Mathey-Doret Music room and on which several of L'Éplattenier's students had worked, adding: "And we were heartened to discover that in our stock of photos of Italy, not one of the beautiful architectural things had been captured, because in every case the photographs distorted the effect, unsatisfying to eyes that had seen the originals."[68] One of the reasons for this dissatisfaction must surely be the fact that Jeanneret invested little effort or imagination in these early photographs. There is no attempt at careful composition or the creation of a sense of scale.

The emphasis is on capturing detail. His photograph of the Ca d'Oro has an uncanny affinity with the kind of daguerreotype that John Ruskin had his valet take of buildings in Venice.

The aim in this kind of photograph is clear, in Ruskin's words: "to take the palace home with me."[69] In other words, it was the amount of decorative detail that was important. As Italo Zannier correctly observes, these photographs were "singularly transgressive" of the rules that already determined the photography of buildings, concerning the apparent distortions created by tilting the camera upward.[70] Although Jeanneret probably never saw this photograph, he had Ruskin's *Mornings in Florence* in his knapsack and had been thoroughly imbued with Ruskin's approach to cultural tourism, which largely turned on a minute analysis of detail.

In his sketchbook, Jeanneret did not attempt to detail Donatello's statue of St. Mark in its tabernacle on Orsanmichele, but focused on the colored marble inlay of the niche and frame. In this he follows Ruskin's example closely. On this first trip to Italy he was above all fascinated by the rich decoration of the Trecento. The high point of his Florentine trip was inside Orsanmichele, the Orcagna Tabernacle:

You can have no idea, no inkling of what is there. The fantastic wealth accumulated in this marble reliquary by a genius like Orcagna defies belief. You have to see it,

68 FLC E2(12)23.
69 Cited by Italo Zannier, "Le Corbusier fotografo," in *Le Corbusier, viaggio in oriente: gli inediti di Charles Edouard Jeanneret fotografo e scittore: 2a ed.*, (Venice: Marsilio, 1985), 71.
70 Italo Zannier, *L'occhio della fotografia: protagonisti, tecniche e stili dell' "invenzione maravigliosa"*. (Rome: Nuova Italia scientifica, 1988), 113.

71 Letter to his parents, September 23, 1907 (FLC R1(4)14).
72 G. Brunel, *Georges Brunel ... Formulaire des nouveautés photographique ... Appareils, accessoires, produits, formules et procédés, la photographie scientifique et artistique* (Paris: J.-B. Baillière et fils, 1896), 56–57.
73 *Picture taking with the No. 3 and No. 3A Folding Brownie cameras (meniscus lens)* (Rochester, N.Y.: Eastman Kodak Company, 1913)18. The identical wording is used in most of the Kodak and Kodak Brownie manuals of the early years of the 20th century.

feel it, caress that polished marble rendered transparent by craftsmanship. With your binoculars, you must delve into the darkest corners. As for me, I am on tip-toe, as if the two additional centimeters would enable me to enjoy an even more intense pleasure. And the artist knew full well that all this was done in a church which would be pitch black, where only the eye of the dedicated artist might, with effort, pierce the gloom.[71]

Similarly, when photographing recent buildings in Paris, such as the newly completed, steel-framed building by Georges Chédanne in the rue de Réamur, his concern was to "get it in" at all costs FIG. 32. The blurred figure on the left indicates that this picture was taken with an exposure of around one second. Publishers would have considered photographs like this unacceptable. For example, Georges Brunel, in his "how-to-do-it" book *Formulaire des nouveautés photogaphiques*, demonstrates the difference between a good and bad architectural photograph FIG. 33.[72]

The photograph with "leaning verticals" is simply wrong, according to Brunel, because it does not correspond to the way the eye sees. The vertical lines of a building are parallel, and when we look at a building we think we see them as parallel, because the brain checks what it sees against what it knows. General advice on photographing buildings, therefore, was that the camera had to be kept absolutely level at all times. Commenting on a photograph such as that on the left in FIG. 36, the Kodak manuals assert:

The camera must be held level. If the operator attempts to photograph a tall building while standing near to it, by pointing the camera upward (thinking thereby to center it) the result will be similar to figure 7. This was pointed too high. This building should have been taken from the middle story window of the building opposite.[73]

FIG. 32 **Jeanneret, photograph of a building in the rue de Réamur, 1908, then occupied by Mahler Laval & Adam (former "Parisien Libéré"; attributed to the architect Georges Chédanne)** BV LC-108-244

FIG. 33 **Georges Brunel,** *Formulaire des nouveautés photographiques,* **pp. 56–57: "defective" and corrected views of a building**

Many professional architectural photographs are taken from elevated positions in order to represent the building as fully as possible. For Roland

74 R. Günter, "Architektur-Fotografie in gesellschaftlichen Zusammenhang," *Marburger Jahrbuch für Kunstwissenschaft* 20 (1981): pp. 123–27.

Günter, this is proof of the sterilizing effect of photography, which, he asserts, has tended to dehumanize the representation of cities.[74] There was a long-running debate in photographic circles about "distortion," which was not discussed in terms of defects in optical performance but rather in psychological terms: what "looks right." Paradoxically, the "corrected" view on the right in FIG. 33 looks "wrong" from another point of view. In the photograph, we know that we are looking up to an upper storey of the Louvre, whereas the "corrected" drawing could be a ground-floor elevation, and yet there is no visible ground.

FIG. 34 is taken from across the courtyard in the Louvre, from a first-floor window. The perspective looks natural but we are aware that, although we can see the ground, we are not at ground level. This creates a kind of distancing, which can be unsettling. There is nothing to "invite" us into the picture space. Buildings seen from directly in front usually have an off-putting effect. Architectural photographers quickly learned that a wide-angle lens allowed them to include tall buildings or large interiors and also include some foreground detail and an "invitation" to enter the represented space. But wide-angle lenses also create distortion of a kind, making foreground objects appear unnaturally large. This is why portraits are never normally taken with a wide-angle lens, because it makes the nose of the sitter appear too large and distorts the shape of the face. But by carefully balancing foreground and background and using diagonal lines to lead from one to the other, photographers have learned how to avoid being criticized for distortion.

Frédéric Dillaye, who published a journal in Paris in the first years of the 20th century, liked to compare photography to the fine arts. As we will see later, the debate about the status of photography as a fine art, which had raged in the mid-19th century, had revived in a new form at the turn of the 20th century. These arguments were "in the air" in the prewar period and

FIG. 34 **Unknown photographer, Richelieu wing of the Louvre, late 19th century**
NGA

75 F. Dillaye, *Les nouveautés photographiques: complément annuel à la théorie, la pratique et l'art en photographie: années 1905–1912* , vol. 19 (Paris: Tallandier, 1905): 154–73.

must have interested someone like Jeanneret, uncertain in his vocation between art and architecture. Dillaye was against the excesses of "art photography," but he wrote a very interesting chapter on what he called the basis of naturalism in photography.[75] The "art photography" movement, known by various names, including the Photo-Secession, was based on the idea of reintroducing hand craftsmanship in the production of the photographic print, using a range of techniques, from color toning, soft-focus effects, special papers and extending to the direct manipulation of the surface of the print using gum-bichromate, bromoil, and other methods. There was an important Photo-Secession group in Munich, the "Linked Ring" society in London, the Photo-Club de Paris, and the group around Stieglitz in New York. According to Dillaye, the "pictorial illusion," whether in photography or painting, depends on a number of factors, of which some lie in favor of photography while others belong more naturally to painting. For example, color was unavailable to most photographers before the First World War, although the complicated autochrome system produced beautiful color prints in the hands of experts like Edward Steichen. Various techniques for reproducing color on film were constantly discussed in the photographic magazines before 1914, but a reliable and relatively cheap industrialized system had to await the 1930s. Dillaye also suggests that although photography has taught artists many lessons about the movement of animals and human beings, the frozen photograph represents movement less well than an artist who understands how to imply imminent change. For him, this meant that it was difficult for photographers to represent "life." In fact, the inclusion of people in photographs in the early 20th century often suffered from a frozen, artificial quality.

Most professional architectural photographers in the 19th century always placed human figures and other recognizable features at different points in the photograph to give a clear sense of scale.

FIG. 35 **Abdullah Frères, Mosque of Eyüp Sultan, Istanbul, 1890s** Library of Congress

In a caricature of this approach, various soldiers and attendants stand to attention and look at the camera in the photograph by the Abdullah Frères from the 1890s. Nevertheless, human scale is a useful way to lead the eye into a picture and provide a sense of scale. Jeanneret learned to do this as well FIG. 16, although the slow shutter speed of his first camera when used on a tripod in overcast conditions usually meant that people in motion were blurred FIG. 32. In a letter to L'Éplattenier about his first experience of the interior of Milan Cathedral in September 1907, Jeanneret wrote:

> *What grandeur—the mystery of the forest, it's crazy, fabulous! Little by little you become accustomed to it until suddenly you see a little man, next to a column. The eye begins to measure and you are rendered speechless.*[76]

Jeanneret did not go out of his way to include people or other recognizable motifs in his photographs in order to give scale, but did so on occasion, particularly in the later pictures he took with this camera FIG. 5. In one of his photographs with his next camera, he sets up a scene, with a young woman apparently being followed by a man, a setting that might have been in a 19th-century genre painting, or indeed one of the new art photography prints → p. 128.

Dillaye warns that linear perspective, which might seem to be perfectly the domain of photography, can be very easily abused, especially with wide-angle lenses. Painters accentuate linear perspective with atmospheric perspective, in which distance is indicated by lighter and bluer hues. Photographers can imitate this by the use of filters or by careful selection of lighting. Jeanneret's rooftop view of Nuremberg is a study in atmospheric perspective.[77]

Dillaye went on to stress the importance of well-illuminated relief, which he calls "perspective d'accommodation."[78] The idea is that the artist

76 Letter to L'Éplattenier, September 19, 1907 (FLC E2(12)6).
77 On the back of the copy of this negative in the CCA collection, Jeanneret noted: "Nürnberg 1908."
78 F. Dillaye, "L'illusion picturale et la photographie," *Les nouveautés photographiques* (Paris: Tallandier, 1905), 19, 159.

can catch the attention of the viewer with highly textured details at various points in the depth of the represented scene.

79 F. Dillaye, "L'illusion picturale et la photographie," *Les nouveautés photographiques* (Paris: Tallandier, 1905), 19, 159.

> *What does perspective of accommodation consist of? Accentuating even more the relief of an object, or part of an object, so as to isolate it from the adjoining parts … Convention, I hear you say? Not at all, this is really the way that the eye identifies objects. It is therefore the right way to represent them.*[79]

The need of the eye to recognize motifs is thus served by the artist, who can pick out significant details from their context. This is obviously more difficult for the photographer, who cannot usually manipulate directly the details in his scene. Variable focus can be used on a sophisticated camera to throw parts of the image out of focus. But in the main the photographer has to rely on lighting to guide the eye. Dillaye's "perspective d'accommodation" can be demonstrated in a characteristic professional photograph from the late 19th century.

A photograph such as the one in FIG. 36 provides a vista into the distance and a continuous floor surface connecting us with it, and also, in the center and on the right, some highly detailed and tangible sculpture that gives the viewer a sense of human scale and interest.

Dillaye's principal message is one that Jeanneret might have encountered in any number of articles about photography, The photographer has a very limited palate of tones and a set of inexorable laws of perspective to deal with. The effective photograph is typically one in which the geometry imposed by perspective and the grouping of tones work together to create a relatively simple but memorable impact.

The methods used in photographs like this were being discussed in the fine arts in terms of the theory of "empathy." The American psychologist William James and the German physiologist Carl Lange independently

FIG. 36 **Unknown photographer, ambulatory of Chartres Cathedral, late 19th century** NGA

developed theories of physiological causes of emotional states.[80] According to the popularized versions of this theory, the aesthetic response to a work of art is stimulated by physiological effects in the brain, and even elsewhere in the body by the natural tendency to imaginatively engage with a building or work of art as if it were an extension of the body.[81] Le Corbusier would later become a committed believer in the direct "physiological" effect of certain forms on the mind, and he would certainly have been informed of the latest theories in 1911 by his fellow traveller, August Klipstein, whose master Wilhem Worringer had written *Abstraction and Empathy*, a book Klipstein seemed to have with him on the trip, since he quotes from it in his journal.[82] Worringer argued that the abstract play of pattern, shapes, and light and shade could be a more direct way of communicating emotion than the more common representative style of painting and sculpture.

The photographic magazines and books published at the turn of the century in the USA and Europe tended to distinguish between professional architectural photography, considered to be largely functional, and "pictorial" or "art" photography, whose purpose was to achieve an aesthetically satisfying effect. Another category, which has been studied recently, was that of the amateur but serious photographer who documented local events and people for historical interest.[83] Most photographic magazines had sections dealing with portraits, landscapes, the nude, travel photography, and so on, but never architectural photography.[84] The essence of travel photography was to demonstrate differences from normal urban, modern life. Prized subjects were the picturesque village, the "exotic" people of the Middle East or North Africa, and the artful composition of light, shade, and texture. For example, Fritz Wentzel, writing on travel photography in 1908, listed all the technical and artistic errors typical of most travel photographs, insisting on the need for special care in choosing the right subject, the best light, and the perfect moment in order to create a balanced composition without distractions.[85]

80 See W. James, *The Principles of Psychology* (Bristol: Thoemmes Press, 1998), first published in 1890. Among those who refined and developed the James-Lange hypothesis was Karl Groos with his concept of *Innere Nachahmung* (K. Groos, "Das aesthetische Miterleben," *Zeitschrift für Aesthetik* IV(2) (1909) and K. Groos, *Das Seelenleben des Kindes* (Berlin: Verlag von Reuther & Reichard, 1911).

81 T. Lipps and R. M. Werner, *Beiträge zur Ästhetik* (Hamburg/Leipzig, 1890), T. Lipps, *Raumästhetik und geometrischoptische Täuschungen* (Leipzig: Barth, 1897), T. Lipps, "Aesthetische Einfühlung," *Zeitschrift für Aesthetik für Psychologie und Physiologie der Sinnesorgane* 22 (1900): 439, and T. Lipps, *Aesthetik; Psychologie des Schönen und der Kunst* (Hamburg/Leipzig: L. Voss, 1903).

82 W. Worringer, *Abstraktion und Einfühlung* (Neuwied: Heuser, 1907).

83 E. Edwards, *The camera as historian: amateur photographers and historical imagination, 1885–1918* (Durham: Duke University Press, 2012). Here, sharpness and good coverage was demanded.

84 See "Die Poesie der alten deutschen Stadt," *Deutsche Camera-Almanach. Ein Jahrbuch* VIII (1909): 133–142, and F. Dillaye, *La théorie, la pratique et l'art en photographie: l'art en photographie avec le procédé au gélatino-bromure d'argent* (Paris: Tallandier, 1904).

85 Fritz Wentzel, "Einiges über das Photographieren aus Reisen," in *Deutsche Camera-Almanach. Ein Jahrbuch* (1908), 152–61.

We have no way of knowing whether Jeanneret read this or other photographic magazines between 1907 and 1911, but the serious way he went about his photography suggests that he at least talked to people who were aware of the conventions.

A photographer who bridged the gap between architectural and art photography was the Englishman Frederick Evans, a member of the "Linked Ring" of art photographers but also a prolific architectural photographer.[86] A friend of many artists, architects, and writers in the Aesthetic Movement in London, he was familiar with the debates surrounding the paintings of James McNeill Whistler. Although he was often obliged to use a wide-angle lens, he professed a preference for as long a lens as possible. His most famous photograph, "A sea of steps," showing the entrance to the Chapter House, Wells Cathedral, was taken with a long lens FIG. 37.

The success of this photograph depends in part on its high degree of selectivity and the effect of lighting to suggest a sense of mystery. What is going on out of sight on the right? There is an intriguing zigzag composition formed of the off-center, illuminated arch at the top left, the bright lighting on the right, and the darker steps descending toward the viewer. Furthermore, the foreshortening of distance and low viewpoint produced by the use of a long-focal-length lens from a distance has multiplied the horizontal lines produced by light glinting on the stone steps, so that a sense of depth is countered by a kind of flat barrier. This sort of play between invitation and resistance is exactly what the artists of the time—from Monet to Cézanne—were exploring in their paintings. Jeanneret also explored the potential of the kinetic meaning of photographs, the suggestion that something interesting is going on just out of sight.

There is no way of knowing what Jeanneret knew of the debates around photography. The subject was taught at the Polytechnic in Lausanne, but not in La Chaux-de-Fonds, and the Art School library had none of the specialist

86 Evans's reputation in Europe can be measured by his article "Die Fortschritte der Kunstphotographie," including photographs of Ely Cathedral, in the German technical journal *Deutsche Camera-Almanach. Ein Jahrbuch* (1905), 89ff.

photography books or journals. The Photo-Club des Montagnes Neuchâteloises was not founded until 1927, although the Casino in La Chaux-de-Fonds had put on photographic exhibitions since the mid-19th century. A number of important photographers came to live and work in La Chaux-de-Fonds.[87] But the debate about art photography also found its way into art journals such as *The Studio*, which was available in the Art School library, and Jeanneret almost certainly saw books or exhibitions of photography during his travels in Germany.[88] The journal *Deutsche Kunst und Dekoration*, which Jeanneret explored in detail, ran articles on photography. For example, Ernst Zimmermann devoted a long and well-illustrated article to the photographs of Alfred Stieglitz, Hugo Erfurth, Gertrude Käsebier, and other members of the Photo-Secession movement, exhibited at an art exhibition in Dresden in 1904.[89] The article discusses in detail how artistic effects can be achieved in photography while retaining the truthfulness of the photograph and without lapsing into excessive manipulation of the print. The evidence of the photographs, at any rate, is that Jeanneret made an effort—with the photographs he took in 1910 and early 1911 with his box camera—to carry into practice some of the principles of pictorial photography.

We know that Jeanneret was dissatisfied with the kinds of views in the postcards he frequently bought. Writing to Charles L'Éplattenier about their book project *La Construction des Villes*, he noted:

> *I have a number of postcards of Berne, Soleure, and so on, which don't enthuse me. I find that photographs do not do a good job of illustrating what we're after. How I regret not having taken this problem seriously before. I could have taken some terrific pictures during my travels.*[90]

This is in the context of a suggestion that he might differentiate their work from that of Camillo Sitte by taking photographs of Swiss towns and villages,

87 Fernando Soria, *Trésors photographiques: une petite historiothèque de chez nous: La Chaux-de-Fonds, 1842–1921* (La Chaux-de-Fonds: Journal du Haut, 2011), 511–13.
88 From the first issue of *The Studio*, articles on the status of photography as art were included. See "Is the camera the friend or foe of art?," *The Studio* I (1893): 96–102. Alfred Maskell wrote a thoughtful article on the "New Photography," *The Studio* IV (1896): 28–33.
89 E. Zimmermann, "Die Fotografie auf des Dresdner Kunstausstellung," *Deutsche Kunst und Dekoration* XIV (April–September 1904): 675–87.
90 Letter to L'Éplattenier, end of April 1910, from Munich (FLC E2(12)72).

FIG. 38 **Jeanneret, photograph of St. Burkard, Würzburg, June 1910, taken on a tripod** BV LC-108-0339.

FIG. 39 **Schultze-Naumburg, photograph of St. Burkard, Würzburg, *Kulturarbeiten*, vol. IV, p. 118, ill. 62a**

instead of the German and Austrian examples chosen by the latter. What was Jeanneret's criticism of the Swiss postcards he had collected? We can obtain a clue from another passage in the same letter:

> *For my part, I have learned a really useful lesson from these things: that it is only the beauty of ensemble that matters, and that this beauty depends on proportion, the rigor of the main surfaces, and the powerful play of values they produce: the use of strong materials and the contrast of great simplicity with judiciously deployed variety.*[91]

Most of Jeanneret's photographs in cities would have been taken on a tripod. This photograph FIG. 38 would have been taken at one or two seconds; you can see the blurring of people in motion in the background. Compared with the view taken by Paul Schultze-Naumburg FIG. 39, Jeanneret's is more austere, revealing the empty space rather than creating a picturesque composition. This comparison also shows how important viewpoint and lighting are in transforming the perception of architecture.

Unlike his photograph of an urn at Versailles FIG. 24, Jeanneret's photograph of the fountain, square, and clock tower in Soleure FIG. 40 → p. 58 bottom right does not focus on specific objects. It is more an image of a place, and Jeanneret has placed his camera carefully to detach the figure of the statue on the fountain while merging its column base with the line of buildings along the left-hand side. This allows a vista of the curving street at the end of the square. He has also used the clock tower as a foil, along the left-hand side, to offset the empty spaces on the right. The camera has been tilted up just enough to get in the clock, without which the clock tower would lose meaning, but not enough to create a strong sense of distortion. Similarly, in his view of the Wesaplatz, Hagen FIG. 41 → p. 58 top left, Jeanneret has made the large expanse of foreground serve the purpose of the image by creating a

91 See note 90: Jeanneret ends this letter by asking for prints of photographs he had taken of La Chaux-de-Fonds in March. These seem to have been lost.

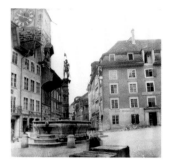

FIG. 40 **Jeanneret, Zytglockenturm, Soleure (Solothurn), March 1910, taken with his first camera** BV LC-108-297 → p. 58

FIG. 41 **Jeanneret, Wesaplatz, Hagen, May 1911, taken with his first camera** BV LC-108-253 → p. 58

strong zigzag pattern in light and shade and the differences in road surface. The effect is to invite the viewer to enter the picture space.

Similarly, we see that his photograph of St. Burkard, Würzburg FIG. 38 was taken on a tripod, with the verticals kept perfectly straight. Furthermore, the large expanse of road surface is given a spatial reference by the wall on the right, which both helps to throw it into perspective and add a frame to the picture. The distant figures also provide a sense of scale.

To understand these photographs taken in 1910, however, we also need to know why he was taking them. Early in 1910, Jeanneret's master Charles L'Éplattenier persuaded Jeanneret to help him prepare a lecture on "l'esthétique des villes" for a conference in La Chaux-de-Fonds in September.[92] As we have seen, this turned into a book project that Jeanneret and L'Éplattenier were going to cowrite—*La Construction des Villes*—which got as far as a sizable manuscript that has since been published.[93] Many of the photographs taken in 1910 and 1911 were intended for this book. Jeanneret was also engaged in another research topic, which he published in 1912 as *Étude sur le mouvement d'art décoratif en Allemagne* and which involved visiting schools of art and architecture in Germany and talking to designers and architects about current trends. While this project explains many of his trips to cities in Germany, it had little effect on his photography. Jeanneret wrote to L'Éplattenier on May 30, 1910, thanking him for obtaining this commission. An important inspiration for L'Éplattenier was a book that he owned by the Austrian urban theorist Camillo Sitte.[94] Jeanneret read Sitte's *Der Städtebau nach seinen künstlerischen Grundsätzen* (1899) in Camille Martin's French translation.[95] The hypothesis that Jeanneret's photographs were intended for publication is supported by Jeanneret's letter, complaining of Moser's loss of some of his negatives. He explains: "Imagine how disastrous this loss would be for me, since the trip I made to eleven German cities last summer was solely to take pictures intended for my book."[96] In

92 H. A. Brooks, *Le Corbusier's formative years: Charles-Edouard Jeanneret at La Chaux-de-Fonds* (Chicago: University of Chicago Press, 1997), 200–07.

93 C.-E. Jeanneret and C. Schnoor, *La Construction des Villes* (Zurich: GTA, 2008) and Le Corbusier and M. Emery, *La construction des villes: genèse et devenir d'un ouvrage écrit de 1910 à 1915 et laissé inachevé par Charles Edouard Jeanneret-Gris, dit Le Corbusier* (Lausanne: Éditions L'Age d'homme, 1992).

94 C. Sitte, *The Art of Building Cities: City Building According to its Artistic Fundamentals* (Westport, Conn.: Hyperion Press, 1979) (original German edition: 1889). On Jeanneret's German sojourn and his conversion to classicism, see Werner Oechslin, "Allemagne," in Jacques Lucan (ed.), *Le Corbusier, une encyclopédie* (Paris: Centre Georges Pompidou, 1987), 33–39; Rosario De Simone, *Ch. E. Jeanneret – Le Corbusier: Viaggio in Germania 1910–1911* (Rome: Officina Edizione, 1989).

95 C. Sitte, *L'Art de bâtir les villes: Notes et réflexions d'un architecte* (Paris: Librairie Renouard, H. Laurens, 1902). The manuscript and its Sittesque background were first discussed by Brooks, "Jeanneret and Sitte: Le Corbusier's Earliest Ideas on Urban Design," in Helen Searing (ed.), *In Search of Modern Architecture: A Tribute to Henry Russel Hitchcock* (Cambridge, MA: MIT Press, 1982), 278–97.

96 FLC E2(12)4.

FIG. 42 **Jeanneret, view of a market square, Lichterfels** BV LC-108-298

FIG. 43 **Jeanneret, Carnet II from *Voyage d'Allemagne***

fact, although we know that Jeanneret was specifically taking Sitte as a model for the book *La Construction des Villes*, which he was writing in 1909–10, he was not in possession of the book as late as May 1910, when he wrote to L'Éplattenier, asking him for the loan of his copy.[97] We do not know how the story with Moser ended, but it seems that at least some of the negatives may have been recovered. Around twenty-four photographs of Germany, taken with the first camera, have survived, approximately nine of Italy, and sixty-seven of France before May 1911. In any case, work on the book helps to explain the subject matter of many of the photographs taken between 1907 and 1911.

Sitte's book is an attempt to understand why most modern cities, with their rectilinear streets, lack the charm of some old towns. His primary argument stems from the fact that whereas the public places of ancient, medieval, and Renaissance times were abustle with people going about their business in markets or social gatherings, in modern times, public buildings are situated in large squares that have lost any purpose except as traffic intersections. This, combined with the laying out of grids of streets designed primarily to carry traffic, has contributed to the sterile and inhuman quality of modern cities. In earlier times, he argues, fountains, public statues, and public buildings were always located at the periphery of public spaces, leaving the square open for human activity while also providing good views of the buildings and monuments. Furthermore, much of the charm of a public space derives from how the approaches are organized. In the best examples, streets entering a public square are never organized symmetrically, but typically open off corners of the public space. His argument was influenced by his own understanding of empathy and how the eye works to engage the viewer in an urban setting. Ákos Moravánsky traces Sitte's approach to the German architect Hermann Maertens, whose book *Der optische Massstab* (1877) adapted Helmholz's research on the workings of

97 In a letter to Charles L'Éplattenier, written from Munich on May 19, 1910, Jeanneret claimed that the book was out of print in Germany (FLC E2(12)65).

the eye to the perception of urban space.[98] In an unpublished essay (1868), Sitte wrote about the physiological basis for aesthetics and made a number of observations that could apply as well to photography of urban spaces; for example: "We see in perspective and think orthogonally."[99] He also noted the importance of recognizable elements, such as a row of columns or a window, which could give a sense of scale. Sitte's book includes many plans and diagrams showing how a public square or street corner can be made more interesting by creating variety and stimulating curiosity. Jeanneret made hundreds of sketches in his notebooks reproducing this kind of analysis, and his perspective sketches and photographs often contribute to this kind of enquiry.

For example, his sketch and plan of the long market square in Lichterfels FIGS. 42–43 comments on the sequence of visual experiences obtained by moving up the hill past the church to the gate at the end. His photograph contrasts with the more picturesque one published by Schultze-Naumburg FIG. 44, who positioned the camera further up the square and framed it with the facade and steps on the right side of the picture.[100] Jeanneret's photograph concentrates on what Sitte discusses: the importance of unencumbered open spaces leading the pedestrian forward with a promise of further interest to come—the church on the left—and the arch and tower at the end. From Sitte, Jeanneret acquired his interest in the urban scale—seeing groups of buildings and spaces rather than individual buildings or monuments.

98 A. Moravánsky, "The optical construction of urban space: Hermann Maertens, Camillo Sitte and the theories of 'aesthetic perception,'" in The Journal of Architecture 17(5) (2012): 655–66, pp. 655–57.
99 "Wir sehen perspektivisch und denken orthogonal" A. Moravánsky (2012), op. cit., p. 659. Sitte's unpublished paper was called "Beobachtungen über bildende Kunst, besonders über Architektur, vom Standpunkte der Perspektive."
100 P. Schultze-Naumburg, Kulturarbeiten, vol. IV: Städtebau, 2nd. ed. (Munich: Callwey im Kunstwart-Verlag, 1906), 316, ill. 180.

FIG. 44 **Paul Schultze-Naumburg, market square. Lichterfels, *Kulturarbeiten*, vol. IV, ill. 180**

Jeanneret's First Camera

Album 1
Photographs taken with
Jeanneret's 9 × 9 cm roll-film camera

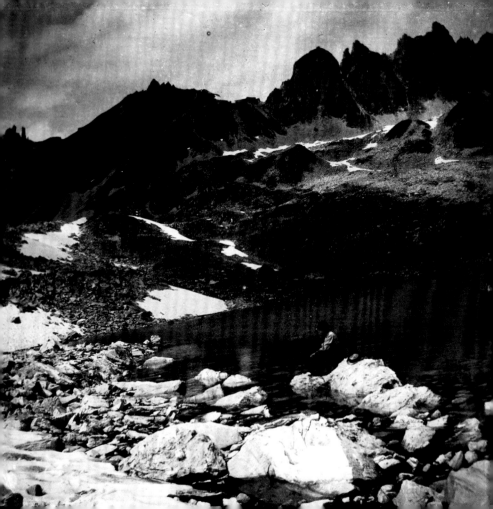

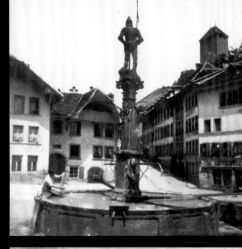

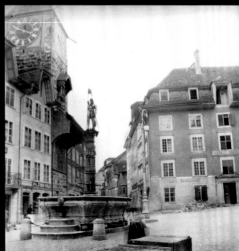

An Attempt at Professionalism

Jeanneret bought a new, more complicated, and expensive camera in March or early April 1911. He told his friend August Klipstein about it in a letter of March 10, 1911, although it is not clear whether he had made the purchase or was about to. "I'm buying a new and more sophisticated camera."[101] On May 3, he tells his parents: "Now that I've a bit more money than I thought, I've equipped myself. I have a perfect camera and clothing good for any eventuality." In this letter he says he has 300 francs in his pocket and 1,000 francs in the bank in Switzerand. He wanted to borrow 1,000 francs at 3½ or 4 percent interest, because he estimated the cost of the voyage d'orient at 2,000 francs.[102] On July 18, 1911, he wrote to L'Éplattenier enthusiastically about his new camera:

> Oh, the wonders of photography! Good old lens: what a fantastic additional eye. I bought myself a terrific camera. Working with it is quite a business, but the results are perfect. Since April I haven't spoiled a single plate.[103]

April 1911 would make sense as the moment to buy an expensive piece of kit. On April 1, he left the office of Peter Behrens in Neubabelsberg, Berlin, where he had been working, miserably, as an assistant since November 1, 1910, and on April 4, he went to Dresden to visit his brother, Albert, who was studying at the Dalcroze Institute. He had been given a raise (180 marks), earning the wage of a senior draftsman, in March 1911, the last month of his employment in Behrens's office.[104] By April 23, however, he was left with only 60 marks, by which time he had visited Karlsruhe and Stuttgart, where he had taken glass plate negatives with his new camera.[105]

It was in Dresden that the Hüttig camera manufacturing company had its factory, and a camera originally produced by this company, the Cupido

101 FLC E2(6)128.
102 FLC R1(5)97.
103 FLC E2(12)92.
104 H. A. Brooks, *Le Corbusier's formative years: Charles-Edouard Jeanneret at La Chaux-de-Fonds* (Chicago: University of Chicago Press, 1997), 236.
105 Letter to his parents, April 23, 1911 (R1(5)70).

FIG. 45 Advertisement for Hüttig Cupido cameras, ca. 1910, showing the mechanism for opening out the camera in one motion

FIG. 46 Richard Hüttig AG, Cupido 80 catalog with the slogan "Die Camera, die sich selbst einstellt!"

FIG. 47 Cupido 80 in the "normal" vertical position

FIG. 48 Cupido 80 in horizontal position; note that the optical viewfinder can be rotated

FIG. 49 Cupido 80 from the back, showing the ground glass screen

80, is in the collection of the Fondation Le Corbusier. The existence of this camera in the Fondation Le Corbusier has always been enough to persuade historians that it was the one Jeanneret owned and used. I will question this later, but first we need to inspect the camera and see what it was capable of doing. In most of its features it would have been similar to other cameras of its type. The first point is that the camera takes 9 × 12 cm plates rather than the 9 × 9 cm roll-film negatives of Jeanneret's first camera. This was considered the minimum for professionals:

> *After the "tourist" we can list the archaeologist, the architect, or the artist,*
> *who want to collect materials for their own use, for the illustration of their work,*
> *some unique images…. The 9 × 12 cm format is the minimum for this and*
> *some enthusiasts do not hesitate to take on 21 × 27 cm cameras…. Furthermore,*
> *the advantages of the folding-format plate cameras are undeniable, offering a*
> *very convenient tool, especially in the 9 × 12 cm format, which is often used today.*[106]

A camera like the Cupido 80 was a sensible step up for Jeanneret, with its "middle-format" negatives, in the increasingly popular "folding" form. Cameras that folded out from a slim box had been manufactured since the 19th century, but the new cameras were being made easier to use and more robust, and were delivered with better lenses and shutters. The selling point of the Cupido 80 was that it folded out automatically; it was the camera that "sets itself up" FIG. 45.

The camera sold in Germany for 205 marks, with the expensive Zeiss Tessar 135 mm f6.3 lens and "Kompound" shutter. It therefore probably cost ten times more than his first camera. An advertisement in a French magazine indicated a price of 245 francs, with the same lens but probably with a shutter that was not as good. A leather camera case (8.25 to 13.50 marks), a set of three metal holders for the glass plates (5.25 marks), and other

106 F. Martin-Sabon, *La Photographie des monuments et des oeuvres d'art* (Paris: Mendel, 1910), 6, 16.

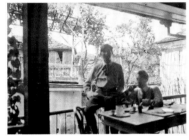

FIG. 50 **Reconstruction of the effect of viewing a scene on the ground glass screen of the Cupido 80** based on BV LC-108-099 → p. 95

FIG. 51 **Jeanneret, self-portrait with Klipstein on the balcony of a house in Kazanlük**
BV LC-108-0166

extras would bring the cost close to 220 marks. In his last month with Behrens, he earned 180 marks, so the price was affordable but it was a considerable step up from the first camera he owned FIGS. 47–49.

The body of the Cupido 80 is a wooden box covered in leather with a metal groove at the back that could accept a ground glass screen and light shade or a metal holder for the glass plate negative, protected by a metal slide that had to be pulled out before a picture could be taken. Although infinitely superior to the Flexo box camera and its like, a plate camera such as the Cupido demanded concentrated attention to achieve good results. As Jeanneret said, taking pictures with his second camera was "quite a business."

The camera would be set up on its tripod, leveled with the aid of the red spirit level, and the lens shutter opened to its widest aperture and cocked open. With the help of a black cloth[107] to keep out the light, a rather dark image could be perceived on the ground glass screen, upside down and back to front FIG. 50.

If the dark image, made grainy by the ground glass screen, is difficult to check for focus or for detail, it gives a very particular kind of image. It encourages the composition of abstract masses of black, white, and gray, usually dictated by the laws of perspective. In his book *Modulor 2*, Le Corbusier remarked, much later, how the graphic impact of an image could be checked by turning it upside down.[108] Similar advice is sometimes given to art students to check the composition of paintings. This is something that anyone who has used a plate camera has learned. Furthermore, observing an image on a ground glass screen impresses on the photographer the need to line up the edges of the frame in a satisfying way. Sharp focus could be achieved by moving the lens board with the aid of a nickeled lever. Distance markings on the lens board could also be used to guess the distance at which the focus would be sharp FIG. 57. This would be essential if the camera was used handheld because there would be no way to check focus

107 The purchase of a black cloth was noted in the retrospective accounts Jeanneret prepared for Klipstein in February 1912 (FLC E2(6)144) FIGS. 79–80 and Appendix 1 → p. 408.
108 Le Corbusier, *Modulor 2; La parole est aux usagers*, 1st ed. 1955, (Paris: Architecture d'Aujourd'hui, 1983), 246.

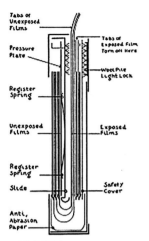

Tabs of Unexposed Films
Pressure Plate
Tabs of Exposed Film Torn off Here
Wool Pile Light Lock
Register Spring
Unexposed Films
Exposed Films
Register Spring
Slide
Safety Cover
Anti, Abrasion Paper

FIG. 52 **Section of pack-film holder**

FIG. 53 **Jeanneret photograph of Uskudar cemetery, taken on pack-film celluloid negative**
BV LC-108-06

visually. All this was important because the very high-quality 135 mm f6.3 Leitz Tessar lens had a much narrower "depth of field" than a box camera. Unlike most earlier lenses, it did not need to be "stopped down" to a narrow aperture in order to get good results. At its widest aperture, it was slightly less sharp but could produce reasonable results. But opening up the lens reduces the "depth of field"—the part of a scene that will be sharply in focus at any one time. A good example is a photograph that Jeanneret set up, of himself and Klipstein sitting on the balcony of a house in Kazanlük FIG. 51. Forty-four years later, Le Corbusier had a copy of this photograph made and sent to Frieda Klipstein, August's widow, in 1955: "I found a photograph taken in the mountains of the Balkans in Bulgaria, in 1910 or 1911. We were there together, Klip and me, in a little inn. I had a copy of the photograph made. It's very blurred but I think that it will please you." [109]

You can see that all the foreground, including the two figures, is unsharp but that the background is clearly in focus. This shows that the camera was incorrectly focused. In this case, the lens of the camera had been opened up to its widest aperture to allow for the limited intensity of light. The picture was probably taken on a tripod—the composition is admirably straight and the background is sharp. The shutter was released by someone else or possibly triggered by a timing device. Given the number of self-portraits Jeanneret took, it is likely that he had a simple clockwork or remote release device for the shutter.

Taking a photograph with glass plates is a lengthy business, if the composition and focus are to be checked on the ground glass screen each time. Another consideration is that cameras were normally supplied with three double plate holders, allowing only six photographs to be taken before retiring to a dark place to take out the exposed plates and insert new ones. The traditional wooden "double dark" plate holders were being replaced around 1910 by thin metal holders that accepted only one glass plate but

109 Letter dated January 18, 1955 (FLC E2(6)144).

110 I would like to thank Carlos Lopez, of the Library at La Chaux-de-Fonds, for pointing these pinpricks out to me.

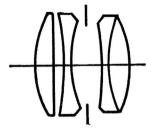

FIG. 54 **Zeiss Tessar triplet lens**

FIG. 55 **Cupido 80, front view**

FIG. 56 **View through the daylight viewfinder of the Cupido 80, showing a tabletop arrangement of objects**

took up even less space. Furthermore, glass plates are heavy and fragile. There is a strong incentive to restrict the number of photographs in a morning or afternoon to the six negatives loaded into the plate holders.

A lighter and more convenient option to the glass plate was the use of "pack film." A "pack-film" holder was supplied with the camera, and this would take twelve celluloid 9 × 12 cm sheets stacked in a holder with an ingenious system for allowing each one to be exposed in turn without opening the back. The exposed area of these sheets measures only around 8.3 × 11.7 cm whereas most of a 9 × 12 cm glass plate would be exposed.

Each negative was attached to a piece of black paper with a tab protruding at the back. After exposure, the tab could be pulled and the negative drawn past a system of rollers to the back of the holder. The paper tab was then torn off. Jeanneret records buying three packages of pack films in Bucharest and Istanbul, offering thirty-six exposures in all. Sixteen of these have survived, either as original negatives, or as contact prints. They have a distinctive line of glue along one edge, which indicates where the black paper leader was attached. In most cases, the negatives have two pinpricks in the corners, where the celluloid sheets were hung up to dry after development.[110]

The view of Uskudar cemetery is a pack-film negative FIG. 53. You can see the strip of adhesive along the right-hand side of the negative. The photograph also shows an unwanted characteristic of the celluloid film sheets. Unless kept perfectly flat and tight against the backing plate, bright light could pass through the thin negative and bounce back, creating a double image. This is exactly what has happened in the upper part of this picture A pack-film holder could be removed, once the dark slide had been reinserted, and replaced with a glass plate, but the natural tendency is to continue until the pack film is empty, and this seems to be generally what Jeanneret did.

The Tessar lens on the Cupido 80 was a new design (1903) by Paul Rudolph for Carl Zeiss of Jena, a center of specialist manufacture of optical-quality

FIG. 57 **Cupido 80, showing the focusing lever on the left and the ivory distance scale (bottom right)**

FIG. 58 **Jeanneret, handheld plate photograph of Smederovo near Passarovits, on the Danube, June 1911** BV LC-108-584

glass. This was a classic design that was later adopted by many other manufacturers, including Kodak, for decades afterward.

The design of the Tessar lens FIG. 54 allowed for sharper pictures to be taken at much wider apertures. The lens belongs to the family of "triplet" lenses and it soon became the standard for good-quality folding cameras for handheld use. It was much easier to manufacture in quantity compared with the previous standard, the double anastigmat or rapid rectilinear lenses. An example of the latter was the double anastigmat Dagor lens manufactured by Goerz from 1893 on FIG. 114. This structure allowed for the design of lenses that could cover a very wide field (ultrawide angle), provided that a small aperture was used, and was thus prized by architectural photographers. Double anastigmat lenses for 9 × 12 cm plate cameras were supplied in a range of focal lengths, including 90 mm, 120 mm, 135 mm, and longer. A 135 mm lens on a 9 × 12 cm plate would offer an angle of view of 58°, equivalent to a 38 mm lens on a 35 mm camera. A 120 mm lens would be the equivalent of a medium wide-angle, offering 64° (34 mm on a 35 mm camera). A 90 mm lens delivers a true wide-angle coverage of 80°, equivalent to around 25 mm lens on a 35 mm camera. It is impossible to identify the field of view of a lens without knowing the distance between lens and subject. To my eye, the photographs taken on Jeanneret's 9 × 12 cm plates are moderately wide-angle, rather than "standard," and I would have expected a lens of 120 mm or even slightly wider to have been used. By contrast, to my eye the 6 × 9 cm roll-film negatives have a significantly narrower field of view, closer to a standard view (45–50° on 35 mm). This would be consistent with the roll-film negatives being taken on a roll-film holder on the plate camera and using the same lens. It is important to note that Jeanneret's perception of space, as represented in his drawings, was extremely wide-angle. Many of his drawings cover a field of view of 120–180°. Jeanneret later suffered a detached retina in one eye, removing his ability to judge space by binocular

FIG. 59 **Photographs of Fontainebleau Castle, showing (blue frame) a straight view and (yellow frame) the effect of a rising front to include the top of the building without distortion**

vision, and it seems that he compensated for this by broadening the field of view to include virtually everything in front of him. Although each eye has a field of view of around 95° horizontally, we normally use only the central part of this "image" for detailed observation, building up a spatial sense through movement of the head and eyeball. I would have expected Jeanneret to have been extremely frustrated with the limited field of view of his first camera and would have selected the widest possible lens for his new camera.

Another feature of the double anastigmat lens was that one half of the lens could be unscrewed, to produce a lens of longer focal length (narrower field of view). Lenses of this kind were made by Voigtländer, Carl Zeiss, Schneider, and others.

The widest aperture of the Kodak Bull's-Eye or Plico box cameras, at approximately f16, would measure around ¼ inch (7 mm), whereas the f6.3, Tessar's widest aperture, would measure more than ¾ inch (21 mm). This let in much more light, which, combined with a "Kombination" shutter, offering a range of precise speeds from one to 1/100 second, was of great assistance in handheld photography. This is because it was possible to select precise combinations of exposure and aperture for a wide variety of lighting conditions, which was not the case with box cameras. The speeds on the Cupido's Compur shutter—1, 1/2, 1/5, 1/10, 1/20, 1/50, and 1/100 second—offered considerable control of exposure.

A number of the exposures with the glass plates and pack-film negatives were taken handheld in the Balkans and around Istanbul. The Cupido 80, and most folding cameras of the period, had a "luminous" viewfinder that could be used with the camera in hand and without recourse to the ground glass screen and black cloth FIG. 56.

This kind of view, with the lens wide open, gives a quite different type of image from the pin-sharp pictures taken on a tripod with the lens stopped down. This was particularly useful when using a roll-film holder or

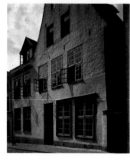

FIG. 60 **Jeanneret, 9 × 12 cm, glass plate photograph of Gabrovo market and clock tower (now resited in a park)** BV LC-108-164 → p. 122

FIG. 61 **Jeanneret, 9 × 12 cm glass negative taken of a town house, probably in Hamburg** BV LC-108-094

pack film, when twelve photographs could be taken on one roll of film without removing the back. But if the daylight viewfinder is practical, it is not very precise. The cross-shaped mask on the viewfinder allows the photographer to prefigure a vertical or horizontal format in the proportions of the 9 × 12 cm glass plates. The small, red spirit level on the right is intended to ensure that the camera is held perfectly level, but it, too, is an inaccurate system. A big advantage offered by cameras like the Cupido is the rising front. The nickeled, knurled knob at the top right of the lens board allows the lens to be raised or lowered by several centimeters. These lenses produced an image considerably larger than the 9 × 12 cm rectangle that actually formed the picture. By displacing the lens from the central axis, the image formed on the negative can be moved, to include more of the top or bottom of the picture. In the examples shown FIG. 59, the blue rectangle in the top image shows the effect without raising the lens. The other image shows the effect of raising the lens to include the top of the building. If the camera is not to be tilted, there will always be as much of the image below the level of the camera as above, which is often not what the photographer wants. To put it another way, the "horizon line" is the line at right angles to the axis of the lens and exactly level with it. If the ground is level, the horizon line normally corresponds to the height of the camera above the ground, somewhere between waist and head-high. All horizontal lines in a scene will converge to a point on the horizon line, either inside the picture or to either side FIG. 63.

In his carefully composed view of Gabrovo market and clock tower FIG. 60, taken on a tripod (notice the blurred passers-by), the horizon line is near the middle of the photograph, showing that the rising front was not used. A large surface of cobbled road is shown in the foreground and we may suppose that the closest part of the pavement, at the bottom, is no more than four feet away. By contrast, his photograph of a German town house FIG. 61 very nearly eliminates the roadway, to get in the top of the

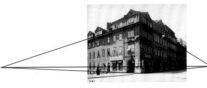

FIG. 62 **Jeanneret, glass plate negative of the Schlossturm, Karlsruhe, April 1911** BV LC-108-0087

FIG. 63 **Jeanneret, 9 × 12 cm glass plate negative, taken in horizontal mode with rising front, indicating the low horizon line** BV LC-108-100

house, almost without tilting the camera. Here, the closest visible part of the road or pavement must be nearly twelve feet away. Once he stopped using his plate camera, Jeanneret quickly resorted to tilting the camera to get in the parts of buildings that interested him FIG. 120.

One consequence of using a rising front is that some of the benefit of having a "bright" lens (opening to a wide aperture) is lost. Once the lens is displaced off-axis, it must be stopped down to a much smaller aperture in order to maintain sharpness, and this demands the use of longer exposures, even in daylight, and hence the use of the tripod. An example is the photograph taken with the rising front, handheld, and with a wide aperture, FIG. 74.

So far so good. The Cupido 80 camera was designed to take pictures in the vertical orientation, but it could be tilted on its side, and a second screw bush was provided so that it could be used on a tripod in the horizontal orientation FIG. 48. Jeanneret was unusual among architectural photographers, however, in that 80 percent of his 9 × 12 cm photographic plates were taken in the horizontal orientation. If, on looking at his photographs, you had been asked to guess what kind of camera he owned, you would have not suggested the Cupido 80, but rather one of the many cameras designed to take horizontal photographs. Before 1914, a high proportion of folding cameras were designed to take postcard-type pictures, in a "landscape" rather than "portrait" orientation. Taking horizontal pictures with a camera designed to take vertical ones is possible but awkward. Much more worrying, however, is that in nearly a quarter of the 136 horizontally oriented plate photographs, Jeanneret also used the rising front. And this was technically impossible with the Cupido 80.

Let us examine the evidence.

In one of the first photographs he took with his plate camera FIG. 62, Jeanneret meticulously composes his picture, using the rising front on the camera to reduce the foreground and get in a glimpse of the roof line at

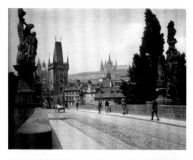

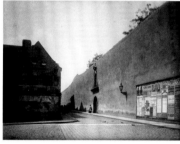

FIG. 64 **Jeanneret, view of the Charles IV Bridge, toward the castle, Prague, May 1911** BV LC-108-98 → p. 86

FIG. 65 **Jeanneret, U Luzickeho seminare, Uvoz, Prague** BV LC-108-99 → p. 95

the top left. The eye level of the camera is well below the top of the balustrade and yet the vertical lines of the building are scrupulously kept level. I read this photograph as something of a test exercise: the subject is lacking in architectural or urban interest compared with most of Jeanneret's pictures. Short of unscrewing part of the lens assembly to tilt the lens (while keeping the back of the camera vertical) it is difficult to see how this photograph could have been taken with the Cupido 80 camera. We cannot turn to Klipstein as the photographer; he was not present on this trip to Stuttgart and Karlsruhe.

There are various ways in which a camera can be made to offer a rising front facility in both a vertical and horizontal orientation. The most straightforward is to make the lens adjustable in both directions (up and down and sideways). The sideways motion is called a cross front. With the camera in a vertical orientation, it would allow the angle of view to include more from one side or the other without turning the camera. A possible use is to avoid reflections—for example, when taking a picture of a mirror or plate-glass window and wishing to avoid seeing the camera in the reflection. Turning the camera on its side, however, turns the cross front into a rising front. We need not concern ourselves here with "swinging front" and "swinging back" facilities, which had been offered on professional cameras for architectural photographers since the mid-19th century. The Cupido did not have a cross front because the single folding action that gave the camera its selling point—"the camera that sets itself up"—held the lens mount assembly rigidly in place, allowing only a vertical movement.

Another option much used in stand cameras was the rotating back. With a rotating back, the camera could be maintained in the orientation for which it was designed and the back rotated so that the negative was either in the vertical or horizontal orientation. The Cupido did not have a rotating back, and the slot for the plate holder was built into the box. For a similar

FIG. 66 **Jeanneret, Tyn Square, Prague, May 1911** BV LC-108-103 →p. 91

FIG. 67 **Jeanneret, Antonin Pelich shop, Neruda Street, Prague, May 1911** BV LC-108-115 →p. 90 bottom left

price, Jeanneret could have bought a camera that had rising and cross fronts and similar lens and shutter options, such as any of the Hüttig Ideal or Lloyd cameras, launched in 1908. According to McKeown, whose book is considered a reference, the Hüttig Ideal 9 × 12 cm camera had an Extra-Rapid Aplanat Helios f8 lens and an Auromat shutter with speeds of 1/25, 1/100, B and T, and was available in 1908.[111] The Lloyd 9 × 12 cm was closer to the Cupido with the same Compound shutter. The Ideal and Lloyd cameras came in vertical and horizontal orientations FIG. 106.

Let us examine these horizontal photographs FIGS. 64–67 →pp. 86, 90, 91, 95. What these four pictures have in common, apart from the horizontal format and the use of the rising front, is a very careful attention to composition within the conventions of architectural photography. In the picture of the Charles IV Bridge FIG. 64 →p. 86, one of four plate photographs taken of the bridge and its statues, the tripod is positioned carefully to include the full height of the statue on the left, while the perspective of the roadway creates both a graphic diagonal and a good effect of depth toward the gateway on the left, whose tower is matched in the composition by the trees and statue on the right. The time of day is well selected so as to create strong forms in the foreground and the effect of atmospheric perspective in the castle in the background. The term "atmospheric perspective" describes the way distant objects often appear lighter, due to haze in the air. Painters are also able to exploit the fact that haze renders distant objects blue. Even the timing of the shot to position the pedestrians well in the scene is carefully done. All this takes time and patience and a good understanding of the genre. We have seen that Jeanneret was under an obligation to take photographs of certain types of place or construction and that he was having particular difficulty finding suitable bridges. The Charles IV Bridge is one of the most famous works in Europe and was evidently worth a careful study. We must assume that this picture was intended to be published.

111 J. M. McKeown and J. C. McKeown, *Price guide to antique and classic cameras* (Grantsburg, WI: Centennial Photo Service, 1985), 207.

The dramatic image of the seminary wall FIG. 65 →p. 95 also shows Jeanneret thinking as a photographer. His interest in urban space and the ways that walls, openings, and closures both induce a sense of movement and temporarily frustrate it, stimulated by his reading of Camillo Sitte's book, help to explain the lack of an obvious "subject." This photograph is unlike any professional or conventional tourist photograph. We will see that the fascination with walls lining streets became a theme of the voyage d'orient, in Jeanneret's drawings as much as in his photographs. From a photographic standpoint, the strong diagonal on the right blocked by the solid shape of the house on the left creates interest, which is further stimulated by the dancing shadows of the roofscape projected onto the wall in the distance. The eye is invited to penetrate to the furthest point in the represented scene. The play of light and dark is also effective.

Jeanneret took two photographs of Tyn Square. One view →p. 90 top left was relatively conventional, featuring the statue of the Virgin Mary and the Baroque houses behind. Another one FIG. 66 creates a composition out of the corner of the square, again focusing on the entrance, which slants off diagonally. The image is anchored by the black lamp standard on the left, which creates a sense of depth by throwing the lighter-colored walls into the background. The rising front has been used in exemplary fashion to keep the vertical lines straight and to reduce the foreground, which draws attention to the small figures of the pedestrians. Architectural photography is to a great extent about creating a sense of depth and scale, and what we see here are some of the classic ways of achieving this, using perspective lines, the scale of recognizable details (pedestrians), atmospheric perspective, and "repoussoirs" in the foreground to offset the background. In landscape painting, "repoussoir" is the term used to describe a vertical feature, such as a tree, introduced at the side of a painting to guide the eye back toward the center. All these are techniques used by artists since the Renaissance. The

fourth photograph, of the Antonin Pelich shop FIG. 67 →p. 90 bottom left, is a puzzle. Why go to such trouble to photograph this shop? Once again, the tripod has been used to permit the use of the rising front. Almost all the pavement has been eliminated without tilting the camera. I rather think that, attractive though this shop is, the photograph is something of a test shot, in which Jeanneret experiments with his nearly new camera.

But the mystery remains. Jeanneret could not have taken any of these twenty-nine plate photographs with the Cupido 80, since the camera could not deploy a rising front in the horizontal orientation. Furthermore, these include some of the most carefully composed and technically most competent of his architectural photographs. And he expresses a strong preference for a "landscape" orientation for his photographs. Were it not for the presence of the Cupido 80 in the Fondation Le Corbusier, no one would have suggested it as the machine on which his photographs had been taken. It is hardly possible that Jeanneret had one camera for the vertical pictures, the Cupido, and another for the horizontal ones. We have to confront some difficult hypotheses. Either someone else took some or all of the 9 × 12 cm photographs, or Jeanneret took them with a different camera. It cannot have been Klipstein. As we have seen, he was not present when Jeanneret began taking the glass plate negatives, including some with a rising front in the horizontal orientation, and five glass plate negatives were taken in Italy after Klipstein had returned to Germany. We do not know of anyone else who followed the very particular itinerary traced by Jeanneret and Klipstein.

Eighty-two 9 × 12 cm glass plates (of the 172 photographs taken with glass plates recorded in contact prints) have survived in the library in La Chaux-de-Fonds. There does not appear to be a pattern to explain the negatives that have survived, apart from the fact that the plates taken of his parents' house have unsurprisingly survived better than those taken in Germany or on the voyage d'orient. The others were presumably lost or

broken. If Jeanneret did not take the plate photographs, how is it that he finished up in possession of the glass plate negatives? Most of the glass plates and pack-film sheets have numbers running from 80 to 602, scratched into the emulsion or written on the film. There are gaps in the numbered sequence but, with a few exceptions, the numbers correspond to the chronological sequence of Jeanneret's travels in 1911, before and after Klipstein's accompaniment, and continuing with some of the pictures taken of his parents' house in 1913–15. The numbering sequence of the 9 × 12 cm glass plates and pack-film sheets is broken into sequences, beginning at 80–97 (April 1911, Germany), 151–175 (May 1911, Prague), 200–228 (July 1911, Istanbul), 260–270 (September 1911, Athens), 300–304 (October 1911, Italy), 400–408 (1912–13, Jeanneret-Perret Villa), 501 (a silver clock), and 601–602 (copper repoussé sign for "Pensionnat Jeunes Filles Mme Huguenin"). The numbering is chronological with a few exceptions. The gaps in numbering may reflect Jeanneret's intention to number in his roll-film negatives on his first camera, the roll-film holder, and his third camera. It is not clear what purpose these numbers served. They were inscribed before the contact prints now in the Fondation Le Corbusier were made, since they appear on these in almost every case, except where the plate has been cropped in the copying process. But they do suggest that the plates should be taken as a whole, as a set.

Another option is that Jeanneret bought some of the photographs from professional photographers. Some of the pictures taken in Germany and Prague are indeed of nearly professional quality. But we have to ask, how did Jeanneret come to possess the glass negatives? It is true that he seems to have purchased some glass plates from the National Archaeological Museum in Athens, but this was an exception. He recorded in his accounts having purchased some photographs: "Five big ones from the museum at 8 piastres = 40 p. Five small ones [from the museum] at 5 piastres = 25 p." This suggests that the photographs were purchased from a museum in Istanbul.

No prints meeting this description survive. On the other hand, some glass plates of unusual dimensions from the National Archaeological Museum in Athens may have been bought by Jeanneret.[112] He told Klipstein that he had bought some magnificent photographs of works of art from the Florentine photographic agency Alinari Brothers. These seem to have been lost, but they would certainly not have included negatives. He also purchased a number of Joaillier prints, in Istanbul. In his letter to Klipstein in February 1912, he includes in his accounts a note about photographs purchased in Istanbul: "That leaves the Joaillier photographs, which come to 32.30 frs. I have the following: 19 ordinary prints (views of Constantinople), 10 [of] Karié-Djami at 3 piastres = 89 p."[113] He also wrote: "And you must send me your accounts for Sebah et Joaillier," which suggests that Klipstein had also bought some Sebah and Joaillier photographs. These were from the firm Sebah and Joaillier, founded by Pascal Sebah in 1857 and continued after his death by his son Jean Sebah in association with Polycarpe Joaillier. In 1899, Jean Sebah purchased the collection of Abdullah Frères, a splendid collection of views of Istanbul taken in the late 19th century. The photographs that survive from this big agency, which operated all over the Middle East, are mostly albumen prints of a very different kind from those in Jeanneret's possession. Photographs and albums of photographs by Sebah and Joaillier are held in the Library of Congress and at Princeton University Library FIGS. 68–70.

It is not clear whether any of the prints purchased by Jeanneret survive. He mentions nineteen general views of Constantinople and ten of the converted Byzantine church, which he calls the Kariye-Djami mosque. This was the Church of the Holy Savior in Chora, now known as the Kariye Camii and host to a museum. The church, originally founded in the 5th century, took its present form in the 14th century, when most of the magnificent mosaics that cover its walls and ceilings were executed. These would

112 For example, BV LC-108-406 and BV LC-108-398.
113 FLC E2(6)145.

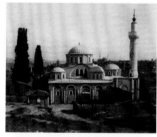

have been of more interest to Klipstein than to Jeanneret and we must assume that the Joaillier prints were purchased at his bequest. Klipstein took detailed notes of the mosaics in his journal.[114]

None of the ten prints of the Kariye Camii purchased from Joaillier have survived among Jeanneret's photographs, so we must presume they went to Klipstein. Of the 19 views of Istanbul mentioned by Jeanneret, none can be positively identified as being by Joaillier. Similarly, Klipstein records in his journal that, on entering the National Archaeological Museum in Athens, he headed straight for the Mycenaean section. He may have bought or even photographed a print of a relief.[115] Jeanneret was more interested in the Archaic and Classical Greek sculpture, which he photographed.[116]

So, did Jeanneret buy the high-quality horizontal photographs using the rising front from a professional photographer? The first objection is that they were taken in a number of different cities in Europe and the Middle East. Secondly, they include photographs that are unlikely candidates for a professional agency FIG. 71 → p. 97 top right.

Jeanneret took four photographs of the Justinian basilica Hagia Sophia, at the time converted into a mosque FIG. 71. These are not at all the kind of photograph taken by a professional agency. The famous views of the great basilica are general exterior views and the spectacular interior. The view of the interior by Sebah and Joaillier, taken at the end of the 19th century is of this classic kind FIG. 72. Jeanneret chose to get in close to the building and accentuate its abstract masses. His photographs create strong rhythms out of the projecting buttresses, converging angles, and strong shadows of its west flank. In an attempt to partially compensate for the converging verticals, he has raised the lens as far as it will go, beyond the lens's coverage, resulting in very strong vignetting FIG. 71.[117] A professional photographer would not have done this, but we can understand the effect Jeanneret was trying to achieve. Vignetting is hard to detect on a ground glass screen,

114 Klipstein journal, pp. 15–16.
115 FLC L4-20-191. The relief is marked "N.M. 264."
116 Some of the glass plates of Greek statues may have been bought from the Acropolis Museum.
117 Vignetting is the term used to describe the falling off of intensity of light at the margins of a lens's covering power.

FIG. 71 **Jeanneret, photograph of Hagia Sofia, west side, 9 × 12 cm glass plate, July 1911** BV LC-108-15 → p. 97

FIG. 72 **Sebah and Joaillier, Hagia Sophia interior** LoC

FIG. 73 **Sebah and Joaillier, view of Hagia Sophia, ca. 1895** NGA 190002083

which is already very dim. There are other examples of extending the lens beyond the correct vertical distance when photographing in the horizontal orientation.

As it happens, the glass plate for his photograph of St. Nikolaus, Prague, FIG. 74 → p. 90 top right has not survived, but Jeanneret's efforts to get in as much of the tower as possible, while reducing the foreground, has led to the top of the tower being quite unsharp. It is probable that he took the photo with a wide aperture, perhaps even handheld, guessing the effect of the rising front. This would have greatly accentuated the fall-off in sharpness and illumination at the top of the image. Raising the lens to this point, cutting off any view of the road surface, also creates an artificial effect; it is as if the building is floating in the air, and a sense of scale and distance, which we have looked at in Jeanneret's other photographs, is missing here. Once again, I see this as a step in Jeanneret's learning curve with his camera. Furthermore, a number of the glass plates taken in the first few weeks of ownership of the camera show signs of poor development and insufficient fixation. It is extremely unlikely that a professional photographer could have sold a negative in the condition of the ones illustrated in the Album → pp. 84–85. These pictures were taken in the first month of owning the camera, and they are not the only badly developed glass plates from this brief period. Glass plates of an interior in Karlsruhe (BV LC-108-89) and the Hessen monument, Frankfurt (BV LC-108-84), as well as three glass plates for the equestrian monument to Augustus in Dresden (BV LC-108-91, BV LC-108-92, and BV LC-108-93), provide a record of Jeanneret's struggle to acquire a correct developing technique. In the photograph of the Holländisches Viertel in Potsdam → p. 85, the use of the rising front in the horizontal orientation is clearly evident; the horizon line is around a quarter of the way up the picture, indicating that Jeanneret had raised the lens by 2.25 cm. After these early chemical disasters, it seems that Jeanneret paid for his films and plates to be developed. The

sheet of accounts lists six payments for development, beginning in Dresden and continuing in Turkey, as well as a further development expense in Italy and a big batch of development in La Chaux-de-Fonds, on his return.[118]

The comparison between these two views of the Orangery at Sanssouci Palace, Potsdam, FIGS. 75–76 is perhaps unfair. The professional cameraman has used a very wide-angle lens to juxtapose a group of statues, the reflecting pool, and a general view of the facade. Jeanneret has concentrated on one side of the other facade, trying to set it into context with the landscape. It is less satisfying as a photograph, but reflects Jeanneret's architectural interests.

From analysis of all the glass plates and other negatives, I am convinced that Jeanneret was their author. Which brings us back to the question of the camera. It has always been assumed that the ICA Cupido 80 now in the Fondation Le Corbusier in Paris belonged to Le Corbusier. In fact, it was not in his possession at his death. It was donated to the Fondation by Judith Hervé, widow of Le Corbusier's official photographer in the postwar period, Lucien Hervé. Mme Hervé explained to me that Le Corbusier had given her husband this camera to try out. There is a remote possibility that Le Corbusier either gave him a different camera or that the Cupido was bought on another occasion.

It is almost certain that the Cupido 80 was manufactured after March or April 1911, when Le Corbusier bought his plate camera. The Zeiss Tessar lens registration number—175709—is listed in George Gilbert's authoritative book as belonging to the series produced in 1912.[119] The official Zeiss archives list lenses registered between January and September 1911 as having a range of numbers from 140,941 to 145,940 and you would expect cameras with these lenses to be in the shops several months later. If this information is accurate, it would have been impossible for Jeanneret to have purchased the Cupido 80 with the Tessar lens in April 1911. The num-

118 FLC E2(6)144.
See Appendix 1 → p. 408.
119 Gilbert lists the Zeiss serial numbers for 1912 as being "173418 thru 200520."
G. Gilbert, *Collecting photographica: the images and equipment of the first hundred years of photography* (New York: Hawthorn Books, 1976), 292.

120 Based on the research of Hartmut Thiele, which was in turn based on the Zeiss archives (document BAZC 4000). I would like to thank Larry Gubas of Zeiss Historica for directing me to this information.
121 Dan Fromm, posted note on Photo.net forum, November 22, 2004.
122 FLC E2(6)144.
123 BV LC-108-201, BV LC-108-202, BV LC-108-203, BV LC-108-204, BV LC-108-205.

bers 175,941 to 180,940 were registered between October and December 1912.[120] Cameras on sale in shops usually had lenses registered one or two years earlier; for example, a group of cameras stolen in 1912 from a shop in London had Zeiss lenses registered in the range 13373x.[121] If Jeanneret's camera was bought in Dresden, where it was manufactured, a recently registered lens might have been available in April 1911, but even so, the number lies outside the range of recorded cameras.

It is probable that the camera he was using broke down in Istanbul or Athens. Jeanneret records two repairs to the camera, one in the Balkans and one in Athens. For whatever reason, he stopped taking 9×12 cm plates or pack-film negatives regularly on leaving Athens and bought himself a third camera, which he describes as a "Brownie Kodak" and with which he took handheld 6×9 cm negatives until his return. He explicitly says that he took only 6×9 cm negatives, with the Brownie, when in Italy: "In Naples, I bought a Kodak Brownie and from then on worked only with films."[122] There are five exceptions to this, glass plates taken in and around Rome: a view of the Campidoglio FIG. 77, a view of the steps up to the Villa Medici, and three views of the Villa d'Este FIG. 78.

This does indicate that he had a 9×12 cm camera in working order in October 1911, but interestingly, in none of these five glass negatives was the rising front used in the horizontal format. A number of the glass plate negatives of the Jeanneret-Perret house, taken between 1912 and 1919, do employ the rising front in the horizontal orientation, but it is difficult to determine which of these photographs were taken by a professional photographer. What is certain is that the photographs of the house taken in the winter of 1912, with the numbers 400–08, do not use a rising front.[123] In the photograph of the Campidoglio, Jeanneret has almost certainly placed his camera on the stone balustrade of the balcony at the top of the steps leading to the main entrance to the Palazzo del Senatore, and has tilted the camera down-

FIG. 75 **Professional photograph of Sanssouci Palace, Potsdam, Orangery** NGA 1900155817

FIG. 76 **Jeanneret, Sanssouci Palace, Potsdam, Orangery, April 1911, 9 × 12 cm glass plate** BV LC-108-82

FIG. 77 **Jeanneret, view of Campidoglio,**
9 × 12 cm glass plate BV LC-108-513

FIG. 78 **Jeanneret, view of Villa d'Este, Tivoli,**
9 × 12 cm glass plate BV LC-108-511

ward slightly to get in the paving of Michelangelo's square.[124] If he had had a rising front, and the patience to use it with a ground glass screen and black cloth, he would have set the camera straight and "dropped" the lens downward to get in the paving without distorting the verticals. The photograph of the Villa d'Este is also taken from the top of the stairs that lead down to the terrace and then to the gardens, which are off to the right. No rising front is necessary here, since the high viewpoint, with respect to the building, balances the play of perspective lines above and below the horizon line.

Is it conceivable that Jeanneret traded in his broken plate camera for the Cupido 80 in Athens, perhaps as a result of having insufficient time to repair it? Alternatively, it is even possible that he purchased the Cupido 80 later, when he took the photographs of the Villa Jeanneret-Perret.[125] It is even possible that his plate camera was exchanged with another model while in the possession of Lucien Hervé. None of these explanations seem very convincing, but there seem to be very few options available to explain the inability of the Cupido 80 to take horizontal photographs with a rising front. When considering evidence, there is a hierarchy that must be observed, from the incontrovertible to the circumstantial. The existence of the Cupido 80 camera in the Fondation Le Corbusier is circumstantial evidence that he may have used it on his travels in 1911. The existence in Le Corbusier's mother's house of the glass plates and other negatives is also circumstantial evidence that he took the photographs, although of a higher order of probability. Incontrovertible, however, are the laws of physics and optics that dictate what it was possible to do with that camera. And if the documentary evidence of the Zeiss archives is to be trusted, the lens registration number of the lens would exclude the possibility that Jeanneret bought the Cupido 80 any time before mid-1912, after the voyage d'orient. We will return to the question of the other plate cameras that Jeanneret might have purchased, but first we must tackle the question of the 6 × 9 cm negatives.

124 The pattern of paving here is not the original one, which was restored under Mussolini in 1940.
125 See note 119.

Jeanneret's Second Camera

87

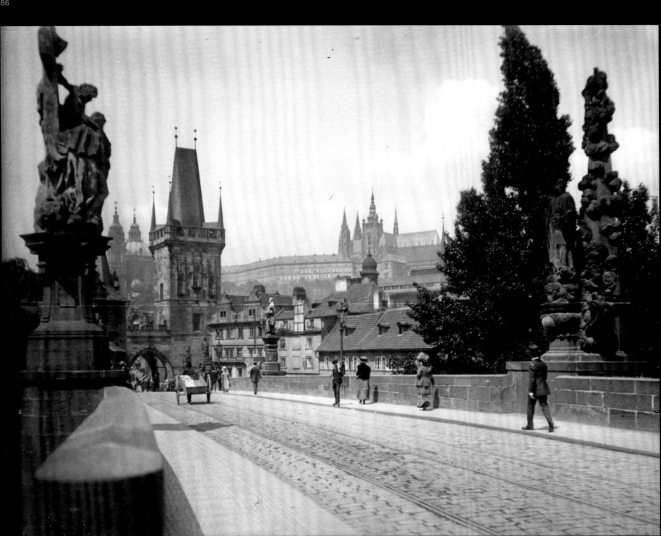

93

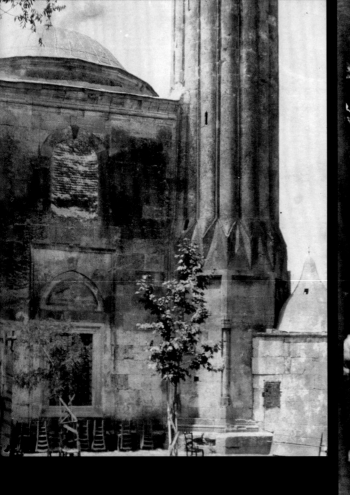

Handheld Photography

It has often been suggested that August Klipstein took a number of the photographs on the voyage d'orient. He joined Jeanneret at Dresden in May 1911 and they traveled together until Klipstein returned to Germany from Athens at the end of September 1911. For the reasons outlined above, I do not consider it possible that Klipstein took all the glass plates, and extremely unlikely that he took any of them. But a different situation arises with the 6 × 9 cm negatives taken during the voyage d'orient because these pictures coincide precisely with Klipstein's presence on that trip. As we saw earlier, a group of 6 × 9 cm negatives and contact prints exist with a distinctive "felt strip" border FIG. 7. Jeanneret does not seem to have taken any 6 × 9 cm photographs with the "felt strip" border before May or after September 1911. So did Klipstein take the "felt strip" negatives? Or did Jeanneret have two cameras with him on the trip? To answer this question we need to probe a little into the relationship between the two men.

Jeanneret and Klipstein had become friends in June 1910 in Munich after Jeanneret answered a note on a bulletin board requesting a French conversation partner.[126] Klipstein was an ardent traveler, having visited Spain and Italy, and they found much to talk about while discussing Jeanneret's trip to Italy in 1907. Whereas Jeanneret wanted to visit Rome, Klipstein's aim was Istanbul and Athens. In a letter to Klipstein in September 1910, Jeanneret says he dreams of a "an idler's tour of Rome."[127] In February 1911, he says that his plan is to finish his studies in Rome, but is prepared to go via Constantinople.[128] On reading the correspondence between the two friends, it seems that Jeanneret assigned to himself the role of photographer, asking only for a little help in carrying the equipment. Commenting on his purchase of a new and more expensive camera, he wrote: "I am buying myself a new and sophisticated camera. I will only ask of you the occasional aid of your back."[129] An intrigu-

126 FLC E2(6)122.
127 FLC E2(6)124, p. 5.
128 Letter of February 13, 1911 from Neu Babelsberg. E2(6)164.
129 Letter of March 10, 1911 (FLC E2(6)128).

130 Le Corbusier, *Voyage d'Orient sketchbooks*, Carnet 1 (New York: Rizzoli / Milan: Electa, 1988), 130.
131 FLC E2(6)144.
132 Letter to Klipstein, February 3, 1911 (E2(6)145).
133 Carnet 1, pp. 82, 124–29, and Carnet 2, pp. 127–29. These notes overlap with each other and with E2(6)145 see Appendix 1 →p. 408.

ing note, which was misinterpreted by Giuliano Gresleri, appears at the back of Carnet 1, on p. 130: "Tell K[lipstein] to buy a Brownie camera."[130] The Carnets have to be read from both ends. This page, four pages from the end, thus belongs chronologically among the first notes in this notebook, when Jeanneret and Klipstein were still in Vienna in May 1911. There are also notes of items bought in Vienna and Prague (pack films, black cloth, and a yellow filter →p. 408 APPENDIX 1 noted on the page of accounts Jeanneret sent Klipstein after the end of the voyage d'orient, in December 1911 FIGS. 79–80.[131] This suggests that Jeanneret was encouraging Klipstein to buy a simple Kodak Brownie camera before setting out on their journey together. It is also clear that Klipstein was capable of taking photographs. He sent Jeanneret a photograph of a bridge from an earlier trip to Spain, and Jeanneret congratulates him for photographing some of the objects he had bought in the Balkans.[132]

The most important, albeit confusing evidence of Klipstein's contribution to photographic activity is a two-page account of sums owed by the two friends to each other. This is not an account of all they spent. More complete accounts of purchases of earthenware pots, textiles, and icons are jotted into Jeanneret's Carnets.[133] We gather from correspondence with Klipstein after the trip that the idea was to share the costs and the photographic proceeds. It is worth analyzing the page of accounts in detail →p. 408 APPENDIX 1.

Interpreting this sheet, we can make certain deductions about each man's expenses on photography. When Jeanneret refers to "48 films" he does not mean 48 roll films of twelve frames each, but rather four films taking 48 pictures in all. The cost of plates and films was remarkably consistent, in Austria-Hungary, the Balkans, and Italy, working out at around 30 centimes for glass plates, 30 centimes for pack-film sheets, and between 15 and 19 centimes per frame of 6 × 9 cm roll film. In Turkey, however, although the pack film and glass plates cost the same, the films seemed to be half the price. Kodak 120 format film could be bought in lengths of six or twelve

FIGS. 79–80 **Jeanneret, page of accounts sent to August Klipstein in December 1911** FLC E2(6)144

frames. On the assumption that they bought the short six-frame films in Istanbul, we can present an analysis of the two men's purchases as follows:

134 FLC E2(6)145.

	9×12 cm glass plates	9×12 cm pack-film sheets	6×9 cm film frames	Number of photos	Cost in francs
Klipstein	36		108	144	30.40
Jeanneret	66	36	216	318	112.30
Total exposures	102	36	324	462	

If my assumptions are correct, the numbers add up reasonably well. I estimate that Jeanneret took 111 glass plates in 1911 and around 251 exposures of 6×9 cm film, if we include both the "felt strip" negatives and those taken with the camera bought in Naples in October 1911. I identify only 15 surviving pack-film negatives, but these are in some cases difficult to distinguish from glass plates when we have only a contact print. This sheet cannot be counted as evidence that Klipstein took 144 photographs, against 318 by Jeanneret. If this had been so—each man buying materials for their own photography—there would have been no need for an account sheet. Furthermore, these numbers do not correspond to the surviving negatives and prints. If each man had taken glass plates and 6×9 cm film negatives, there would have been at least four cameras to carry around. The expenses of each man were to be shared, as well as the proceeds, in the form of prints of the photographs. Jeanneret explains in later letters how he is making bromure copies of his negatives for Klipstein. It seems that Klipstein had more ready cash than Jeanneret during the voyage and lent his friend some money. Jeanneret finished up owing Klipstein 1,000 reichsmarks, as an IOU witnessed by a man they met in Istanbul, Walther Beck, testifies. Mention of this affidavit is included in a letter to Klipstein on February 3, 1912.[134] By February 1912, Jeanneret had paid back 900 of this debt.

Let us consider the photographic evidence for the authorship of the "felt strip" negatives. A case can certainly be constructed for Klipstein. He and Jeanneret shared an interest in vernacular art and architecture: Jeanneret having been enthused to search for Slavic folklore by his friend and mentor William Ritter, and Klipstein following the precepts of his teacher Wilhelm Worringer, who argued that real aesthetic quality belonged to the instinctive and abstract work of "primitive" people uncorrupted by industrialization and art education. A typed transcription of August Klipstein's diary on the voyage d'orient has survived. The 33-page typescript, with handwritten corrections by the author, was topped and tailed after his death by his widow, Frieda Klipstein, including a brief biographical introduction, concluding with a transcription of Jeanneret's letter of September 1911 and Le Corbusier's letter of condolence to her after August's death in 1951. Klipstein's typescript was probably based on notes taken during the voyage d'orient but written up later, because it includes several alternative drafts of the same accounts. A copy of this typescript, from the Klipstein archive in Bern, is held in the library in La Chaux-de-Fonds. It begins with an interesting page of philosophical speculations stimulated by reading Worringer's *Abstraction and Empathy*.[135] Whereas the Romantic love of Istanbul now seems laughable, writes Klipstein, there was something in this appreciation, since there is in the Orient a more intensive sensibility and a better understanding of an ideal unity than in a modern world dominated by materialism. The dominance of classicism and the pedantic search for art-historical knowledge are over, he declares.

We no longer require another history of art, for enough of those have been written,
but a philosophy of art, and the best beginnings of such a philosophy already
exist. Only a philosophical-aesthetical view will bring with it a true appreciation
of all epochs of art, and a vibrant blossoming of the same will usher in an interest

135 W. Worringer and H. Kramer, *Abstraction and Empathy: A Contribution to the Psychology of Style* (Chicago: Elephant, 1997), first pubished as *Abstraktion und Einfühlung*, 1907.

in Oriental art. For the aesthetics of line and color in the visual arts, this represents a moment of far-reaching and fruitful significance.[136]

136 Klipstein journal, pp. 1, 2 (BV LC-106-1082).

Klipstein had spent several years studying art history in Paris and shared with Jeanneret an appreciation of Cézanne, Matisse, and other modern artists. The formalism of modern art found a stimulus and echo, for them, in the abstraction of Islamic decorative art, the simplicity of the vernacular architecture of the Balkans, and the purity of the architecture of the mosques. Later, describing a suburb of Budapest, Klipstein marveled at the natural disposition of the houses, their unity with the landscape, the charm of their enclosed gardens, and the small squares where children could safely play. It was this kind of vernacular architecture that was captured extensively on the "felt strip" negatives.

On the other hand, there are few descriptions by Klipstein of vernacular architecture in the towns and villages in Hungary, Serbia, and Romania, where the photographs were taken. Klipstein mostly described the streets, their state of cleanliness, and the hostelries in which they ate and slept. It is extremely interesting, and slightly puzzling, therefore, that Jeanneret asked Klipstein to send him contact prints, or the negatives, of his Balkan photographs.

Send me as soon as possible [underscored three times] either the negatives or the bromure prints of the photographs of the Balkans (Knajewatz, Radojevaz, the Bucharest monasteries, Kazanlük, and above all the terrace of the Skete of Saint Anna. Insist on leaving a black border (the negative image must be cut out exactly). I need these for a villa that I am currently designing.[137]

FIG. 81 **View of a vernacular house, probably in the Tarnovo region of Bulgaria, June 1911** BV LC-108-148

This is extremely interesting, since many of the "felt strip" photographs are indeed of houses in Knajewatz and Kazanlük. On the other hand, nothing

137 Letter to Klipstein,
December 18, 1911
(FLC E2(6) 137).
138 Ibid.
139 Letter to Klipstein, February
3, 1912 (FLC E2(6)145).
140 Le Corbusier, *Les voyages
d'Allemagne: carnets;
Voyage d'Orient: carnets*
(Milan: Electa / Paris: Fondation
Le Corbusier, 2000), 53.

from the monasteries in Bucharest, which Klipstein describes in his journal, or the Skete of Saint Anna exists among the surviving photographs. This may appear to confirm that the "felt strip" negatives were taken by Klipstein. But it is also clear that Jeanneret had himself taken many photographs in the Balkans. In the same letter, he urges Klipstein:

> *Don't keep me waiting for the mailing from Laubach: pots, icons, shawls, 9 × 12 cm negatives, and the Belgrade package, etc.*[138]

And indeed, two large packages were sent from Klipstein's home in Laubach to La Chaux-de-Fonds; Jeanneret complained in February 1912 about the cost of the mailing (22 francs, including 13.50 in customs duty), which he paid.[139] Although he said he had not opened the packages, Jeanneret claimed that he had developed his negatives and was delighted with his pictures of the Balkans. The two men had sent back—apparently to Klipstein's home—a large consignment of pots, icons, glass negatives, and other heavy material they had accumulated during their trip through the Balkans, and he had divided up the spoils and sent Jeanneret his share, including the 9 × 12 cm glass plates. A long list of the contents of these parcels, which included icons, Persian miniatures, several Bokhara rugs, vases, a chandelier in two pieces, and various pots and textiles, are listed on pages 125–27 of Carnet 1, mixed in with the costs of these items and other things seen but not bought. Included are two "boxes of negatives," although we cannot know how many glass plates were in each box.[140] Jeanneret, meanwhile, had presumably kept the lighter roll films and had developed them in La Chaux-de-Fonds. I conclude that the photographs—prints or negatives—that Jeanneret wanted Klipstein to send him were the same as the glass plates mentioned further down in the letter and which were presumably taken by Jeanneret. If Klipstein did take photographs, most of them have not

FIG. 82 **Jeanneret, view of procession of women at a funeral, Baja, Hungary, June 1911** BV LC-108-28

FIG. 83 **Jeanneret, photo of antique sarcophagus, Istanbul, July–August 1911**
BV LC-108-379 → p.133

FIG. 84 **Laboring monks of the Karakalou Monastery, Mount Athos, August 1911** BV LC-108-546

FIG. 85 **Klipstein (attrib.), death of St. Athanasius of Athos, in the refectory of the Monastery of Great Lavra** FLC L4-20-259

FIG. 86 **Klipstein (attrib.), painting of a fresco in the Roussikon Monastery, Mount Athos** FLC L4-19-69

survived among the collections in Paris, La Chaux-de-Fonds, or Montreal; perhaps they were never sent to Jeanneret. But, as we will see later, around thirty prints in the Fondation Le Corbusier can be attributed to Klipstein, and we must assume that the others would have been of this kind.

There are other photographs that can be associated with passages in Klipstein's diary. He gives long descriptions of the costumes worn by the men and women in the Hungarian town of Baja, where the two men had gone in search of pottery.

> *A kind of white blouse made of very rough linen, short skirts, similar to those worn in Hessen, but not emphasizing the hips so much; on top of the skirt, a woven apron in a striped pattern, with red as the dominant color mixed with green and yellow to create a powerful color effect. The weave is very coarse, so that it looks more like a piece of carpet ... but that's exactly what makes it so highly decorative.*[141]

There are several photographs of peasants in traditional costume on market day →p. 125, as well as a funeral procession consisting mainly of women, which was also described by Klipstein FIG. 82. Of course, both men saw the same things and either could have taken the photographs. More particular, reflecting Klipstein's art-historical interests, was a description of some sarcophagi in the Archaeological Museum in Istanbul. Klipstein describes some of these in detail (BV Klipstein's journal, p. 17) and there are two photographs of antique fragments that need to be considered.

This photograph FIG. 83 does not match Klipstein's descriptions, which focused on the iconography of figures represented on the sarcophagus, and I consider it to come closer to Jeanneret's interest in the Antique. Finally, in building a case for Klipstein's authorship of these "felt strip" negatives, we know that the prime cause for visiting the monasteries on Mount Athos was Klipstein's interest in Byzantine art. For around eight days they visited

141 Klipstein journal, p. 6a.

142 See FIG. 84
143 Klipstein journal, p. 25.
144 FLC drawings nos. 1912
(recto and verso) and 5885.

FIG. 87 **Klipstein (attrib.), photograph of wild dogs, Istanbul**
FLC L4-19-190

FIG. 88 **Klipstein (attrib.), photograph of bear tamer, Istanbul**
FLC L4-19-219

monastery after monastery, while Klipstein made detailed notes on the artworks. There are photographs of some of the monks.[142]

Again, this photograph FIG. 84 could have been taken by either man. But there is another group of photographs, which are of the frescoes that Klipstein was studying.

In the Great Lavra Monastery, which they visited on August 28, the refectory includes a large number of frescoes, mostly from the 16th century. One of them is of the death of Athanasius the Athonite, the founder of the Great Lavra, the first monastery on Mount Athos (AD 963). There is also a detail of the fresco of the Last Judgment, showing the whale-like "undying worm" that, according to the 9th-century Apocalypse of Mary, contributed to the grief of the wicked on the Day of Judgment. These paintings are in the magnificent cruciform refectory with its built-in benches and tables topped with marble. Klipstein gives a warm description.

The refectory is the most beautiful we've seen so far. Particularly noteworthy is the arrangement of the tables ... all of them marble-topped. The walls of the main room, of the churches and the ambulatories are completely covered with frescoes.[143]

Jeanneret was less interested in these frescoes; instead, he painted two watercolor sketches of the courtyard and made a plan and details of the bedroom they slept in.[144]

Several rather dark and poorly composed photographs exist of mosaics in monasteries on Mount Athos FIGS. 85–86. These photographs are among a group of prints that do not have the "felt strip" borders and mostly have an orange or brown tone to the prints. None of the negatives of these prints have survived. The dimensions are slightly different from those of the "felt strip" negatives. They include one of the photographs of frescoes that is inscribed on the back in Klipstein's hand: "Detail of the Ruf. Trapezon du

145 FLC L4-19-70.
146 The numbers are, in the FLC L4-19 group: 69, 70, 185, 189–93, 196, 205, 213, 219, 220, 221, 224, 226, and 229.
147 Letter to Klipstein (FLC E2(6)145).
148 Letter to Klipstein, September 2, 1910 (FLC E2(6)124).

Roussikon, Athos, mid-19th century by a Caucasian painter" FIG. 86.[145] The Roussikon was the last of the monasteries Klipstein and Jeanneret visited on Mount Athos. Several of the brown prints have German inscriptions on the back.

For example, a photograph of scavenging dogs FIG. 87 is inscribed "Hundefamilie Constantinopel" while another FIG. 88 is inscribed on the back "'Constantinopel 2 Bärenführer." In fact, there are eighteen prints in the collection of the Fondation Le Corbusier with German inscriptions on the back, some specific and some only with the German word "Constantinopel."[146] None of these have the "felt strip" characteristic, all conform to the kind of interests we find in Klipstein's diary, and all have a distinctive orange or brown tone to them.

Giuliano Gresleri, aware that these prints looked different from the contact prints from the glass plates and the "felt strip" negatives, ascribed some of them to the photographer Joaillier. This is because, as we have seen, Jeanneret referred to purchasing some prints from the Sebah Joaillier agency.[147] But one of the prints he attributes to Joaillier FIG. 89 also has "Constantinopel" inscribed in German on the back. It is different in style and quality from the Sebah Joaillier photographs, which are typical of the professional, architectural large-plate photographs of the period. If we can take the group of 18 prints inscribed in German, we can add two others, one inscribed "Temple of Luxor, Upper Egypt" and another of a bridge in Spain, in Jeanneret's hand, "Madrid gift of Klipstein," which are in the collection but do not come from the voyage d'orient. The first of these can be explained by Jeanneret's desire to visit Egypt and the second by the letter he wrote to Klipstein specifically asking him for pictures of gardens or bridges from Spain. Listing the things L'Éplattenier wanted him to photograph, he said, "As for bridges? That's where I'm short."[148] It is reasonable to suppose that these prints, identified in German either by Klipstein or his widow, Frieda, were taken by

FIG. 89 **Klipstein (attrib.), view of Sebsafa Kadin Camii mosque, Istanbul** FLC L4-19-185

FIG. 90 **Photograph of the base of a tower in a market square, Gabrovo, 6 × 9 cm "felt strip" negative** BV LC-108-152 → p. 123

FIGS. 91–92 **Details**

August Klipstein. If we add to this corpus of Klipstein photographs some others of the same quality or similar subject matter—for example brown prints of Byzantine mosaics—and which do not belong to the "felt strip" negatives, we come up with around thirty-three photographs. None of these have survived as negatives or contact prints, which reduces the likelihood that they were taken by Jeanneret. They have different proportions to the "felt strip" negatives, being closer to 3:4 than 2:3. We note straightaway that the photographic quality is very different from the "felt strip" negatives, and that none of them are in the collection of the library in La Chaux-de-Fonds. This is because they were probably sent to Le Corbusier, much later by Klipstein's widow, Frieda. She wrote to him on March 31, 1953, following the death of her husband in 1951, saying that she was thinking of transcribing the letters Jeanneret had sent August.[149] It may have been at this time that the short introduction to the typescript of Klipstein's diary was added to the pages typed up and commented on by Klipstein himself before his death. A note in Le Corbusier's studio records the visit of Mme Frieda Klipstein, who left off a package on November 11, 1953 inscribed: "A souvenir of your trip to the Balkans."[150] This turned out to have been a statuette of an elephant that Klipstein had bought during the voyage d'orient; Jeanneret had asked Klipstein for a photograph of it.[151] It may have been on this occasion that she also dropped off a packet of Klipstein's photographs, since some of them have her handwriting on the back. The important point is that these photographs were made on a different camera from the one used for the "felt strip" negatives, and correspond more precisely with Klipstein's interests.

The "felt strip" negatives were taken with a superior lens compared with that of the Klipstein prints. Contrast and sharpness (especially in the center) are outstanding. It is almost certain that most of the photographs on the "felt strip" negatives were taken handheld. The corners of the photographs are slightly fuzzy. The widest aperture (for example, f6.3 on the Tessar lens)

149 FLC E2(6)99.
150 FLC E2(6)110. Le Corbusier wrote to thank her on November 29.
151 "Take a photo for me of the famous Knajewatz pot and of the elephant," letter to Klipstein, February 3, 1912 (FLC E2(6)145).

FIG. 93 **Drawing of a house in Kazanlük** FLC 6085

FIG. 94 **Photograph of house behind a long wall,
6 × 9 cm "felt strip" negative** BV LC-108-559
→ pp. 126–27

FIG. 95 **Paul Schultze-Naumburg,**
Kulturarbeiten, **vol. II, Gärten, p. 157, ill. 109**

was designed to aid in focusing on the ground glass screen, not for best-quality photography. But to take sharp photographs handheld, a shutter speed of 1/100 second or even 1/250 second is advisable. The best shutters of the time, such as the "Kompound" shutter on the Cupido 80 and other ICA cameras, had a range of speeds up to 1/100 second. But to photograph handheld at 1/100 second, a stop of between f8 and f5.6 was required in most daylight conditions. And this meant that the negatives would be quite sharp in the middle but slightly blurred in the corners.

Close inspection of one of the "felt strip" negatives illustrates several of these points FIGS. 91–92 → p. 123. The subject is similar to the glass plate negative we looked at earlier FIG. 60. In the glass plate photograph, a tripod was used along with a slow shutter speed that allowed the moving figure in the foreground to be substantially blurred. In the "felt strip" negative, the photographer has moved toward the tower and used a faster shutter speed, freezing the movements of the people in the shot. The center of the image is very sharp, but this falls off slightly at the corners FIG. 91.

I have suggested that Klipstein had an interest in vernacular architecture and folklore culture, which might explain the large number of photographs of vernacular buildings and peasants. But so did Jeanneret and, as Giuliano Gresleri definitively demonstrated in his book, there is a close matching of these photographs to sketches made by Jeanneret during the voyage d'orient. I do not propose to review this material again, and the reader is encouraged to consult Gresleri's pathmaking volume. I will just draw attention to one aspect of Jeanneret's interests that finds significant expression in the "felt strip" photographs.

Jeanneret developed a fascination with the effect of long blank walls on the street, which hinted at interior domesticity but gave complete privacy to the inhabitants. This drawing FIG. 93 is inscribed: "The garden is tiny … The rendering is in earth and finished in whitewash. The lower register is in

FIG. 96 **Jeanneret, part of the Carthusian monastery of Ema, November 1911** BV LC-108-463

FIG. 97 **Garden of a house in Kazanlük, 6 × 9 cm "felt strip" negative** BV LC-108-141

FIG. 98 **Sketch of the same house** FLC 1793

ochre-orange." Jeanneret was struck by the peace and calm produced by these houses, sometimes off busy streets, by the sense of enclosure, and the planting of a simple but fragrant garden. He is also struck by the formal simplicity of the public face of these houses, lacking any "architecture" in the stylistic sense. This is partly to do with searching for a universal form of planes and solids, which had begun with his embracing of modernized, stripped classicism during his research in Germany in 1910 but more importantly with his obsessive inquiry into what made a good dwelling. Again, a precedent may be found in Paul Schultze-Naumburg's *Kulturarbeiten* FIG. 95. Schultze-Naumburg dedicated his second volume to gardens, illustrating a number of garden pavilions, gatehouses, and gazebos, as well as the gardens themselves. His comment on this photograph FIG. 97 was:

> FIG. 97 *shows the simple garden on a road that leads through the suburb and out into the open. Here, too, the exterior wall of the house has quite wisely been set in the frontage so that the house dominates the road and garden alike. This modest house, designed as a simple cube, with its equally simple pyramid-like roof looks, as always, very friendly and cheerful despite the complete lack of any ornamentation. What more can one demand of such a simple little house?*[152]

This appreciation of simplicity and rationality was exactly what Jeanneret was learning to see and understand on his voyage d'orient.

An early paradigm for workers' housing, in his imagination, were the cells of the Charterhouse of Ema, which he first visited in September 1907 and sketched, and where he returned in November 1911. He wrote excitedly to his parents: "Yesterday, I went to the Charterhouse … I found there the solution to the individual worker's house. Only it would be hard to match the views. Oh, those monks, the lucky devils.[153] He writes about this evocatively in a letter to L'Éplattenier dated September 19, 1907.

152 P. Schultze-Naumburg, *Kulturarbeiten*, vol. II: *Gärten* (Munich: G.D.W. Callwey, 1904), 158.
153 Letter to his parents, September 14, 1907 (FLC R1(4)13).

Afternoon at the Charterhouse at Ema. Ah, those Carthusians! I could spend my life living in what they call their cells. It is a unique model for working-class houses—heaven on earth. I will write to Sebastian Faure to get him to come and see for himself.[154]

He sketched the monk's cell and garden carefully but seems to have taken only one photograph of the monastery. A copy of this rather underexposed view in the Canadian Centre for Architecture collection is identified by Jeanneret as "Chartreuse Emma" (sic).

Sometimes the photographs matched the sketches very closely, but in most cases drawing and photography played complementary roles. His sketches were either used to make rapid notes about materials or specific features that interested him, or were prepared, as this one was, with a view to eventual publication or exhibition. Once again, there is no evidence that Klipstein worked as closely with Jeanneret as this FIG. 96.

These 6 × 9 cm "felt strip" negatives rival in quality the larger 9 × 12 cm glass plate negatives. There is also a continuity of photographic style between the 9 × 12 cm glass plates and the 6 × 9 cm film negatives.

There is no fundamental difference between photographs like the one in FIG. 94 and →p. 129, except that the latter, with a wider field of view thanks to the bigger negative, is taken from a closer viewpoint. Both evince a fascination with the public/private balance in vernacular architecture, with the hard defining wall allowing a glimpse of a cool garden and warm hospitality behind.

So what camera was used to take the "felt strip" photographs? Did Jeanneret buy two new cameras: a plate camera in March or April 1911 and a 6 × 9 cm roll-film camera in May? If so, why did both the "felt strip" 6 × 9 cm negatives and, with only five exceptions, the 9 × 12 cm plate negatives stop in October? Why did Jeanneret purchase a new and inferior 6 × 9 cm camera—the so-called Brownie Kodak—in Naples in October? We are beginning

FIG. 99 **ICA roll-film holder**

FIG. 100 **Roll-film holder for the ICA Ideal camera**

FIG.101 **Photograph of a church, 9 × 12 cm glass plate negative, marked up to show the coverage by LC** BV LC-108-170 → p. 124

FIG.102 **Handheld view of the same scene from nearly the same spot, 6 × 9 cm "felt strip" negative** BV LC-108-161 → p. 124

to accumulate a lot of cameras: the 9 × 12 cm plate camera, Klipstein's camera, a good 6 × 9 cm roll-film camera, and a lower-quality Brownie? And this is assuming that he sent home the 3½ inch square camera after Prague FIG. 5. When listing things to pack, in Vienna, including shirts, socks, handkerchiefs, paper and brushes, and so on, he writes: "Camera and film negatives. Send to the office."[155] This may be a reference to sending his first camera back to his office in La Chaux-de-Fonds. But there is no reference to two cameras. This leads me to suppose that the 9 × 12 cm plates and 6 × 9 cm roll-film negatives were taken with the same camera. It was possible to mount a roll-film holder onto the back of a plate camera; indeed, this is the same principle used today for mounting interchangeable roll-film backs onto plate cameras and medium-format, single-lens reflex cameras.

Eastman, in collaboration with William Walker, had patented a roll-film holder as early as 1885, and had developed a popular line in the 1890s of Premo film holders, which could be used on any plate camera, but these were being phased out by 1911, due to the popularity of purpose-designed roll-film cameras. Instead of being mounted on the side of the camera closer to the lens, as in the Flexo and similar roll-film cameras, the rolls of film in a roll-film holder are usually positioned at the rear. This means that the film has a tortuous path, being wound round a roller and bent back at a sharp angle. In the rather complicated ICA model FIG.100, the film was held flat by two leather-covered doors that locked shut once the film had been inserted. You can see the little red window, which told the operator when the film had been wound on correctly for the next shot. It is my belief that Jeanneret had a roll-film holder of this kind for use on his plate camera and that, when the plate camera broke down, he stopped using the roll-film holder and bought a cheap folding Brownie in Naples. If this is the case, the angle of view of the photographs taken with the 6 × 9 cm roll-film holder would be narrower than with the 9 × 12 cm glass plates FIGS. 101–02.

155 Carnet 2, p. 128. G. Gresleri (ed.), *Les voyages d'Allemagne, Carnets; Voyage d'Orient, Carnets* (Milan: Electa, 2000), 102.

It would seem reasonable to suppose that Jeanneret, having taken the plate negative FIG. 101, replaced the 9 × 12 cm glass plate holder with the roll-film holder and took another photograph, handheld, from a slightly nearer position. The glass plate picture uses the rising front to get in the top of the building (resulting in some vignetting of the sky) and would have been taken at a slow shutter speed and a small stop, while the handheld photograph focuses on the human action of a woman entering the building, freezing the action of the woman's movements. Convergence of the vertical lines show that the camera was slightly tilted. I deduce from this that the angle of view of the 6 × 9 cm "felt strip" negatives was narrower than that of the 9 × 12 cm negatives, confirming my hypothesis of the use of a roll-film holder on the 9 × 12 cm plate camera.

Then there is the question of the lens. The Zeiss Tessar triplet lens on the Cupido 80 and on many of these cameras was an excellent lens, but it had a limited field of view. In other words, it was not used for wide-angle lenses, because the coverage did not improve as you stopped the lens down to a smaller aperture.

The lenses that did this were known variously as double anastigmat or rapid rectilinear and were double lenses FIG. 114. A feature of this kind of lens is that each half of the lens can be used separately, to create a narrower field of view; what we would call a telephoto effect. There is one piece of evidence that indicates that Jeanneret's camera had a double rather than triplet lens. In one case, Jeanneret appears to have taken two views of the same scene from exactly the same position, one on glass plate and the other on packfilm negative. The surprising thing is that the second picture has a narrower angle of view (as if "zoomed in").

Note that the two images are taken from exactly the same position and the negatives are approximately the same size. Pack film negatives provide an image measuring ca. 8.3 × 11.7 cm. It is conceivable that the detailed

FIG. 103 **View of the Sultan Selim mosque, Edirne, 9 × 12 cm glass plate, June 1911** BV LC-108-197 → p. 99

FIG. 104 **Detailed view of the Sultan Selim mosque, Edirne, taken on 9 × 12 cm pack-film negative, June 1911** BV LC-108-393 → p. 98

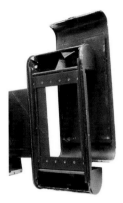

FIG. 105 **Ernemann roll-film holder**

FIG. 106 **Ernemann Heag IV, 1908**

FIG. 107 **Huttig Ideal camera, 1908**

FIG. 108 **Voigtländer Alpin, 9 × 12 cm camera, 1907–28**

FIG. 109 **Voigtländer Avus fitted with roll-film back**

FIG. 110 **Cover of Ernemann Liste Nr. 91 catalog (before 1907)**

FIGS. 111–12 **Two pages from the Ernemann catalog no. 91, showing Heag II and Heag IV cameras**

FIG. 113 **Ernemann pack-film holder**

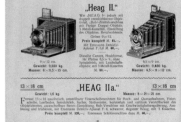

FIG. 114 **Double anastigmat Dagor lens (Goerz),**
1892

view is a rephotograph of the wider one, but Jeanneret would have had to do that in a laboratory or at home, and there is no other example of a pack-film negative being used apart from this brief period in the summer of 1911. Alternatively, Jeanneret could have unscrewed one part of a double anastigmat lens. Such a lens was the Collinear f6.8 120 mm lens fitted to the Voigtländer Alpin FIG. 108. Other double anastigmat lenses were the Carl Zeiss Amatar, the ICA Maxima, and the first to adopt this principle, the Goerz Dagor (1892).[156]

Summarizing the evidence, if we discount the ICA Cupido 80, we would be looking for a camera designed to take glass plates, pack-film sheets, as well as 6 × 9 cm negatives in a roll-fim holder. It would be capable of using both rising and cross fronts and preferably be oriented horizontally. It would be logical for the camera to be equipped with a wide-angle lens, such as a 120 mm double anastigmat, with a wide field of view that could be exploited by the rising and cross fronts. A double anastigmat lens would meet these conditions and also provide the option of a telephoto effect by removing the rear part of the lens. A number of such cameras, made in Germany, were available in 1911 FIGS. 105–13. It is of course also possible that the camera was made in France or Switzerland. Another mysterious clue—dating from late March or April 1911, the moment that Jeanneret bought his plate camera—is a journal entry that reads: "Anastygmat F.7.4 G Verres Roussel."[157] H. Roussel was a French lens maker based in Paris, so this note probably refers to a camera fitted with an f7.4 double anastigmat lens. European camera shops often evaded part of the import duty on foreign models by fitting locally made lenses and shutters to imported camera bodies.[158] Jeanneret could have come across a German or American camera fitted with a French lens and shutter. Richard Hüttig AG had developed a line of Lloyd and Ideal cameras that all had cross-front as well as rising-front lens movements and came in horizontal as well as vertical formats, and these were marketed

156 C. B. Neblette, F. W. Brehm, and E. L. Priest, *Elementary photography for club and home use* (New York: Macmillan, 1936), 52.

157 Jeanneret, "Carnet III," in G. Gresleri, *Le Corbusier (Ch. Ed, Jeanneret) Les voyages dAllemagne, Carnets,* vol. 5 (Milan: Electa/Paris: Fondation Le Corbusier, 1994), 117.

158 E. S. Lothrop, *A century of cameras from the collection of the International Museum of Photography at George Eastman House* (New York: Morgan & Morgan, 1982), 102.

FIG. 115–16 **Jeanneret, houses in the Beyazit and Ak Serail district, Istanbul, August 23, 1911** BV LC-108-361, BV LC-108-367 →p. 134

FIG. 117 **Le Corbusier, Citrohan I, 1920** FLC 20709

by ICA in 1911, along with their Maximar. Other firms, such as Voigtländer and Ernemann, also made horizontal as well as vertical cameras and most had rising fronts in both directions. Heinrich Ernemann Werke AG and ICA were deadly rivals in Dresden—both companies had factories located on Schandauer Strasse—and were engaged in a price war between 1908 and 1911.[159] One consequence of this was that Ernemann concentrated on exporting its cameras, advertising widely in French, English, Swedish, Spanish, and Italian magazines.[160] Dresden could rightly proclaim itself the center of the German photographic industry. It was in Dresden that an International Photographic Exhibition was held in 1909.

In Dresden, the most inventive manufacturer of cameras was not Hüttig AG but the Heinrich Ernemann Werke AG. From 1903 on, the firm produced a series of models under the name Heag. All of these cameras had cross-front as well as rising-front camera movements. They could all be supplied with triplet or double anastigmat lenses. They were available in vertical and horizontal configurations and could be fitted with roll-film and pack-film backs, as well as plate holders for glass plates. The cameras are difficult to date since the models evolved from year to year. The Ernemann "Liste Nr. 91" catalog, with its *Jugendstil* cover designed by Professor Hans Unger, was printed between 1903 and 1907 FIGS. 110–12.[161] The horizontal-format Heag II would have met Jeanneret's needs very well, given his penchant for taking predominantly horizontal pictures. It was offered with an Aplanat f6.8 lens. Ernemann also developed a series of roll-film backs designed for the Heag cameras.

Voigtländer & Sohn, based in Braunschweig, Germany, had been pioneers in the manufacture of portable plate cameras. The Alpin range featured lightweight metal bodies painted black and had a horizontal orientation. It offered a wide range of shutters and lenses, but was normally sold with a double anastigmat Collinear 120 mm f6.3 lens in a Compound or

159 R. Hüttig & Sohn, Wünsche AG, Dr. Krügener, and Carl Zeiss were all absorbed into the ICA conglomerate in 1908, in Dresden.
160 P. Göllner, *Ernemann Cameras: die Geschichte des Dresdener Photo-Kino-Werks: mit einem Katalog der wichtigsten Produkte* (Hückelhoven: Wittig, 1995), 77.
161 The Jugendstil "goddess of light" logo on the cover was designed by the well-known Dresden graphic artist Professor Hans Unger in 1903. Catalog 101 is dated 1907 (ibid., p. 91).

Koilos shutter. In the *British Journal Photographic Almanac* in 1910, the camera sold for £11.10 shillings in England, complete with six single metal dark slides (around $58 in the USA and 300 Swiss francs), while the Voigtländer catalog for 1907 listed the camera with the f6.3 Collinear 120 mm lens and Compound shutter for 200 reichsmarks.[162] In 1912, a slightly later model (Version 2 1908–28) was advertised at 230 reichsmarks.[163]

The roll-film holder pictured in FIG. 105 is actually a slightly later model, but it is substantially the same as the one available in 1911. The Ernemann roll-film holder was designed with the films on the lens side of the negative, thus allowing for a more logical film transport path. The dark slide opened on the long side of the negative. Although this particular roll-film holder took 8.5 × 10.5 cm negatives, others were available to take 6 × 9 cm negatives.

It will be seen that in the case of Voigtländer Avus, the roll-film holder positions the films on the side away from the lens, creating a film path that is not as good. All these cameras also accepted pack-film holders.

Without being able to prove it, but on the basis of the style and content of the photographs and the evidence of the very different quality of the photographs that I believe were taken by August Klipstein, I have decided that Jeanneret probably took the "felt strip" negatives. Without being able to explain the coincidence of these negatives with Klipstein's presence alongside Jeanneret, however, I have to accept the remote possibility that Klipstein had two cameras and took the "felt strip" photographs as well as the other photographs identified by him or his wife. It remains unclear why Jeanneret would have remained in possession of the negatives if Klipstein had taken them.

Assuming that I am right, I deduce that Jeanneret used his plate camera with a 6 × 9 cm roll-film holder to take handheld photographs more freely than with the glass plates. He would have appreciated the number of pic-

162 *British Journal Photographic Almanac*, advertisements, 1910, pp. 1068–69. In the 1906 *BJPA*, the price was given as £9.
163 Newspaper advertisement on the web (advertisement scanned by H.R. Spennemann, Heritagefeatures).

FIG. 118 **Klipstein, photograph of Jeanneret standing next to one of the fallen columns of the Parthenon, on the Acropolis, 6×9 cm "felt strip" negative** BV LC-108-175 → p. 136

FIG. 119 **Jeanneret, photograph of Klipstein standing next to the capital of a fallen column on the Acropolis, 6×9 cm "felt strip" negative** BV LC-108-413 → p. 136

tures that could be taken without reloading and would have used the narrower field of view to photograph people and vernacular architecture wherever there was no need for a wide-angle view. An example was the scene in Istanbul after the great fire that devastated parts of Istanbul and much of Pera on August 22, 1911. Jeanneret set off to view the scene and took a full roll of twelve 6×9 cm negatives of the still smoking ruins FIGS. 115–17.

It seems that Jeanneret's curious eye was being led in different directions here. In part, there is a spontaneous reaction to the tragedy of destruction, filtered through a taste for picturesque massing. But there is also the realization that, stripped of surface decoration, some of the modest working-class housing in the area took on monumental forms. This was a point he also made about the Roman ruins, where the brick structures were left magnificently exposed after the marble decoration had long since been salvaged. In his book *Une Maison – Un Palais* (1928), he illustrated FIG. 115 with a caption suggesting that these ruined modest structures had become monumental as a result of the fire. It is not exaggerated to find in the stepped form of the house in FIG. 116 the premonition of his reinforced concrete housing unit Citrohan (1920; FIG. 117). These photographs demonstrate the lessons Jeanneret had learned after three months of taking high-quality photographs. Despite being handheld snaps, the images are carefully and dramatically composed. The "felt strip" 6×9 cm photographs, taken in sunshine, are of excellent quality. There is no evidence that Klipstein accompanied him on this visit of the ruins, which Jeanneret describes in detail in one of his essays for *La Feuille d'Avis*.

In two Romantic images, Jeanneret and Klipstein posed for pictures on the Acropolis. It is impossible to say what role the two friends had in the composition and mise-en-scène of these images—both taken with Jeanneret's camera—but the spiritual message is close to the metaphysical speculation of Ernest Renan's *Prière sur l'Acropole*, which Jeanneret had

with him and which seems to have conditioned his response to the site.[164] Klipstein's response to the Acropolis is interesting. In his journal, he declares himself ill and exhausted, having lost weight—he thought he must weigh less than ninety-four pounds—and eager to get back home.

> *21.9.1911 Seen very little of Athens in general, apart from the Acropolis, which has left a deep impression on me, and has given me an understanding of Greek architecture, which is coming under such frequent attack these days and being dismissed as tasteless. Proportions! Ran my hands over the columns lying on the ground. Jean [=Jeanneret]: there he saw beauty. I dragged myself up to the Acropolis every day … [he then makes a comparison with Roman architecture] … By contrast, the impression left by the Acropolis was a powerful one.*[165]

Jeanneret's descriptions are even more ecstatic:

A more prosaic view of Jeanneret on the Acropolis exists, on one of the brown prints that I associate with Klipstein's photographs FIG. 120. Lacking an understanding of available lighting or of the principles of photographic composition, this photograph is much less effective than those taken or planned by Jeanneret.

164 E. Renan, H. Bellery-Desfontaines, and E. Froment, *Prière sur l'Acropole compositions de H. Bellery-Desfontaines gravées par Eugène Froment* (Paris: E. Pelletan, 1899).
165 August Klipstein, journal, pp. 30–31 (Bibliothèque de la Ville, La Chaux-de-Fonds).

FIG. 120 **Klipstein, Jeanneret on the Acropolis, September 1911** FLC L4-19-67

The "Felt Strip" Negatives

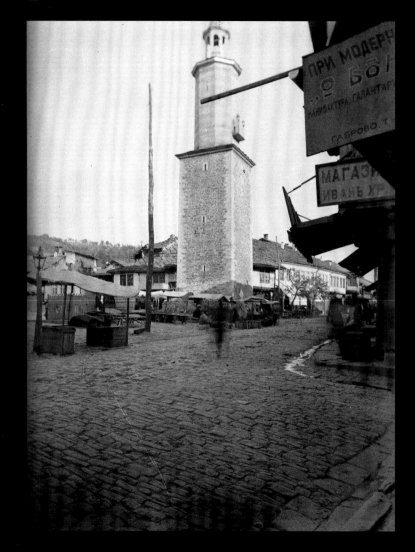

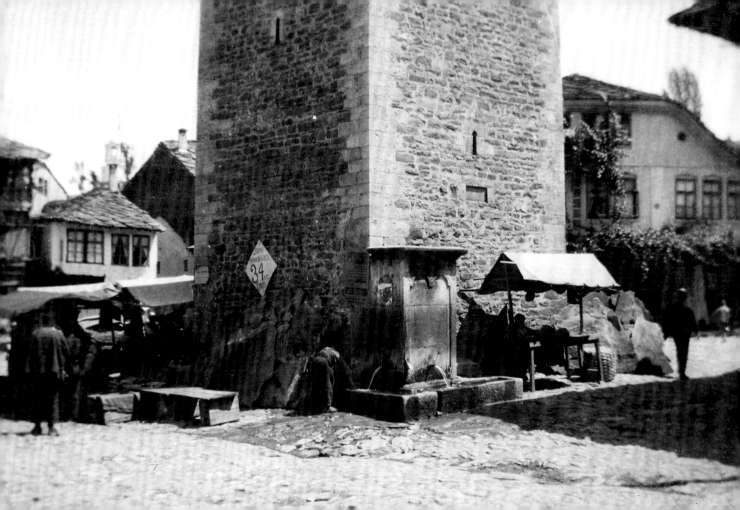

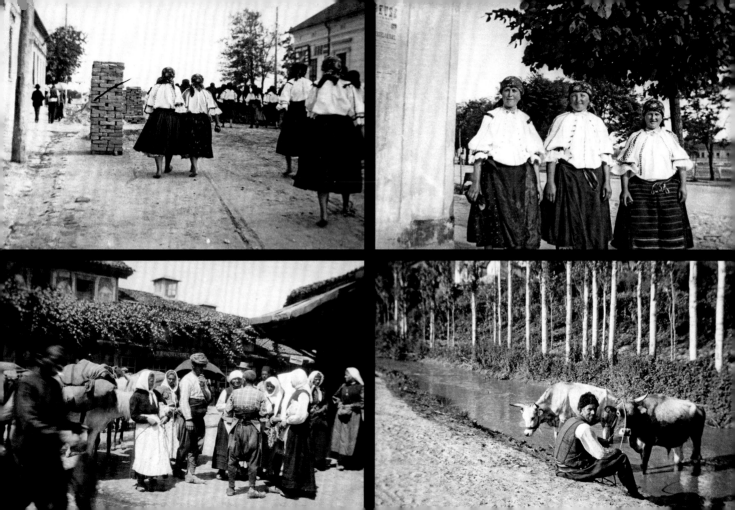

A Cheap Alternative

On his arrival in Naples around October 6, 1911, Jeanneret bought himself a Brownie. We know this because he made a note on his page of accounts: "In Naples, I bought a Brownie Kodak and from then on worked only with films."[166] In the letter, he said more specifically: "In Italy, I worked with Brownie 6 × 9 cm negatives only (around 120 pictures). I will send you prints of these as well, since they are excellent views of Pompeii, Rome, Pisa, etc."[167] In fact, around ninety negatives or prints have survived of the remainder of the trip, mostly from Pompeii and Rome, and a further 120 pictures between 1911 and 1917. They have a quite different quality to the "felt strip" negatives discussed earlier. They were almost all taken handheld and probably with a wide aperture and relatively fast shutter speed.

Jeanneret did not hesitate to tilt the camera to get in parts of the buildings that interested him. The camera was not equipped with a rising front, and would not have had a ground glass screen. It is possible that Jeanneret bought himself a box Brownie, but it is much more likely that what he bought was a folding Brownie.

The No. 2 Folding Brownie, manufactured between 1904 and 1907, with its wooden lens board, was replaced by the No. 2 Folding Pocket Brownie, with a metal lens board. This sold for $5 in the USA and 174,000 were manufactured. The lens was a meniscus achromatic, which meant that it could be used only at a small aperture (around f12). According to the model, the camera had three or four apertures. Preset focusing points at eight, twenty, and 100-foot intervals allowed for some adjustment of focus. The horizontal No. 2 Folding Brownie would have suited Jeanneret's approach to composition: 83 percent of the 210 pictures taken with this camera were in the horizontal orientation. Composition of the picture was in a small daylight viewer, which could be turned round when the camera was in its vertical orientation.

FIG. 121 **Jeanneret, Guglia (column) of San Gennaro, Naples, October 1911, 6 × 9 cm negative with Kodak Brownie**
BV LC-108-487 → p. 152

FIG. 122 **Jeanneret, St. Peter's Basilica, Rome**
BV LC-108-441 → p. 151

166 Page of accounts, attached to letter of December 18, 1911 (E2(6)144).
167 Letter to Klipstein, December 18, 1911 (E2(6)137).

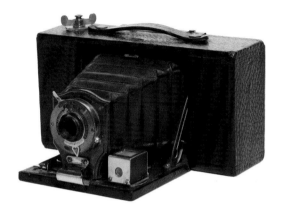

FIG.123 **Kodak No. 2 Folding Brownie advertisement, 1910**

FIG.124 **No. 2 Folding Brownie**

FIG.125 **Jeanneret, Les Saars, Neuchâtel (left) and Valanque (right), April 1916** FLC L4-19-176

FIG. 126 **Jeanneret, apse of Santa Maria Maggiore, Rome, October 1911** BV LC-108-466

FIG. 127 **View of Pompeii, October 1911** BV LC-108-436

Unlike the "felt strip" negatives, the Brownie produced distinctive little bursts of light at the corners and often spilled light along the top or bottom edges of the negative. The negatives in FIG. 125 have not been cut, showing this distinctive streak of light in an extreme form.

In other cases, the little blip can be seen more discreetly bottom right in FIG. 126, along with a little nick at top left. Although not as distinctive as the "felt strip" characteristics, these features can be recognized in the ninety 6 × 9 cm negatives taken in Italy and 120 other photographs taken with this camera up to 1919.

There is a distinct change of approach in Jeanneret's photographs in Italy that cannot merely be explained in technical terms. None of the photographs in Italy seem to have been taken on a tripod and there is a definite loosening of discipline in the composition of the photographs. Jeanneret himself was dissatisfied with his photographs in Italy, apparently on technical grounds: "My pictures in Italy with the Brownie were not very good. They are a little pale."[168] By "a little pale," he was referring to the negatives, and indeed some of the pictures are underexposed, producing thin negatives and dark prints FIG. 127.

But most of the photographs were poor because hurriedly taken. To understand this change of approach, we have to look at what else Jeanneret was doing during the voyage d'orient. His main two activities were drawing and writing. Many of his drawings of the vernacular houses he saw in the Balkans are comparable to his photographs, in that they are perspective sketches (and some plans) primarily intended as aide-mémoire. When he began inspecting the mosques of Istanbul and Bursa, however, his attention shifted from photography to drawing. For example, we have seen two of the photographs of the Sultan Selim mosque in Edirne FIGS. 103–04, well-composed views of the exterior. He took similar views of a few mosques in Istanbul and one or two views of the mosque cloisters, but no interiors. His

168 Letter to Klipstein, February 1, 1912 (E2(6)145).

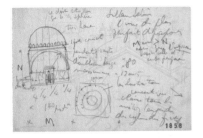

FIG. 128 **Jeanneret, sketches of the Sultan Selim mosque** FLC 1858

FIG. 129 **Jeanneret, sketch of Hagia Sophia** Carnet p. 78

FIG. 130 **Klipstein, sketch of Hagia Sophia** FLC 1941

descriptions, in an essay entitled "Les Mosquées," are all about the interiors, the sense of space, the effect of the candelabras, and so on. He made many sketches of details that interested him and several analytical plans and elevations in an effort to understand the building.

Inscribing his sheet "Sultan Selim; one with the most perfect proportions," he draws a section, at left, on which he speculated about the proportions while on the right he sketched the great candelabra of concentric circles suspended low over the heads of the faithful. Similarly, whereas his photographs of Hagia Sophia concentrated on certain features of the building, his sketches analyze the overall form of the building, seen from a bird's-eye perspective or in greatly simplified and rationalized views of the exterior. His note refers to the standardized windows, which create an effect of monumentality. By comparison, a sketch inscribed by Jeanneret "St. Sophie according to Klip" is Klipstein's more picturesque, but accurate view. Klipstein is trying to make a record while Jeanneret is trying to understand how the massing works and, in so doing, greatly simplifies the forms.

This is not the place to analyze the ways in which Jeanneret tried to learn from his experience of the voyage d'orient. From the point of view of the photography, however, we can make some clear distinctions. From his discovery of the vernacular architecture of the Balkans, Jeanneret as photographer became increasingly interested in finding a way to capture a sense of place. He took fewer 9 × 12 cm glass plates and pack films to concentrate on his 6 × 9 cm negatives. Some of the best of his photographs in Istanbul are of views without a particular building or object of interest as subject. These photographs succeed as compositions of light, shade, and texture, and an astute placing of objects and people to create a sense of distance.

By comparison, the photographs in Italy revert, in the main, to a note-taking quality. During two days of intense study in Pompeii, for example, Jeanneret took over twenty-five photographs of the ruins and dozens

169 C. Sitte and C. T. Stewart, *The Art of Building Cities: City Building According to its Artistic Fundamentals* (New York: Reinhold Publishing Corporation, 1945), 1.

of sketches. Most of his sketches were plans, often including measurements, or perspectives that went beyond the surviving ruins to reconstruct the original or even improve it. For instance, his photograph of the house of Sallustus is a hurriedly taken snap of the end of the courtyard. In his sketches, he analyzes the plan and includes a couple of sketches, including one showing a view similar to the photograph, marked up with some dimensions and an explanation of the effect of entering the house and the sense of scale. It is clear that at this level of analysis, the photograph is a relatively poor kind of document. Jeanneret was losing interest in photography as his architectural curiosity grew more technical.

Another example, characteristic of what architects were supposed to do when inspecting antique ruins, was Jeanneret's picturesque reconstruction of the columns of the Temple of Jupiter at Pompeii. He was no doubt directed to this spot by the ringing words of Camillo Sitte on the opening page of his Introduction:

> *If, after a day of patient investigation [in the ruins of Pompeii], he walks across the bare forum, he will be drawn, in spite of himself, to the summit of the monumental staircase toward the terrace of Jupiter's temple. On this platform, which dominates the entire place, he will sense, rising within him, waves of harmony like the pure, full tones of sublime music.*[169]

FIG. 131 **Jeanneret, photograph of the house of Sallustus, Pompeii, October 1911, Kodak Brownie** BV LC-108-453

FIG. 132 **Jeanneret, sketch plans and perspectives of the house of Sallustus, Kodak Brownie** FLC 5887

A photograph records the situation in 1911, with parts of the cella of the temple in the foreground and the colonnade of the forum behind FIG. 133. In a sketch in his notebook and a larger watercolor worked up afterward FIG. 134, Jeanneret reconstructed the portico of the temple, through which he sees the forum and the hills beyond. A later inscription on this drawing explains, "Pompeii, October 1911. The silhouetted columns have been 'added' to explain the space." In other words, not only are the nonexistent columns

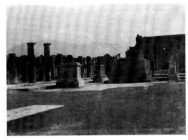

FIG.133 **Jeanneret, view of the forum from the portico of the Temple of Jupiter** BV LC-108-471

FIG.134 **Jeanneret, watercolor of the forum seen through the portico of the Temple of Jupiter, Pompeii, 23.5 × 32 cm** FLC 2859

reconstructed, but the foreground is tidied up to exaggerate the sense of space. This drawing calls attention to something else that Jeanneret was doing, especially as the trip drew to its close. It was one of a series of watercolors exhibited in La Chaux-de-Fonds, then in Neuchâtel and Paris, under the title "Le langage des Pierres" (The Language of Stone). As the trip continued, Jeanneret needed to produce an exhibitable or publishable output. He clearly decided that his photographs would not meet the bill. The voyage d'orient can be seen as a progressive disenchantment with photography, passing from a serious attempt to take professional architectural photographs for publication, through an engaged and creative use of the medium to analyze buildings and places, and on to a rapid, casual, and erratic form of picture-taking in Rome.

Another product was the series of essays that he was beginning to work up, based on notes in his journal, for publication in *La Feuille d'Avis* in La Chaux-de-Fonds. These were, in other words, part of the artistic "product," in drawings and in words that Jeanneret could show as resulting from his trip. It is significant that Jeanneret published very few of his own photographs in the period immediately after his trip—possibly because he was not satisfied with them, but more likely because his interests moved on quickly. The beautiful glass plates of buildings in Germany and Prague might have featured in his book *La Construction des Villes*, had it ever been published.

Of all the photos Jeanneret took between 1907 and November 1911, few were published. Apart from the other examples discussed here, a photograph of one of the sculptures from the Parthenon pediment in the Acropolis Museum (BV LC-108-0403) was published in his book *Almanach de l'architecture moderne* (1925, p. 65), along with a photograph of a vernacular house in the Ile de France (L4(20)200, p. 116). Twenty-four years later, he published several of his photographs from the voyage d'orient in his book *La Ville Radieuse*: the Cathedral and Baptistery, Pisa (BV LC-108-0479),

FIG. 135 **Le Corbusier, *Urbanisme*, 1925**

the Colosseum, Rome (L4(19)139), the Parthenon, Athens (L4(19)93), a view of the apse of St. Peter's, Rome (L4(19)142), and a different view of the Hundred Steps, Versailles (all on p. 139), as well as a farmhouse near Toulouse (the same house as L4(20)25, p. 322) and a view of a cemetery in Turkey (BV LC-108-167, p. 155).

One of his photographs to which he ascribed great significance was the view of the cupola of the Pantheon in Rome, taken with his folding Brownie in October 1911.

This remarkable photograph was used as a chapter heading in his article "Le sentiment déborde," later incorporated into his book *Urbanisme* FIG. 135 →p. 149.[170] He reused this image in his lectures, alongside images of the other works that he considered of outstanding value—the Parthenon, Michelangelo's vestibule in the library of San Lorenzo—and another photograph he took, probably in 1916, of the staircase of the Hundred Steps flanking the Orangery, Versailles FIG. 136.

Jeanneret was not the only photographer to be struck by the Hundred Steps at Versailles. The American Edward Steichen took an extremely romantic view of it in 1908, now in the collection of the National Gallery of Canada, in Ottawa. His picture, however, entitled "Nocturne," emphasizes the mysterious mass of masonry from the side, rather than exaggerating the monumentality, as in Jeanneret's photograph. A print of the Hundred Steps flanking the Orangery exists in the Fondation Le Corbusier FIG. 137, but no negative or contact print. It is impossible to say whether Jeanneret took this photo, but it may be one of a number of photographs he took of Versailles in December 1912 and again in 1916. The proportions of the image, however, do not correspond to a 6 × 9 cm negative. Jeanneret published a similar photograph in his book *Une Maison – Un Palais*, 1929, where it represents French rationalism by way of contrast with the chaos of American architecture FIG. 136.

170 *Esprit Nouveau* 19 (December 1923).

FIG.136 **Le Corbusier, *Une Maison – Un Palais*, 1929, p. 17**

FIG. 137 **Jeanneret, view of the Hundred Steps flanking the Orangery, Versailles, December 1912 or 1916** FLC L4-20-182

FIG.138 **Jeanneret, view of Versailles, December 1912 or 1916, Kodak Brownie** FLC L4-19-51

FIG.139 **Jeanneret, view of Versailles, December 1912 or 1916, Kodak Brownie** FLC L4-19-514

FIG.140 **Jeanneret view of Versailles, December 1912 or 1916, Kodak Brownie** FLC L4-19-59

Jeanneret had resisted visiting Versailles for many months in 1909, when he was working for Auguste Perret. He eventually took his parents there and was fascinated by the monumentality of the palace and its grounds. In January 1913, he told William Ritter that he had visited Versailles, which he had seen as a microcosm of Paris and which had greatly impressed him. After praising some of the garden statues, he went on:

> *An hour later you come face to face with the cliff of the Orangery staircase, where those infinite deployments of stone and metal orders cry out. I tell you, I was in the presence of divinity, dancing and crying out like an oracle.*[171]

This extraordinary text illustrates an extraordinary photo. Flights of stairs were something of a theme during the voyage d'orient and I think we can interpret them as an attempt to capture the monumental effect of the great works of architecture of the past without reproducing the details of the classical orders. This hypothesis can be supported by the dozen other photographs he seems to have taken on this occasion FIGS. 138–40. We can also interpret these images as a progressive departure from the conventional pictures that compare the expanse of the facade with close-up details of sculptures or fountains.

These photographs, clearly taken in winter with the Kodak Brownie (after October 1911), may precede the view of the Hundred Steps, possibly dating from 1916, when Jeanneret again visited Versailles. They demonstrate an almost perverse refusal to show the details of the architecture, and can be compared with photographs taken in Rome in October 1911, of the Baths of Caracalla, and several other photographs of steps. They contrast with the view of an urn taken with his first camera in December 1908 FIG. 24.

171 Letter to William Ritter, January 14–16, 1913 (FLC R3(18)243). Jeanneret apparently spent ten days in Paris and Versailles after December 3.

Apart from the photographs of the house for his parents on the rue de Montagne overlooking La Chaux-de-Fonds and the Villa Favre-Jacot, Jeanneret continued to take photographs until the end of the First World War. His subjects were Swiss vernacular and Baroque architecture, a sequence of views of Nancy, and miscellaneous views of his family in various locations. They were mostly taken with his Kodak Brownie. From 1919 on, however, Jeanneret apparently stopped taking photographs, although he some-times referred to taking pictures in his letters.

Jeanneret's Third Camera: the "Brownie Kodak"

Jeanneret: Photographer

Adequately understanding a photograph, whether it is taken by a Corsican peasant, a petit-bourgeois from Bologna. or a Parisian professional, means not only recovering the meanings which it proclaims, that is, to a certain extent, the explicit intentions of the photographer; it also means deciphering the surplus of meaning which it betrays by being part of the symbolism of an age, a class, or an artistic group.[172]

172 P. Bourdieu, *Photography, a middle-brow art* (Stanford, CA: Stanford University Press, 1990), 6–7.

Jeanneret invested a very varying degree of attention to his photographs, but their interest is not in direct proportion to the effort he put in. Some of the plate photographs, especially in the first month after he acquired his plate camera, required considerable concentration and effort. Many of the resulting photographs, while excellent in technical terms, have little to say in terms of Jeanneret's developing interest in architecture. Others, technically quite poor, are redolent with meaning.

FIG. 141 is taken at dawn or dusk. Jeanneret is trying to incorporate something of the view of the landscape from the Acropolis, while endeavoring to capture the mood of the great ruins in the falling light. We know, from Jeanneret's letters, how moved he was by the experience of spending whole days on the Acropolis in the presence of these ancient stones, but the photographs do not necessarily communicate this level of intense feeling. FIG.141, taken inside the portico of the Parthenon, is almost exactly the same view as the one by the professional Swiss photographer Fred Boissonas that Le Corbusier later published in *l'Esprit Nouveau* FIG. 142, but Boissonas's photograph uses the shadows to model the columns in dramatic fashion.[173] This was the key article in the series that was later published as *Vers une Architecture* (1923), in which Le Corbusier claims that the essential values of architecture are all contained in the Greek Parthenon.

FIG.141 **Jeanneret, Parthenon, glass plate**
FLC L419165 → p.136

FIG.142 **Fred Boissonas, views of the Parthenon, published by Le Corbusier in his article "Architecture, pure création de l'esprit," *Esprit Nouveau* 16, May 1922**

FIG. 143 **Colored postcard of Eyoub cemetery, outside Istanbul** LoC 06066

FIG. 144 **Colored postcard of Eyoub cemetery, outside Istanbul** LoC 06065

Jeanneret's photographs from the trips to Germany and the voyage d'orient are more interesting for what they tell us about Jeanneret's vision and the future Le Corbusier's approach to architecture. For a start, they reveal what Jeanneret did not photograph. He rarely photographed "important buildings," of the kind listed in guidebooks. In Florence, he ignored the work of Brunelleschi and Alberti almost completely and in Venice, the work of Palladio. In Istanbul, he photographed some famous buildings but, as we have seen, often from peculiar angles. There are no photographs of Bursa, which Jeanneret and Klipstein visited and which Jeanneret drew in detail. If Jeanneret photographed any interiors, they have not survived, and yet it was the architectural interior to which he dedicated many of his drawings. Only one or two badly underexposed pictures survive of church interiors, but there may have been others thrown away as useless.[174] A whole book could be composed of the photographs that Jeanneret did not take.

But if Jeanneret felt himself under no compunction to photograph the most famous buildings, he went out of his way to focus on particular interests. We have already noted the impressive series of views of vernacular buildings taken during the Balkan stage of the journey. Another obsessive interest was in cemeteries. Under the influence of William Ritter, Jeanneret and Klipstein had sought out Christian and Islamic cemeteries in the Balkans, carefully photographing them on 9 × 12 cm glass plates.

The 9 × 12 cm glass plate of the decorated cross →p. 88 is a conventionally picturesque view. But it was the other photograph that Jeanneret published twenty-four years later in his book *La Ville Radieuse* →p. 89 bottom left. Carefully composed, also on a 9 × 12 cm glass plate, it is a very strange photograph mixing simplicity, a natural order, and a sense of nostalgia. Another photograph—this time on a 9 × 12 cm pack-film negative, is of a Turkish tomb, leaning at an angle that is offset by two cypress trees →p. 89 right. It was later published as the frontispiece to an article entitled "Mustapha-Kemal will

173 M. Collignon, *Le Parthénon l'histoire, l'architecture et la sculpture* (Paris: Hachette, 1914).
174 An example is a tilted view of the interior of San Paolo fuori le mura, which is almost completely black (BV LC-108-467).

FIG. 145 **Jeanneret, Orangery, Potsdam, first camera, June or October 1910** BV LC-108-335

FIG. 146 **Jeanneret, view up the facade of Gesù Nuovo, Naples, October 1911** BV LC-108-489 →p. 152

FIG. 147 **Jeanneret, view of the steps, Piazza San Pietro, Rome, October 1911** BV LC-108-506 →p. 150

have his monument," in which he also published his photograph of the minaret and tomb of "Uc Serefeli Camii" FIG. 1 →p. 96.[175] His photographs of the Jewish cemetery are similarly austere →p. 89 top left.

The Istanbul cemeteries featured in the tourist guides as romantic places, where the magnificent site and picturesque abandon suited Victorian sentimental taste FIGS. 143–44. Jeanneret's photographs are rather different. It is curious that he took such care to photograph these tombs, usually on 9 × 12 cm glass plates or pack film. It is unlikely that he thought that he could use them in his book *La Construction des Villes*. It seems that he was extremely moved by these half-abandoned and desolate places and made no attempt to make them appear picturesque. This is an aspect of Jeanneret's visual imagination that will become more important later. In a real sense, these tombstones are "objects for poetic stimulation" (objets à réaction poétique), mysterious forms that become lodged in the artist's imagination in the same way as would the seashells, bones, and bits of driftwood he collected in later years.

Surveying all these early photographs, one is struck by the fact that Jeanneret experimented little with unusual or dramatic angles. There are exceptions.

In FIG. 145, Jeanneret has pointed the camera at the reflection of the Orangery in Potsdam in one of the pools. There are also some strange shots showing reflections on wet flagstones in Pisa.[176] In Naples, he was fascinated by the diamond-studded facade of the Gesù Nuovo church and took several pictures of it, including the one in FIG. 146 looking diagonally up the facade. He also took a surprising view of the steps of St. Peter's in Rome, with the sea of steps almost obscuring Maderno's facade and Bernini's arcade FIG. 147. This is another example, comparable to his views of Versailles, of Jeanneret trying to capture the monumentality of the place without capturing the detail of the classical orders. There are several such photographs

175 Published in *L'Esprit Nouveau* 25, July 1924, n.p.
176 BV LC-108-481 and BV LC-108-482.

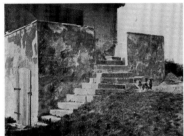

of steps and stairs, some of them almost abstract FIG. 148. In this, Jeanneret may well have been influenced by Schultze-Naumburg, whose *Kulturarbeiten* volumes show a great interest in how buildings are rooted to their site and integrated into roads or streets. Schultze-Naumburg included sequences of photographs of flights of steps, differences of level, and many kinds of detail, including doors, windows, and gates. In FIG. 149, he has captured a particularly successful arrangement of steps leading down to the street on one side and a grassy bank on the other.

Jeanneret's photographer's eye was, in a manner of speaking, usually conventional at this point, although his selection of subjects was highly distinctive.

FIG. 148 **Jeanneret, steps leading up to the Villa Medici, Rome, October 1911** BV LC-108-506

FIG. 149 **Paul Schultze-Naumburg,** *Kulturarbeiten*, vol. 1, p. 78, ill. 57

Return to Italy, 1921

On July 30, 1921, Le Corbusier, in his new persona, wrote to his friend William Ritter:

In a fortnight, I'm leaving for Rome to breathe in, in the summer heat, the air of those great stones, and to see the Sistine Chapel.[177]

Since moving to Paris late in 1917, Jeanneret had had a whirlwind experience. Through his connection with Auguste Perret, he had met the painter, journalist, and fashion house director Amédée Ozenfant, who had opened new horizons to him as a painter. Together they had founded the Purist art movement, staged two exhibitions, and launched a luxurious art journal, *L'Esprit Nouveau*. It was as author to a series of articles for their review that Jeanneret chose the pseudonym Le Corbusier, which he increasingly adopted as his new persona.[178] The three years had also seen the collapse of business ventures in which he had squandered the capital invested by his friend Max du Bois and several close friends, including his father.[179] Throughout 1920, 1921, and 1922, Le Corbusier was writing twenty to thirty letters per day in pursuit of his business activities, but by 1921, the business was in a terminal slide toward bankruptcy. On July 19, Le Corbusier accepted gratefully a loan of 7,500 francs from his friend Ozenfant, and around August 15 they set off together to Rome, accompanied by Ozenfant's business partner and lover, Germaine Bongard. They both needed rest and recuperation, but it seems that the vacation did not go well. Ozenfant complained of a "disagreeable" attitude on Le Corbusier's part, and the latter admitted himself that he had become introverted and asocial.[180] Nevertheless, the trip was important in the development of their ideas, as we shall see.

177 Letter to Ritter (FLC R3(19)385).

178 As he said to Ritter in a letter of March 1921, "Le Corbusier, nouvelle incarnation, semble donner: brillantes perspectives, art libre autant que possible." FC R3(19)389.

179 See T. Benton, "From Jeanneret to Le Corbusier: rusting iron, bricks and coal and the modern Utopia," *Massilia* 2 (2003): 28–39.

180 Ozenfant wrote a letter on the headed paper of their hotel in Rome, in which he accused Le Corbusier of being extremely grumpy and unpleasant.

There is a set of photographs in the Fondation Le Corbusier, including thirty-nine taken in Italy in August 1921, which pose a number of problems. None of the negatives have survived, and there are no copies in the libraries in La Chaux-de-Fonds or the Canadian Centre for Architecture. The prints have the white borders characteristic of enlargements rather than contact prints, and they have been professionally printed, so it is impossible to tell the exact dimensions of the negatives. But many of them have an unusual proportion (closer to 5:8 than the 2:3 of the 6 × 9 cm negatives or the 3:4 of the 9 × 12 cm glass plates). I will refer to them as the "oblong" photographs. Assuming that the prints reproduced the negatives in correct proportion, this excludes any of Le Corbusier's three known cameras. The optical quality of the photographs is variable, but the camera does seem to have been fitted with a rising front, operating in the vertical direction only. Another photograph, both in the Charlotte Perriand archive and in the Canadian Centre for Architecture, shows Le Corbusier, Ozenfant, and a woman who may be Germaine Bongard. The negative is square and may belong to a camera owned by Bongard.[181] Since both Ozenfant and Le Corbusier are shown in this and other photographs, it prompts the question as to whether Pierre Jeanneret might have accompanied them on the trip. Although the partnership between Le Corbusier and his younger cousin Pierre Jeanneret had not yet begun, Le Corbusier had found him an apartment at 95 rue de Seine and they were in touch over rent.[182] Pierre had also played a role in the creation of the *Esprit Nouveau* magazine in 1920, designing the covers. Another photograph in the Charlotte Perriand archive (which includes a number of Pierre Jeanneret photographs) also shows both Le Corbusier and Ozenfant in the picture FIG. 150. Intriguingly, there is a photograph, similar in proportion and quality to this one, of Pierre Jeanneret standing by a railing on the roof of St. Peter's, overlooking Bernini's colonnade.[183] It is quite possible, therefore, that Pierre Jeanneret took all the photographs in this set

FIG. 150 **Pierre Jeanneret (attrib.), Le Corbusier and Amédée Ozenfant in Rome, July 1921**
Charlotte Perriand Archive

181 The photographs in the CCA collection, which have not yet been cataloged, came from the collection of Pierre Jeanneret's niece, Jacqueline.
182 See Le Corbusier's attempt to extract rent from Pierre, September 2, 1921 (FLC U2(9)365).
183 This is among the uncataloged photographs donated to the CCA, Montreal by Jacqueline Jeanneret, Pierre's niece.

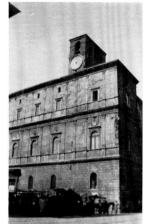

FIG. 151 **Pierre Jeanneret (attrib.), Santa Trinità dei Monti, from the Spanish Steps, Rome, July 1921** FLC L4-19-136

FIG. 152 **Pierre Jeanneret (attrib.), Palazzo Farnese, Rome, July 1921** FLC L4-20-34

FIG. 153 **Pierre Jeanneret (attrib.), Palazzo della Cancelleria, Rome, July 1921** FLC L4-19-140

FIG. 154 **Pierre Jeanneret (attrib.), Sant'Ivo alla Sapienza, Rome, July 1921** FLC L4-20-45

FIG. 155 **Pierre Jeanneret (attrib.), Via Giulia, Rome, July 1921** FLC L4-20-64

FIG. 156 **Pierre Jeanneret (attrib.), Le Corbusier standing on the cupola of St. Peter's, Rome** FLC L4-19-124

FIG. 157 **Pierre Jeanneret (attrib.), St. Peter's, Rome** FLC L4-19-129

FIG. 158 **Pierre Jeanneret (attrib.), view of the roof of St. Peter's, with Ozenfant** FLC L4-19-134

FIG. 159 **Pierre Jeanneret (attrib.), view of the apse from the roof of St. Peter's, Rome** FLC L4-20-40

FIG. 160 **Le Corbusier-Saugnier, "La leçon de Rome,"** *L'Esprit Nouveau* **14, January 1922**

FIG. 161 **Pierre Jeanneret (attrib.), vernacular houses in Italy, August 1921** FLC L4-20-6

FIG. 162 **Pierre Jeanneret (attrib.), view of holiday home identified by Le Corbusier as Esbly, 1933** Charlotte Perriand Archive

of "oblong" pictures FIGS. 151–59. There is no mention, however, of Pierre Jeanneret in the correspondence between Ozenfant and Le Corbusier.

The subject matter of the photographs might support the hypothesis that Pierre took them. They have a broader cultural range than Le Corbusier's interests and are typical of what an architect might want to photograph on a first visit to Rome. Many of them are shot in the vertical orientation, unlike Jeanneret's preference for horizontal pictures. There are pictures of Renaissance and Baroque buildings, such as the Palazzo della Cancelleria, the Palazzo Farnese, Sant'Ivo alla Sapienza, the Via Giulia, and a large sequence of images of St. Peter's.

Whereas Le Corbusier had shown scant interest in St. Peter's in 1911, this had become a central obsession by 1921. He and Ozenfant obtained the keys to visit the roof and cupola of the Basilica and a number of photographs record this expedition.

Le Corbusier's enthusiastic conversion to the grandeur of Michelangelo's architecture was reflected in an article he wrote for *L'Esprit Nouveau* on his return to Paris. Published in the January 1922 issue of the magazine was an article by Le Corbusier-Saugnier (the pseudonym for articles cowritten by Le Corbusier and Ozenfant) entitled "The Lesson of Rome" and another on Michelangelo's *Last Judgment* in the Sistine Chapel signed De Fayet, which was one of Ozenfant's noms de plume. Whereas Jeanneret had gone out of his way, during the voyage d'orient, to exclude the details of the classical orders and focus instead on massing, Le Corbusier now wrote with great clarity and purpose on what he called "modénature"—the articulation of moldings with which Michelangelo captured the light and enlivened the mass of his wall surfaces. Le Corbusier used professional photographs to illustrate these details FIG. 160.

In addition to the photographs that can be identified from this trip to Rome and Florence, there are a number of other prints with the same

"oblong" proportions and printed by the same laboratory. They include a set of photographs of vernacular houses FIG. 161. These may have been taken on the same trip as the visit to Rome, or on another occasion. There is also a group of photographs of a monumental bridge and aqueduct and steps up to a terrace and some views of farmhouses near Toulouse. We would have to postulate a camera taking 116 film (2½ × 4¼ inches), A130 film (2⅞ × 4⅞ inches), or equivalent. There is a photograph, copies of which exist both at the Canadian Centre for Architecture and in the Charlotte Perriand archive, that shows Pierre Jeanneret holding a roll-film camera FIG. 166. The picture dates from around 1928. It is possible that this is the camera used to take the photographs in Rome.

Among the prints with this unusual format are some that look as if they were taken in France. FIG. 163 is of a farmhouse, and another one was inscribed "Ile de France" on the back by Le Corbusier. Circumstantial evidence that these photographs might have been taken by Le Corbusier or Pierre Jeanneret derives from the fact that another one was illustrated in *Almanach de l'architecture moderne*, p. 116. A photograph of the same farmhouse as the one shown in FIG. 163 was illustrated in his book *La Ville Radieuse* (1935) and identified as a farmhouse near Toulouse. Some other prints with the oblong format showing Le Corbusier and his wife, Yvonne, are in the Charlottte Perriand archive, which would support the suggestion that they were taken by Pierre.

Unfortunately, we know very little about the trip in August 1921. The diary for that year has gone missing and no letters sent home during the trip have survived. We do not know whether Le Corbusier and Ozenfant traveled to Rome by train or by car. He was not yet in possession of his splendid Voisin automobile, with which he undertook long journeys from 1926. It is possible that Ozenfant drove them in his car, since he was a fanatical car fan. This might account for the pictures of vernacular architecture in France and Italy. But otherwise it would have made more sense to travel by train,

FIG. 164 **Pierre Jeanneret, Le Corbusier on board the SS Patris, CIAM Congress, 1933**
Charlotte Perriand Archive

FIG. 165 **Pierre Jeanneret (attrib.), construction site, late 1920s or early 1930s** FLC L4-20-71

returning via Châbles, Switzerland, where he and Ozenfant stayed with his parents in their rented chalet around September 3. Although these photographs are rather sterile, compared with Jeanneret's pictures of vernacular houses in the Balkans, they respond well to his new interest in pure geometric forms. Many modern architects in the 1920s, and especially in Italy, looked to vernacular architecture to defend the undecorated purity of the modern movement buildings.[184] We also find among this set of "oblong" photographs some themes dear to Le Corbusier, such as staircases.

If Le Corbusier did take these photographs, they represent a style of photography rather different from what we have seen so far. There is less attention to formal pattern-making, especially in the photographs of Rome and Florence, and more of a documentary approach to showing a building or architectural feature. It is possible that Pierre took them in Le Corbusier's presence. Until some new evidence appears to suggest where and how these photographs were taken, we will have to leave their attribution in suspense. I find it impossible to judge who took these pictures. A reasonable solution might be to suggest that the "oblong" pictures were taken by Pierre, but that the pictures in the proportions of the 6 × 9 cm negatives might have been taken by Le Corbusier using his Kodak Brownie.

Pierre Jeanneret later used a 6 × 6 cm camera, and there are some photographs of this type from 1933 of the holiday shacks at Esbly, where Le Corbusier and Yvonne spent some time on vacation. Le Corbusier made a couple of sketches of these wood-and-tar-paper shacks and wrote an enthusiastic piece about them in *La Ville Radieuse* (p. 29) under the headings "Renversement d'usages séculaires" and "Le Logis minimum." A photograph of Le Corbusier in North Africa was probably taken by Pierre during the epic car journey they undertook in 1931, through Spain and Morocco to Algeria and the valley of the M'zab. There are also 6 × 6 cm photographs of Yvonne, Le Corbusier, and members of her family (proba-

184 For an extended discussion of this theme, see M. Sabatino, *Pride in modesty: modernist architecture and the vernacular tradition in Italy* (Toronto: University of Toronto Press, 2010), and my review in *Harvard Design Magazine*, December 2010.

FIG. 166 **Charlotte Perriand, Le Corbusier,
Pierre Jeanneret, and Jean Fouquet,
in Perriand's apartment on Place Saint Sulpice,
1928** Charlotte Perriand Archive

bly on the occasion of their wedding in 1930), Le Corbusier and friends in Jean Badovici's houses in Vézelay, early 1930s (also published in *La Ville Radieuse*), and Le Corbusier and Pierre fooling about on board one of the cruises in the Aegean during the CIAM Congress in 1933 FIG. 164. Pierre Jeanneret went on to become a highly competent photographer, whose views of India in the 1950s are worth careful study.[185]

Many of the photos from the 1920s and 1930s, taken with different cameras and printed in various ways, must also remain in suspense. Some may have been taken by Pierre Jeanneret. There is, for example, a set showing the construction of a modern group of buildings, perhaps from Czechoslovakia or Germany, that look as if they date from the late 1920s or early 1930s. These might even have been taken with Le Corbusier's plate camera, or similar device, since they are technically very good.

The most reasonable explanation is that from 1920 on, Le Corbusier was simply too busy to take photographs. While there is no evidence that he took a camera on any of his many travels in the 1920s and 1930s, there is one photograph he might have taken in Venice in August 1922, but it seems strange that there are no other photographs from this trip.[186] He never photographed his own buildings. Daniel Naegele claims, in his thesis, that Pierre Jeanneret frequently took photographs of their buildings in construction, but I have found nothing to support this. The photographs of the 1920s' villas under construction were all commissioned from professional photographers. The truth is that Le Corbusier had too keen an eye for the quality of professional photographs of his own buildings to attempt to take the pictures himself. I believe that he used the experience he had acquired in 1911 when he tried to take good-quality photographs, to sharpen his eye. There is now an extensive literature on how Le Corbusier directed the professional photographers who illustrated his work in articles and books.

185 A large collection of Pierre Jeanneret's photographs in India are now in the CCA collection and are being cataloged under the supervision of Maristella Casciato.
186 FLC L4-19-158. This view of the Palazzo Ducale from the piazzetta is not a professional photograph, but it does not share the proportions of the "oblong" set. It may have been taken with Le Corbusier's plate camera.

Le Corbusier, the Cinema, and Cinematographic Photography 1936–38

FIG. 167 **Can of film containing the 18 rolls of Le Corbusier's 16 mm film shoots mounted on one spool**

FIG. 168 **Box originally containing a 50-foot roll of 16 mm film, with Le Corbusier's notes identifying Algiers, the villa at Roquebrune (E1027), and the Pavillon des Temps Nouveaux, January–April 1938**

FIG. 169 **Box originally containing a 50-foot roll of 16 mm film, with Le Corbusier's notes, identified as "Zeppelin," "favella," and "Hotel Gloria," July 1936**

In the summer of 1936, Le Corbusier obtained a small 16 mm film camera equipped with a stop-frame feature that enabled the user to take individual (still) photographs as well as moving images. There is no direct mention of the purchase of this movie camera, either in his private diaries or correspondence. On July 31, 1936, when Le Corbusier had already left for Brazil on the *Graf Zeppelin*, his secretary wrote him several pieces of information, including: "Cinéma" properly insured—for 6 months—114 francs paid by Mr. P.J."[187] "Cinéma" was the word Le Corbusier used to refer to movie cameras, and I interpret this statement as indicating that Pierre Jeanneret had taken out insurance on the movie camera for six months at the significant price of 114 francs. This suggests to me that, at the very least, this was the first time Le Corbusier had traveled with the camera, or that it was soon after he had acquired it. From July 1936 until the end of 1938, he took eighteen (or probably nineteen) fifty-foot rolls of film (fifteen meters each). On these he captured 120 short sequences of film and around 5,930 still photographs. Fourteen of the Kodak boxes that originally contained these rolls of film have survived and are in the Fondation Le Corbusier. They contain some identifications and dates in Le Corbusier's handwriting. On the basis of this information, and a knowledge of Le Corbusier's movements in this period, it is possible to establish a hypothetical sequence of events.

The original black-and-white reversal 16 mm film itself survives on a single spool of film and is conserved in the Fondation Le Corbusier in Paris. This is because the filmmaker Jacques Barsac mounted the eighteen rolls together, to facilitate the editing of a series of films he made about Le Corbusier in 1987, the centenary of the architect's birth. This long roll of film was subsequently scanned at low resolution onto a DVD, and extracts of the films have been included in various exhibitions in the last ten years.[188] The film tin containing the combined rolls is marked up with the legend "Numbers 1 to 18" but it is likely that there was a nineteenth roll and that it was

187 FLC F2(17)308.
188 A higher-resolution scan was later made during the preparation of the exhibition *Le Corbusier et la photographie*, Musée des Beaux-Arts La Chaux-de-Fonds, La Chaux-de-Fonds, 2012.

FIG. 170 **Le Corbusier, photographs taken with his Siemens B movie camera (summer 1938), cut up, printed, and collaged on a mock-up of the images printed in *Des Canons, des munitions*, pp. 18–21**

FIG. 171 **Box of a 50-foot roll of film, "Sept 1936; Le Lac, maman coiffée…"**

cut up in 1938 when Le Corbusier had some frames showing the construction of the Pavillon des Temps Nouveaux printed up for inclusion in *Des Canons, des munitions? Merci! Des logis … s.v.p.* A mock-up shows some of these frames FIG. 170, but a different version was used in the book. A short segment of this roll survives (roll 17), but most of it seems to have been lost, either by the publisher or the laboratory that made the prints.

Barsac had made no effort to follow the chronological sequence indicated on the boxes, so the first task was to try to separate the film sequences into their original rolls and restore a chronological sequence. Since it was not permissible to do this by spooling through the film on an editing machine, it was necessary to do this in software. I logged the entire roll on a spreadsheet →p. 410 APPENDIX 2 and made some hypothetical divisions into the nineteen rolls. It is to be hoped that I will eventually be permitted to inspect the rolls and identify the physical splices of the film.

It is helpful to follow briefly the sequence of shots—film and still photographs—because it helps to explain why Le Corbusier selected moving film or still images to record different things. My argument will be that although Le Corbusier experimented with a number of photographic styles that he had absorbed from avant-garde photography, he also invented some strategies that combine a filmic and a graphic approach to the medium.

The first date on the boxes reads "Summer 1936." It is on a box of Kodak film that Le Corbusier annotated as follows:

Nungesser et Coli [Le Corbusier's apartment]; painting; summer 1936; T100 painting with rope (with tripod); athletics Jean-Bouin Stadium; three bones film; Corbu on the vault and grass, lantern.[189]

This whole roll, as well as the next three, consist almost entirely of moving images of his apartment, his wife, Yvonne—a reluctant subject— →pp. 198–99

189 See Appendix 2 →p. 410 for the transcriptions of all the boxes.

his dog, Pinceau II, his roof garden—including a sequence of himself walking on the parapet—views from the apartment down onto the Jean-Bouin Stadium and several sequences of his own paintings, including some as still photographs. The mention of "Painting, rope, T100, film" refers to two sequences of film shot of his painting *Femme couchée, cordage et bateau à la porte verte* (1935) and T100 indicates its size. The "Trois os" (three bones) refers to a sequence of film in which Le Corbusier circles around three sawn butcher's bones, part of his "collection particulier" of organic found objects FIGS. 245–47. All these sequences seem to have been taken in summer light. So far, this is the classic repertoire of the proud owner of a new movie camera. Roll 5 begins at Recife, Brazil, in July 1936, where he films the *Graf Zeppelin* airship, in which he had traveled from Germany, and a Baroque church in the town. Le Corbusier had been invited to give a lecture tour in Rio de Janeiro and to advise on the design of two important projects, the Ministry of Education and Health and a proposed new university. In rolls 6 and 7, we find filmed shots in Rio, of what Le Corbusier called the Santa Teresa favela, the island Paqueta—a pleasure haunt for the *cariocas*—and a number of filmed sequences taken on the boat as it crossed the bay. We also begin to find more still photographs, of people and places on Paqueta, and then of Rio, as he visited various sites for his architectural project for the University of Rio, in the company of the Brazilian architect Lucio Costa. Some of these photographs dramatically reflect Le Corbusier's excitement in response to the exotic vegetation, dazzling light effects, and beautiful people →pp. 215–35.

Then, on the Italian ocean liner *SS Conte Biancamano*, between August 14 and 27, 1936, he took 744 photographs of mechanical elements on the ship (roll 7).[190] This has all the appearance of a lexical study of mechanical form, using the freedom provided by the hundreds of frames available to him to explore patterns of similarity and difference in sequences of images

190 Some of these photographs, misdated and misattributed, were published in Le Corbusier, S. v. Moos, A. Rüegg, A. v. Vegesack, Nederlands Architectuurinstituut, Vitra Design Museum, Metropolitan Cathedral of Christ the King, Barbican Art Gallery. and Royal Institute of British Architects, *Le Corbusier: the art of architecture* (Weil am Rhein: Vitra Design Museum, 2007), 288–89.

of the same or similar objects →pp. 247–87. This amounts to a crash course in the grammar of the "New Photography," to which we will return.

Arriving in the port of Villefranche, Nice's harbor, Le Corbusier was met by Yvonne and Pierre Jeanneret, who had driven down from Paris, as well as by Jean Badovici and his then partner, Madeleine Goinot. They spent three days in Villefranche (August 27–29).[191] There, still on roll 7, he takes a sequence of photographs of the *USS Quincy*, a brand new American heavy cruiser currently in Europe on her first operational mission. The *Quincy* had been sent to aid in the evacuation of refugees from the Spanish Civil War and had just delivered 490 refugees from Barcelona to Marseilles and Villefranche.[192] In and around the harbor, Le Corbusier experimented with the dramatic composition and angles of the "New Photography" →pp. 291–305. On roll 8, he took several photographs of his own paintings in his apartment studio, followed by sequences at Le Lac. There are some short sequences of film, but mostly still photographs. It is not clear whether this roll was taken before or after his lecture tour to Brazil in July or even after his holiday in Le Piquey in September. I have not found a record of Le Corbusier visiting his mother's house just before his trip to Brazil. There is another film (roll 11) that begins in Le Piquey and ends with Le Lac, at the end of September and the beginning of October. He certainly visited his mother after his holiday in Le Piquey. Roll 9 consists only of still photographs and was shot in Le Piquey on the west shore of the Bassin d'Arcachon, near Bordeaux, where Le Corbusier had his holiday, with Yvonne, Badovici, and Madeleine Goinot between the beginning of September and October 1 →pp. 317–35. In his undated letter to his mother, he describes his itinerary from August 27 as "Three days at Villefranche, two days in Paris, then 'Voisin' [Le Corbusier's car] here. Badovici here, too. Homeric swims, for example Chanteclerc to the dune du Figuier beyond Petit Piquey and as far as Jaquey. No plans for the present. I am here. I know

191 See the letter to his mother, undated (FLC R2(01)228).
192 Launched on June 15, 1935, she was commissioned in Boston on June 9, 1936.

nothing. I need to take stock a bit. In a fortnight I'll be ready to do some work."[193] On October 2, a Friday, he says they drove back from Le Piquey on Monday (September 28).[194] Roll 10, still in Le Piquey, includes some filmed sequences of the ocean and of horse riding on the beach. The eleventh roll begins in Le Piquey but continues at his apartment, where he took photographs, from above, of mounted police trying to control some public unrest. The end of the roll was shot at his mother's house, Le Lac (Vevey) at the beginning of October. In a letter to his mother on October 2, having just returned from Le Piquey, he announces, "I'm waiting for important news from Rio in order to plan my work and then I'll jump on a train to say hello to my little mother," and later in the same letter, "You can expect to see me, I hope, in the coming week."[195] A box labeled "Sept 1936" mentions his mother's house, Le Lac: "mother with her hair down," "riots at the Parc des Princes [sports stadium]," and "Albert on the roof." This roll probably spanned the end of September and the beginning of October. Immediately, he reverts from photography to film, taking a number of sequences of his mother and her house, and especially the views of Lake Geneva from inside and outside her house →pp. 191, 196–97.

Between October 30 and November 4, 1936, Le Corbusier visited Badovici in one of the houses that the latter had purchased and converted at Vézelay (roll 13). He filmed Fernand Léger's recently completed fresco on an external wall of one of the houses and sets up a filmed sequence in which Badovici and one of his friends walk out onto a terrace and look out over Vézelay. This sequence of three shots is a rare example of Le Corbusier trying to create an edited sequence in camera. Most of his filmed shots have no obvious connection with each other. He also took a number of still photographs of trees and branches in the park in Vézelay →pp. 342–43. There follows a visit to Norbert Bézard in his hometown of Piacé in the Sarthe department. Le Corbusier referred to Bézard as "the peasant," but he was

193 FLC R2(1)228.
194 FLC R2(1)229.
195 FLC R2(1)229.

an extremely articulate and imaginative man who wrote articles for *Plans* and later abandoned the farming life to practice ceramics in Paris. Le Corbusier helped him out with commissions for his ceramics. The photographs show Bézard and others in a forest and in his house, where Le Corbusier paid particular attention to Norbert's elderly mother.

Over Christmas 1936 he was back in his mother's house, and roll 14 includes film and photographs of the house under snow. At the beginning of 1937, Le Corbusier had a kind of breakdown in his physical health, suffering from acute neuralgia, which kept him in hospital for over a month. For recuperation afterward, he offered himself a long vacation in Brittany, in July 1937. Roll 15 begins at Le Lac, proceeds with shots of a gravel works in Burgundy, and then concentrates on Plougrescant, Brittany →pp. 353–69. In roll 16, he took a few panoramic sequences of film, but concentrated on several hundred photographic studies of the rocks around Le Gouffre, near Plougrescant, as well as an excursion to Mont Saint-Michel. Roll 17 is the short remnant that remains of the film showing the Pavillon des Temps Nouveaux in the late summer of 1973. Roll 18 begins with shots of the demolition of the Pavillon des Temps Nouveaux in January 1938 and continues with hundreds of photographs taken during a trip to Algiers and the M'zab Valley in April →pp. 375–85. On the same roll are images recording his stay in May 1938 at E1027, the house designed and built for Badovici by Eileen Gray →pp. 390–401. He took several pictures of the house, its garden, and the interiors, with their spectacular Eileen Gray furniture. He also took the opportunity to photograph the two wall paintings he executed at the same time, taking as many as 127 photographs of one of them.

This is a record of a considerable investment of time, effort, and imagination, and what is remarkable is that, with the exception of a dozen or so frames, he never had any prints made of all these photographs. This is the exception that proves the rule, since the only known prints made from

these images, published in *Des Canons, des munitions? Merci! Des logis ... s.v.p.*, are from a roll of film that was cut up and partially lost (roll 17). Around seventy frames survive in a strip showing the Pavillon des Temps Nouveaux being demolished in January 1938. The published photographs show the building in construction in the summer of 1937 and prior to demoliton in January 1938.[196] In fact, he probably never even saw his own photographs. 16 mm frames are very small and tiresome to look at with a magnifying glass. I think we must imagine this work as an act of visualization: conceiving, composing, and clicking. What is extraordinary is that, despite the simple viewfinder of a small cine camera, many of the photographs are very carefully composed. And, I would argue, they reflect a significant investment in conceptualization. Nor is there any firm evidence of him trying to edit or even project the film sequences he shot. If he owned a 16 mm film projector, it has been lost. The strongest evidence that he had a means of projecting 16 mm film comes from the fact that he owned a short comic film of two golfers FIG.172. This may have been a product of one of the lending libraries of short films, such as the Club Pathé Baby, which was very active in France but which circulated films in the 9.7 mm format. This amusing example of high burlesque from the silent film era may have been closer to Yvonne's taste than her husband's. It suggests, however, that the couple did watch rented or bought films on either their own film projector or

196 Le Corbusier and A. Maurois, *Des Canons, des munitions? Merci! Des logis ... S. V. P. Monographie du "Pavillon des temps nouveaux" à l'Exposition internationale "Art et technique" de Paris 1937* (Paris: L'Architecture d'Aujourd'hui, 1938), 18–21.

FIG.172 **Stills from a comic film owned by Le Corbusier**

someone else's. I have found no mention of this in the copious correspondence and anecdotal evidence collected by Le Corbusier's biographers.

Strangely, Le Corbusier did own a film projector—the Cine Gel—but this was a postwar model designed for the 9.5 mm format of film. It was manufactured in France in the 1950s for the 9.5 single-sprocket film, a popular format in that country. It could not have projected the double-sprocketed 16 mm film shot by Le Corbusier between 1936 and 1938. There is no trace of any film camera or footage taken for projection on this piece of equipment.

Le Corbusier's generation was fascinated by film, of course. Charlie Chaplin and other comic actors and directors had a high reputation in artistic circles for their ability to communicate to a popular audience using the new technology. Le Corbusier's recorded interest in film, however, had more to do with documentary film and what he called "l'esprit de vérité."[197] He, of all people, knew how photographs could distort and "improve" reality, by the choice of perspective and lighting, by touching up prints, and by painting out undesirable elements on the negative. Film seemed to him to be an innocent medium, representing things as they really were, warts and all. Despite having met several film directors, including Sergei Eisenstein in Moscow, Le Corbusier shows little sign of having reflected on the principles of film montage. His filmed sequences are really like animated panoramas.

The Camera

We will return to the photographs and some of the meanings we can extract from them. But first we must ask the basic question: "What kind of film camera did Le Corbusier acquire and what was it capable of doing?" In approaching this question, there is a nice ready-made answer. When choosing a revolutionary piece of equipment, capable of taking moving pictures

197 See Le Corbusier, "Esprit de vérité," *Mouvement, Cinématographie, littérature, musique, publicité* 1 (1931): 10,11. This was also the title of a chapter in his book *L'Art décoratif d'aujourd'hui* (Paris: Crès, 1925),167.

FIG. 173 **ICA Kinamo 35 mm film camera, designed by Emanuel Goldberg, advertisement in** *Amateur Movie Makers*, **December 1926**

FIG. 174 **ICA Kinamo 16 mm spring-wound camera**

and still photographs, with a good lens and extremely small dimensions, the European artist would opt for the ICA Kinamo.[198]

A ZEISS advertisement in the American journal *Amateur Movie Makers* (December 1926) promoted the Kinamo FIG. 173 as follows:

> *The Ica Kinamo has made thousands of feet of Pathé News Reels. The Navy filmed the Shenandoah's transcontinental flight with it. The Roosevelt brothers took the Kinamo to Thibet [sic]. Roy Chapman Andrews had five of them on his trip into the Gobi desert on his successful search for Dinosaur eggs.*[199]

The Kinamo began as a hand-cranked camera, but had recently been issued as an "Automatic"—that is to say, spring-operated—model. The 16 mm version of this camera was even smaller and less obtrusive FIG. 174. It was greeted in the British photographic press with enthusiasm:

> *The Zeiss Ikon firm have just introduced an entirely new model in their range of cine cameras, the "Kinamo S10," an instrument with automatic drive, which is designed to meet the wants of the amateur who uses 16 mm film. They have succeeded in making a gem of a camera. Extraordinarily compact and dainty—4½" high by 3½" broad and only 2¾" thick—it weighs only a shade over a lb. Its makers claim it to be the smallest cine camera with a clockwork motor yet made. And I can well believe it.... The "Kinamo S10" has a particularly good finder, unusually serviceable for a hand camera.*[200]

The Kinamo was originally designed in 1924 by the brilliant Russian engineer Emanuel Goldberg. His laboratory was absorbed into the Internationale Camera Aktiengesellschaft company in Dresden—the same firm that had bought up Richard Hüttig's company and the Cupido plate camera. Goldberg was put in charge of movie camera production for ICA, which was then

198 For the background to the design and diffusion of the Kinamo movie camera, see Michael Buckland, *Emanuel Goldberg and his Knowledge Machine* (Westport: Libraries Unlimited, 2006).
199 *Amateur Movie Makers*, December 1926.
200 "In the Shop Window," *Amateur Photographer* 533 (December 12, 1928).

FIG.175 **Bell & Howell Filmo 16 mm movie camera**

FIG.176 **Pathé Motocamera**

united with four other companies to create Zeiss Ikon in 1926. The camera was one of the first to incorporate a watchmaker's spring to enable some twenty-five seconds of film to run at a steady pace before rewinding. At almost the same time, Bell and Howell brought out their own spring-operated camera, the Filmo FIG.175, which dominated the American market, along with the various Kodak models, until the arrival of sound-on-film models around 1935. Pathé marketed a camera closely modeled on the Kinamo.

The Kinamo was conceived as a good-quality, robust, and lightweight documentarist's tool, something that ethnographers, journalists, and biologists could use in remote areas. A version adapted for use on a microscope was also available. The combination of still photographs and moving images was ideal for this. Goldberg was also a bit of an impresario and to help promote the camera, he made a number of films, involving members of his family as stars and some well-worked-out comic plots.

The radical Dutch filmmaker Joris Ivens was so enthused by what he heard about the Kinamo that he looked up Goldberg and went to work in his department at the Zeiss company constructing the machines on the factory floor. He later made a number of films in Holland and Belgium, using this camera. Ivens quickly established a reputation as a revolutionary documentary filmmaker, whose films, such as *Misère au Borinage*, exploited the small size of the camera to enable highly realistic sequences among the miners.[201] In 1933, Goldberg was kidnapped by the Nazis in Germany but was released and found exile in Paris before emigrating to Palestine in 1937. So Le Corbusier might even have met him when he was thinking of acquiring a cine camera. This is even more likely given that Pierre Chenal—who had worked closely with Le Corbusier, making the three films about his architecture between 1929 and 1931—was a great admirer of the Kinamo. Chenal's film *L'architecture d'aujourd'hui* was commissioned by the newly founded journal of the same name in Paris and introduced the public to the

201 Other documentary films by Ivens include *De Brug*, *Zuiderzee* (1930) and *Philips Radio* (1931).

202 See A. Redivo, *Bâtir L'Architecture d'Aujourd'hui; construire l'achitettura moderna 1930. Il contribuito di due film di Pierre Chenal* (Venice: Istituto Universitario di Architettura di Venezia, 2001).
203 Manuscript of an article intended for the journal *Prélude*, founded in 1932 by Le Corbusier, Dr. Pierre Winter, François de Pierrefeu, and Herbert Lagardelle (FLC E1(11)253).
204 *La Ville Radieuse*, p. 135.
205 FLC F3(6)3, p. 13 recto. Just previosuly, he had made a note to ring Chenal, perhaps on the same subject, on February 28, 1936 (FLCF3(6)2).

architecture of Auguste Perret and Le Corbusier (Pessac, Villa Stein, Villa Church, Villa Savoye, and the Plan Voisin). In *Bâtir*, Chenal contrasted the way that a steel-and-concrete building skeleton was later covered with a decorated stone skin with the modern work of Auguste Perret, Rob Mallet-Stevens, and Le Corbusier and Pierre Jeanneret.[202] From 1930 on, Le Corbusier invariably projected Chenal's film *L'architecture d'aujourd'hui* at the end of his lectures, for example during his lecture tour in the USA in 1935. He appeared in the film, as did his Voisin car, and most scholars agree that Le Corbusier had a hand in envisioning several of the sequences. He held Chenal in high esteem and wrote an admiring piece about him, which was not, in the end, published:

Quick, intelligent, analytical, and lyrical, with a remarkable sense of timing, he manages to capture the essence of modernity with his whirring camera…. Whereas the filmmaker can easily handle passionate human dramas, amorous intrigues, and detective stories, it is not so easy to set something before the public based only on what the camera can see within the four walls of a building. You need a unique talent to succeed without lapsing into an unbearable photographic cliché.[203]

Chenal shot these films with a Kinamo movie camera. The value that Le Corbusier placed on Chenal's film can be attested by the fact that he had several single frames printed and published in *La Ville Radieuse* FIG. 177. On a sheet of paper, Le Corbusier collaged a number of frames from Chenal's film, including the famous view of his hand gesturing over the model of the Plan Voisin of Paris.[204]

In the event, most of these frames—including a view of the Villa Savoye and three views of the Villa Church, not omitting the women exercising on the roof terrace of the Music Pavilion—were not printed in the book. Le Corbusier wrote in his diary, in May 1936: "Tell P. Chenal to film Nun-

FIG. 177 **Le Corbusier, collage of still frames from Pierre Chenal's film *L'architecture d'aujourd'hui*, 1930, marked up for inclusion in *La Ville Radieuse*** FLC B2(11)138

206 Chenal's early feature films include *Fat Man's Worries* (1933), *Street Without a Name* (1934), *Crime and Punishment* (1935), and *Les mutinés de l'Elseneur* (1936), and he was probably already at work on *L'Alibi*, on which he collaborated with Erich von Stroheim and Louis Jouvet.
207 J. Lossau, *Der Film-kamera-Katalog: 16 mm, 9,5 mm, 8 mm, Single-8, Super-8, Doppel-Super-8. The Complete Catalog of Movie Cameras* (Hamburg: Atoll Medien, 2003).

gesser [24 rue Nungesser et Coli] and Vevey [the house of his mother, Le Lac, at Vevey]."[205] And we have seen that, indeed, his own apartment and his mother's house were among the first things Le Corbusier filmed with his camera. We can perhaps imagine Le Corbusier telephoning Chenal to ask his friend to make this film, and Chenal replying: "I'm too busy right now, but you can borrow my Kinamo camera and do it yourself." By 1936, Chenal had long abandoned his marginal existence as a documentary film director and had made several feature-length productions.[206]

It must be said that, by 1936, the ICA Kinamo, now marketed by Zeiss, would have seemed old-fashioned to a real film enthusiast. The film magazines were full of the new invention of "on-film" recorded sound. As the RCA advertisement says, "It's the roar of the whistle that makes the movie live!" FIG. 178. The classified section of *Amateur Movie Makers* in 1935 and 1936 included a number of readers trying to sell their ICA Kinamo cameras and similar mute equipment.

But the nice answers are not always true. I will show that the camera Le Corbusier used was not a Kinamo but a version of the camera incorporating many of the same principles, manufactured by the German electrical equipment manufacturing giant Siemens. The proof comes in two parts. Just as cameras may leave physical traces on all the films shot with them—as we saw in the case of Jeanneret's cameras—movie cameras, too, leave a distinctive fingerprint on the films run through them.

In the case of the stock Le Corbusier filmed, this is extremely unusual. The exposed frame overlaps the sprocket holes more on one side than it does on the other, having an elongated proportion almost equivalent to modern, 16:9 ratio, high-definition digital video. Jürgen Lossau, an expert on these cameras, has published a table indicating the characteristic fingerprints of different cameras.[207] The Kinamo (or at least its successor, the Zeiss Movikon) and the Siemens B are the only cameras to have a finger-

FIG. 178 **RCA sound-on-film camera and projector advertisement,** *Amateur Movie Makers,* **January 1936**

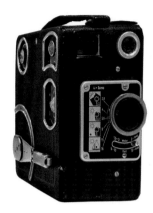

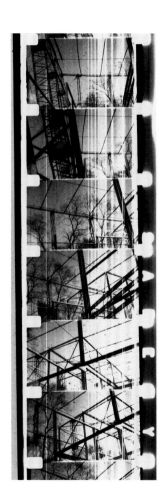

FIG. 179 **Jürgen Lossau, table from**
The Complete Catalog of Film Cameras, **2003**

FIG. 180 **Siemens B 16 mm movie camera
of the kind owned by Le Corbusier**

FIGS. 181–82 **Le Corbusier, self-portrait,
shot with the Siemens B 16 mm movie camera**
FLC Séquence 31873

FIG. 183 **Segment of the dismembered 17th reel
of 16 mm film showing the overlapping of the
image over the sprocket holes**

print that approximates to the film shot by Le Corbusier, and of these two, the closest is the Siemens B FIGS. 179 and 183.

But the clincher is that Le Corbusier took a number of photographs of himself, naked or nearly so, and on one of them the outline of the movie camera can be dimly perceived FIGS. 181–82. Correcting for the mirror image, the reflection clearly shows the small rectangular relief panel on which the lens is mounted, which is completely missing on the Kinamo. It is by reference to this photograph that we can also identify the model of Siemens camera in question FIG. 180. So, let's look at the Siemens B and see what it could do.

Siemens B 16 mm Movie Camera

The Siemens B was produced for the first time in 1933, in Berlin. It was equipped with a Busch Glaukar Anastigmatic f2.8 20 mm lens that had only two focus positions: "near" and "far." The camera weighed 1.45 kilos and measured 70 × 123 × 125 mm. It had four speeds (64, 24, 16, and 8 frames per second) as well as a single-frame "still photo" function.[208] The fifty-foot rolls of film were supplied in a metal cassette that could be removed and replaced in mid-roll. The cassettes remained the property of Siemens and they had to be sent to the laboratory for processing, after which the processed film would be returned on a metal spool. It is possible that Le Corbusier made use of this feature to remove cassettes of film half-used and then reinsert them later. This would help to explain some otherwise puzzling sequences in the chronology of the shots.

The best introduction to the camera is a promotional movie entitled *Gehen, sehen, drehen*.[209]

In this film, an audience of well-dressed men, women, and children are introduced to the Siemens B FIG. 186. The film begins with a few sequences

208 Some models had only three speeds: 64, 16, and 8 frames per second. Le Corbusier's camera shot film at 24 frames per second.
209 The video can be accessed via YouTube.

FIG. 184 **Siemens B 16 mm movie camera**

FIG. 185 **Siemens B 16 mm movie camera, showing the loading bay for the film cassette**

FIG. 186 **Still frames from the Siemens Kino promotional film** *Gehen, sehen, drehen*

of "Stimmung" in the avant-garde mode of 1920s' silent films: locomotive wheels, high divers, women in bathing costumes, and a motorcycle and sidecar combination hurtling round a bend. Then a dapper instructor demonstrates the Siemens B, emphasizing its simplicity. To show how easy it is to load the cassettes of film into the camera, first a woman and then a small child perform the feat. The demonstrator explains the use of the various speeds: 16 frames per second for normal shooting, 64 frames for slow motion, and 8 frames for comic speeded-up effects. Le Corbusier's camera was also provided with a 24-frames-per-second speed. The use of the still-frame feature is explained by showing an animation of wooden toys shot using the stop-frame technique. Finally, everyone pitches in to take a few sequences in the room: the women are filmed reflected in a mirror as they make themselves up while the men perform comic antics. The slogan "Gehen, sehen, drehen" harks back to Julius Caesar's words after one of his victorious campaigns in what is present-day Turkey: *Veni, vidi, vici.*

The film emphasizes that filming with this camera was easier than photography, and there is some truth in this. As we have seen, camera controls had become much more complicated with the introduction of faster lenses and complex shutters, requiring delicate decisions to be made about exposure, focus, and shutter speed. With the Siemens B, focus was simple—near and far—and the shutter speed was normally fixed at around 1/20 second. The lens offered six apertures, from f2.8 to f16.[210] An "explanatory table" defined the use of the different apertures, either in words, or, with some

210 Some models offered only 4 stops.

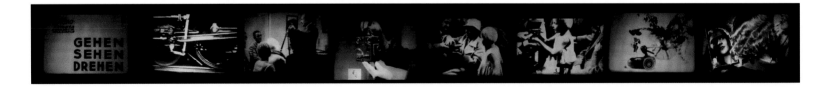

211 At the time, 270 reichsmarks would have been worth 1,785 francs, or around 1,700 euros today.

FIG. 187 **Page 28 from Le Corbusier's diary, for July 1936** FLC F3(6)3, p. 28

FIG. 188 **Le Corbusier, photograph taken with his Siemens B camera of his studio, showing a camera case on the right** FLC Séquence 05775

models, in pictograms (f16 for sunny conditions in snow, f11 for sunny conditions on the beach, f8 for direct sunlight, f5.6 for sunlit street scenes, f4 for open shade, and f2.8 for darker shade).

Shooting film with the Siemens B was fairly straightforward. Wind it up, press the shutter release backward, and let it run. To take still photographs, the shutter release was pushed in the other direction. It was important to set the exposure correctly, because the widest aperture of the lens at f2.8 would result in a seriously overexposed shot in anything like bright sunlight. In fact, Le Corbusier took hundreds of photographs in Algeria in April 1938 that were almost all seriously overexposed. The film stock he used was black-and-white reversal film, which was less tolerant than negative film to over- or underexposure. Similarly, even at the widest aperture, there was a limit to what would come out in dark interiors, and here, too, Le Corbusier made mistakes, not least in the many pictures he took of his paintings in his studio and of himself. There was another possible source of error, since the camera could be set at a faster or slower speed (64 or 8 frames per second) and this enabled still photographs to be taken at around 1/50 or 1/5 second, respectively. Theoretically, the aperture would be automatically changed to match the speed, but this could be overridden.

Le Corbusier made no mention of his movie camera in any of his letters, or even in his personal diary. This is extraordinary, especially if he actually bought the camera, which was listed in the 1935 Siemens catalog at 270 reichsmarks.[211] Although Le Corbusier and Pierre Jeanneret had been very busy between 1929 and 1933, a number of the clients had not yet paid them their fees and Le Corbusier had incurred crippling costs in the building of his apartment in the block of apartments in Boulogne-sur-Seine. His fees for the Centrosoyuz building in Moscow (designed 1928–33) came through only in May 1938. The bailiffs had been in to remove furniture from the Le Corbusier atelier in 1935. Le Corbusier himself lived off

his publications and lecture tours, and it is possible that he thought of the film camera as a means of illustrating his lectures. If this is what he had in mind, he made no attempt to follow it through. With rare exceptions, he did not film or photograph architecture. Although he took a number of film sequences and still photos of proposed sites for his architectural or urban projects in Rio de Janeiro and Algiers, he made no attempt to do the same on other trips, preferring to rely on sketches.

The only traces that can be found of his acquisition are in his diary FIG. 187. Among a series of notes in preparation for his trip to Rio on July 8, 1936, we find a sketch of his suitcase with measurements and a note: "check 'cinéma' and photos." This was on page 28 of the diary. On page 27 recto, he had noted the times of the trains to Frankfurt and the time of departure of the *Graf Zeppelin* on July 8, 1936. As mentioned earlier, "cinéma" was the term Le Corbusier used when referring to movie cameras, and I take this to be a note to himself to check whether the movie camera and the transparencies for his lectures would fit in the suitcase. The weight regulations of the *Graf Zeppelin* airship, on which he was to fly to Brazil from Frankfurt, were strict. The two little sketches in FIG. 187, dimensioned $140 \times 90 \times 200$ mm, correspond to the size of the Kinamo camera case, which can be seen in one of his photographs FIG. 188. The camera case listed for the Siemens B measured $140 \times 90 \times 145$ mm, and Le Corbusier's may have been a bigger model designed to hold one or two spare film cassettes.

The Siemens B Photographs

What is the importance of the Siemens B photographs? They must be considered as virtually purposeless and therefore highly disinterested (one of Le Corbusier's favorite words). Apart from the very few frames cut up and

FIG. 189 **Le Corbusier's snap of Yvonne in their apartment**

FIGS. 190–91 **Le Corbusier, photos of Yvonne on the beach at Plougrescant, Brittany**

printed, they are images with almost no physical locus. Imprisoned inside rolls of 16 mm film that could not be projected (as still images), they are the product of split-second decisions in framing and composition. Movie projectors at this time could not project still images without burning the film. The only way to see these pictures would have been with a professional Moviola (or similar) editing machine, winding the film through by hand. My approach here is to treat this considerable body of work as a kind of visual journal, flickering instances of visual memory. What follows, then, is a series of "albums" organized by place and theme.

The Private Le Corbusier

As I have said, many of the images and film clips shot by Le Corbusier deal with family. Le Corbusier married his great love, Yvonne Gallis, in 1930, and virtually all his paintings of the 1930s revolve around her. But Yvonne—a great beauty in the 1920s—clearly did not like being photographed. Several of his snaps of her show her angrily scowling or turning away.

In 1936, Le Corbusier was approaching his fiftieth birthday, a time when many men and women exhibit a certain sexual nostalgia. Yvonne was passing through the menopause and clearly suffering from Le Corbusier's long absences. Among the candid images of Yvonne, in the apartment or on the beach in Le Piquey, there are few that show her enjoying herself. Yvonne did not like the seaside and normally appears overdressed and uncomfortable in Le Piquey and in Brittany FIG. 190. One sequence, however, on the beach in Le Piquey shows Jean Badovici playing the fool with a seaweed beard and moustache, and Yvonne cavorting with an enameled tin bowl on her head. This is how Le Corbusier explained Yvonne's situation to his mother:

FIG. 192 **Le Corbusier, portrait of his mother, September 1936** →p. 189

FIG. 193 **Le Corbusier, photograph of Norbert Bézard's mother, in Piacé, 1937** FLC Séquence 16377

She is so devoted and scrupulous in her housework. She is overworked (since we often have guests) and she is on her own. Last year, especially, she was on her own for months on end. It's a real trial for her, because Boulogne is a long way from Paris, from everything she likes. It's a cloistered existence, complete solitude from 2:00 to 8:00 p.m. Yvonne has set herself to her task with such a will that she's on her feet from seven in the morning and remains so for hours on end. Her varicose veins have suffered as a result.

Furthermore, she's passing through the change of life, with the depression that comes with it. Nature is mysterious; there are gradual but profound transformations that have psychological effects. We have to understand all that. Men are stronger, and are in possession of all their powers at the age of fifty.[212]

Despite Le Corbusier's devotion to his wife, he had just shared a brief erotic relationship with Mrs. Marguerite Tjader Harris, in New York, with whom he maintained an intimate correspondence throughout his life. In my view, there is an erotic melancholy about many of his paintings and photographs of the mid-thirties. The photographs Le Corbusier took of himself in the mirror, naked or nearly so, add to this picture of midlife crisis →p. 204.

In some of his letters to Marguerite in 1936, Le Corbusier admits that he has let himself slide into an uncharacteristic resignation. Despite his international acclaim, all his projects seemed to hit a barrier of official rejection, the machinations of rival architects, and the jealousies of his critics. But, on the basis of what an "Indian" fortune-teller told him in Rio de Janeiro, he was convinced that his hour would soon come. Whether he really believed this soothsayer or not, these were the years when he began to become increasingly interested in astrology and alchemy.[213]

So, this is a first heading: these photographs offer us a psychological portrait of the architect at a moment of crisis in his career, when his world-

212 Le Corbusier, letter to his mother, December 19, 1936 (REF).
213 R. A. Moore, "Alchemical and mythical themes in the Poem of the Right Angle 1947–1965," *Oppositions* 19/20 (winter/spring, 1980).

wide reputation was countered by a near universal rejection of his ideas by authority, and when his easy relationship with his beloved Yvonne was coming under stress.

Le Corbusier's relationship with his mother, who continued to hold a particularly powerful control over her younger son, provided a firm footing for him in this difficult period. We see her in film and photo, in her house at Vevey, in Le Corbusier's apartment, and at the zoo at Vincennes in Paris →pp. 189–95. Many of these photographs are extremely sensitive character studies. Some of them, such as a picture of his mother with her hair down, are almost painfully private →p. 190. When Le Corbusier visited his friend Norbert Bézard in Piacé in the Sarthe region in 1937, he went out of his way to photograph Norbert's aged mother, clearly another matriarch. It is interesting that Le Corbusier took a number of pictures of the dining table on the porch of the Hotel Chanteclerc, with bottles of wine and pastis and his friends in relaxed conversation. This unbuttoned moment, rarely documented in the workaholic Le Corbusier's existence, helps us to understand how dependent he was on these annual holidays.

Le Corbusier also had a soft spot for animals. A favorite subject was his schnauzer, Pinceau II (Pinceau I had died tragically while Le Corbusier was absent in the USA in 1935). There are many photographs and even some snatches of film of Pinceau II, in the apartment at Nungesser et Coli and on the beach in Le Piquey. Pinceau had a rather wild temperament—Le Corbusier told his mother that he wanted to send him to a training school—and eventually had to be put down for his erratic behavior. But Le Corbusier clearly enjoyed Pinceau's Dionysiac energy and took trouble to record it on film. He also liked to photograph the cats and dogs at the Hotel Chanteclerc and the horses that pulled the carts in Brittany.

FIG. 194 **Le Corbusier, Pinceau II on the beach near Le Piquey, September 1936** →p. 334

Family and Friends

At Home in Paris
On first obtaining his 16 mm movie camera, in June or July 1936, Le Corbusier made a number of film sequences of his apartment, with his wife, Yvonne, his dog, Pinceau II, and recently completed paintings in his studio.

At his Mother's House, Le Lac, Vevey
Le Corbusier liked to film his mother, and the views from the house he had built for her on the north shore of Lake Geneva, on the three occasions he visited her there between October 1936 and February 1937.

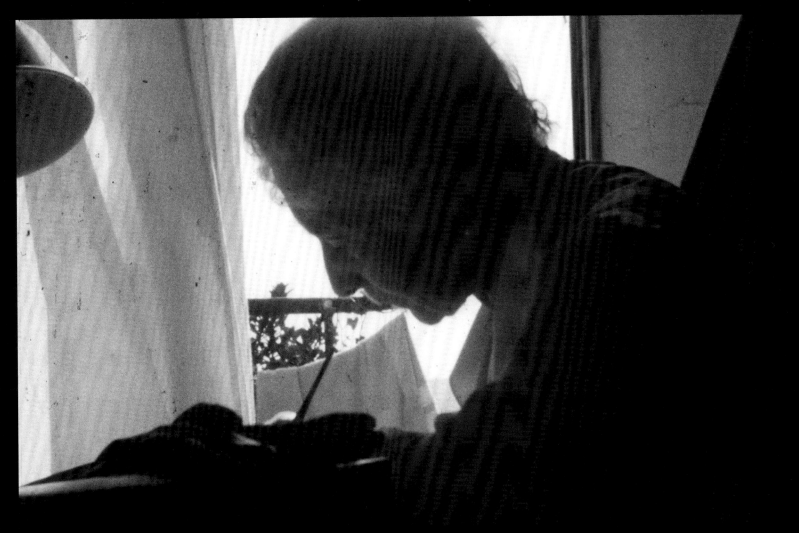

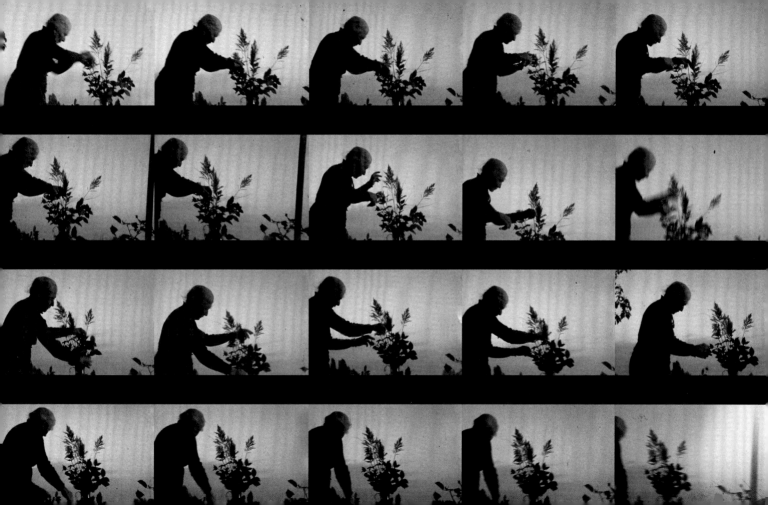

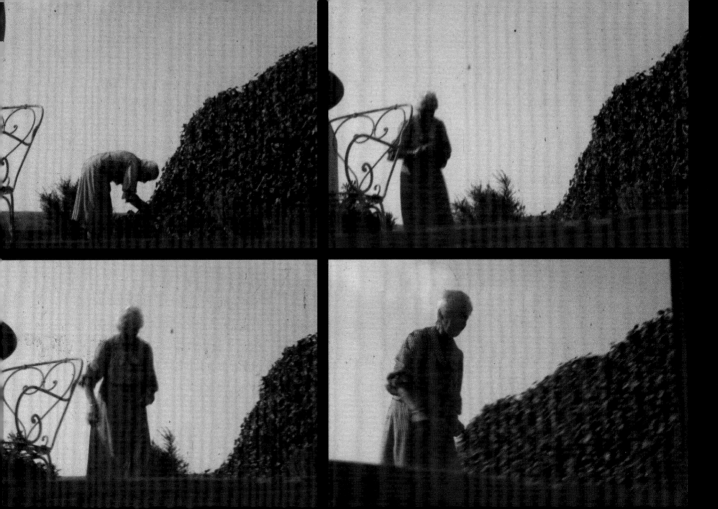

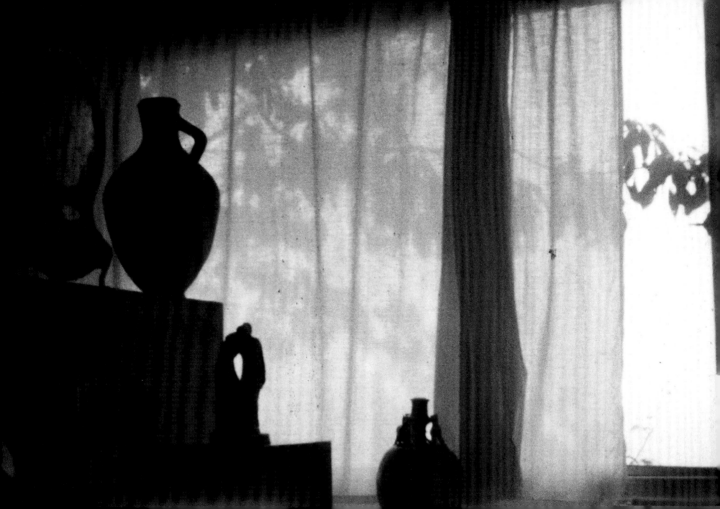

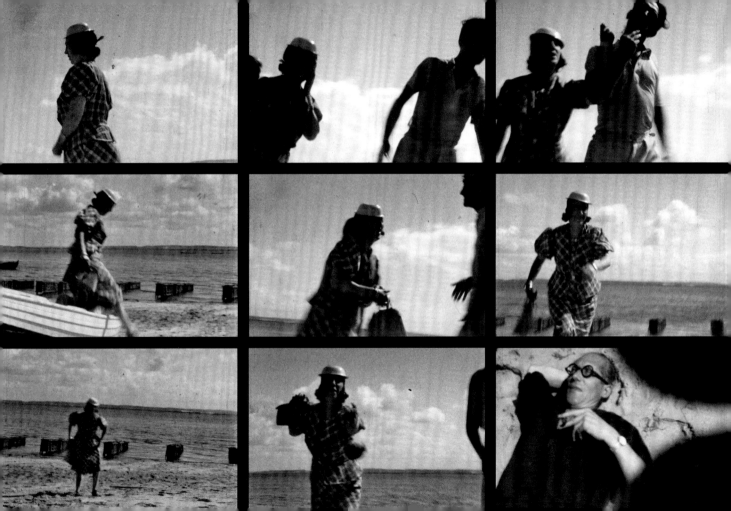

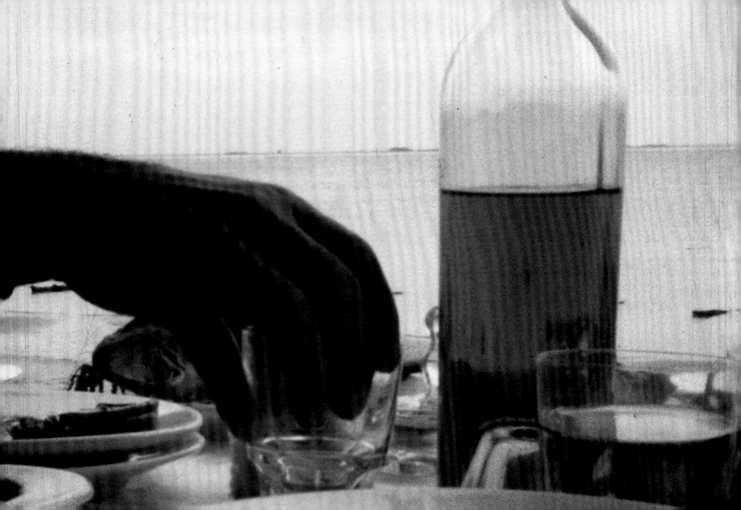

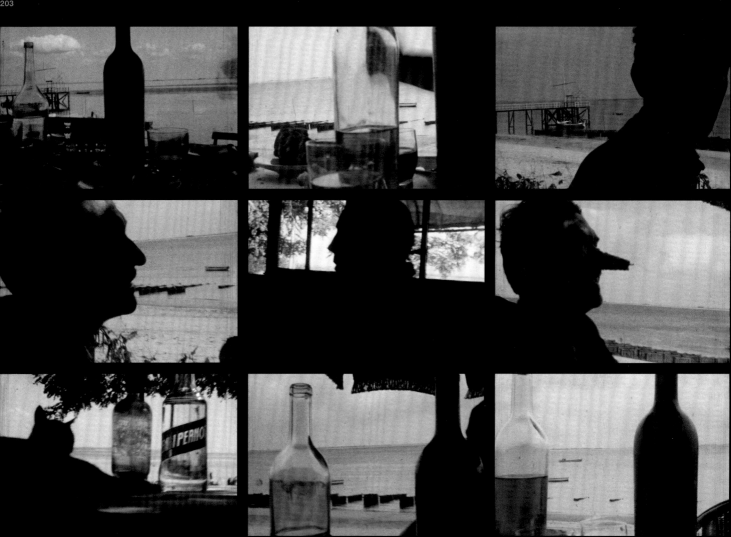

A Month in Brazil

Le Corbusier had visited Rio de Janeiro briefly on his first trip to South America, in the winter of 1929. He had been invited to give ten lectures in Buenos Aires, but managed also to visit Montevideo, São Paulo, and Rio de Janeiro. He gave two lectures each in São Paulo and Rio and devised a rough sketch plan for Rio involving a new business downtown with skyscraper office blocks, projecting into the lagoon, and an audacious curving viaduct that would have served both to communicate between the city center and its seaside suburbs and to relieve pressure on housing by accommodating thousands of apartments in the viaduct itself. This scheme was the product of an airplane flight over the city with the mayor, Antonio Prado Junior.[214]

In this simplified drawing, the downtown area of the Baroque and 19th-century city is shown at the bottom, with the port bottom left, and the spines of mountain ridges that divide the rest of the town into self-contained suburbs on the right. Almost dead center in the drawing, next to the sea on the Esplanade, was a little tower block, the Hotel Gloria, where Le Corbusier stayed on both occasions.[215]

The new invitation to give six lectures in 1936 came from the Brazilian Minister of Education himself, Gustavo Capanema, but was brokered by Le Corbusier's friend Alberto Monteiro de Carvalho, in a correspondence that began in April 1936. It was an uncomfortable discussion, because Le Corbusier wanted some kind of contract assuring him a consultancy or an architectural commission, over and above his lecture fees, travel, and expenses.[216] Two projects in particular interested him: a new Ministry of Education and Health building that was being planned and a project for a University City. Both of these had been given provisional approval and were being worked on by teams of Brazilian architects, artists, and

FIG. 195 **Le Corbusier, drawing made during a lecture in Rio de Janeiro, November 1929**
FLC 32091

214 Reported in an unidentified newspaper article, see Le Corbusier, C. R. d. Santos, and Fondation Le Corbusier, *Le Corbusier e o Brasil* (São Paulo: Tessela-Projeto, 1987), 35–36, and mentioned in one of Le Corbusier's Rio lectures.
215 A wide strip of landfill was later added, setting the Gloria and the Esplanade further back. Part of Le Corbusier's idea was actually carried out, on motorways which linked the suburbs via tunnels in the mountain ridges.
216 Le Corbusier was, nevertheless, extremely grateful for the generous remuneration offered by the Braziian government; see his letter to his mother, July 1, 1936.

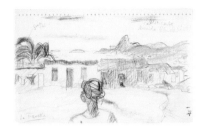

217 FLC I3(3)5.
218 Letter to Monteiro de Carvalho, June 15, 1936 (FLC 3(03)15).
219 Notes for Volta lecture, dated July 11, 1936 "à bord Zeppelin (Equateur)," FLC U3(17)90.

engineers. Capanema would not offer Le Corbusier any contractual role in these important projects, theoretically because Brazilian laws restricted the role of foreigners in Brazilian construction. The fact was, however, that a French town planner, Donat-Alfred Agache, had prepared a plan for Rio that, despite various setbacks, was still being worked on, and an Italian architect, Marcello Piacentini, was being contracted to advise on the University City.

On July 8, Le Corbusier caught the train to Frankfurt, where he embarked on the *Graf Zeppelin* for the four-day trip to Brazil. Le Corbusier traveled on the *Graf Zeppelin*, as his film clips show, and not the *Hindenburg*, as has been stated by various authors, based on a misreading of a letter from Alberto Monteiro de Carvalho, who suggested on April 8, 1936 that Le Corbusier travel on the *Hindenburg*.[217] He had not wanted to take the zeppelin, preferring the time for reflection offered by a sea cruise.[218] Perhaps he had been spoiled by his trip to New York in 1935 on the extremely luxurious *Normandie*. Curiously, he took no photographs and made no sketches during the four days he spent on the zeppelin, which must have offered spectacular views. Instead, he seems to have occupied himself drafting his lecture for his forthcoming trip to Italy.[219] The weather was stormy and the landfall of the zeppelin at its field near Recife in Pernambuco was not without incident. Le Corbusier took five film clips of the *Graf Zeppelin* at its anchorage in Pernambuco, taking some care to create an editable sequence →pp. 216–17. First, a discovery shot, panning from the flat landscape to discover the long shape of the zeppelin. Then, a reverse angle, looking back down the airship from a closer viewpoint, followed by a dramatic view upward of men working on the anchoring tower. Finally, at the end of his stay in Recife, there is a tracking shot taken from a car, of the airship in the middle distance. Le Corbusier also visited Recife and took several panning shots of a Baroque church and its square, without obvious purpose.

FIG. 196　**Le Corbusier, sketch marked "Favella," Rio de Janeiro, October 1929, Sketchbook B4, p. 287**

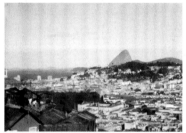

FIG. 197 **Le Corbusier, 16 mm views of the favela on the Santa Teresa hill** FLC Séquence 07350 →p. 219

FIG. 198 **Le Corbusier, 16 mm views from the favela on the Santa Teresa hill** FLC Séquence 07376

FIG. 199 **Le Corbusier, sketch, "depuis la grande favela," view over Rio** Carnet 6 FLC 5035

Le Corbusier arrived in Rio, after the transfer from Pernambuco, around July 13. He quickly returned to the favela, which he had visited in 1929. He climbed the steep stairs up the slopes of one of the ridges that descend into the city like fingers of a hand →p. 219 top left Le Corbusier referred to this as the Favella Santa Teresa, both on the film box and in his lectures in Rio. [220] Many villas, belonging to literary and artistic figures in carioca society had been built along the slopes of the ridge, but these were interspersed with the shantytowns of the poor, who fill every space in the hills around Rio. It was typically in one such favela—long since replaced by middle-class housing blocks—that Le Corbusier chose his vantage point.

In 1929, together with Josephine Baker and the painter and illustrator Di Cavalcanti, he had admired the natural life style and dignity of these people, despite their desperate poverty and insanitary conditions. In his fourth lecture in 1936, elaborating on his plan for Rio, he explained:

> To make myself better understood, I am going to show you now the
> Santa Teresa hill and the silhouettes that you know and love: the Sugarloaf,
> the palm trees, the beaches, the greenery, lots of space, the sea; these images
> are comforting.[221]

He then sketched this landscape schematically, before drawing an armchair, inserting a seated figure on it, adding a table and sideboard, and then, dramatically, enclosing all this with the orthogonal lines of a housing cell with picture window, finishing off his drawing with the grid of tiles that helps to support the perspective FIG. 200. He photographed several views from his room in the Gloria that correspond to this sketch FIG. 201 →p. 215.

He filmed the view from the favela on both sides, toward Botafogo Bay and the Sugarloaf peak on one side and toward the smoke-ridden port on

220 My Brazilian colleagues Hugo Segawa and Daniela de Ortiz dos Santos insist that the location of these shots is more likely to have been the Morro da Conceição.
221 Typed text of the fourth lecture, August 10, 1936 (FLC C3(18)117), p. 4.

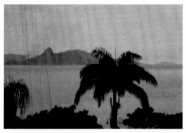

FIG. 200 **Le Corbusier, preparatory drawing for the fourth lecture in Brazil, August 10, 1936, FLC copy of lecture sketch**

FIG. 201 **Le Corbusier, photograph from his room at the Hotel Gloria** FLC Séquence 7815

FIG. 202 **Le Corbusier, photograph taken with his 16 mm film camera of oil silos on an island en route to Paqueta** FLC Séquence 7742

the other. He went on to describe the "miracle that can enter the heart, day or night" in the face of such a view:

> It is a wonderful thing, and I have to say that in Rio this blessing is offered only to certain privileged people who, moreover, are often extremely poor, living on the steep slopes of the hills.

> The black man has his house almost always on the edge of a cliff, raised on pilotis in front, the door is at the back, toward the hillside; from up in the favelas, one always has a view of the sea, the harbors, the ports, the islands, the ocean, the mountains, the estuaries; the black man sees all that …[222]

The people he filmed and photographed on the Santa Teresa ridge were, for him, not just beautiful and picturesque characters, but some of the "privileged," who could benefit from the fabulous view to be obtained from his viaduct housing apartment block →pp. 218–21.

It was the aim of Le Corbusier's outrageous housing-motorway-viaduct to provide hundreds of thousands of apartment dwellers the same privileged view of the landscape as that obtained from the ridge. One of his inspirations for this extended ribbon of housing, 100 meters high and with a motorway on the top, was the 19th-century Viaduct of Santa Teresa, which had been converted to carry a tram.[223]

He took a number of views of Rio, still photographs and short moving sequences, trying to imagine the effect of his viaduct housing ribbon on the skyline. Partly no doubt to get a better view of Rio from the bay, Le Corbusier took the ferry to the island of Paqueta, noting with interest the gleaming steel fuel silos on the way FIG. 202.

He photographed these and even sketched them in his fifth lecture (August 12, 1936), commenting:

222 Typed text of the fourth lecture, August 10, 1936 (FLC C3(18)117), p. 4.
223 FLC Carnet 6, sketch 5036.

These aluminum painted forms gleamed in the sunlight with an extraodinary grace and their perfectly pure forms were picked out in an amazing light.
You'll recognize these as the Standard and Shell oil tanks, tucked away at some distance from Rio on their islands. These oil tanks provide an unexpected silhouette on the skyline, which prompts me to ask the question: "Is this architecture?"[224]

224 Le Corbusier and Y. Tsiomis, *Conférences de Rio: Le Corbusier au Brésil*, 1936 (Paris: Flammarion, 2006), 139–34.
225 Claude Prelorenzo, "Quand Corbu faisait son cinéma," *Le Visiteur* 17 (November 2011), 66–75. I would like to thank Daniela Ortiz dos Santos for pointing out this sequence of images.

And he went on to suggest that they were indeed architecture.

Paqueta was an island at the far end of the bay, frequented by the Rio intelligentsia and bourgeoisie, who went there to have a good time. Le Corbusier filmed the promenade, with its elegant ladies, and took a number of still photographs of the fishermen FIGS. 204–06.

These photographs demonstrate a remarkable precision of composition and an acute sense of timing. Back in Rio, Le Corbusier toured the possible sites for the Ministry of Education and Health and the proposed University City, accompanied by Lucio Costa. A sequence of shots of the old Royal Palace of Bom Retiro form a panorama FIG. 203.

It is difficult to understand exactly what Le Corbusier intended to achieve by taking these overlapping pictures, a technique he used quite often. It is as if, frustrated by the limitations of the lens, he simply multiplied the images to extend the view. A similar intention seems to have motivated his cinematic technique, with which he appears to "paint" the scene.[225] This was how he filmed the view from the promenade of Botafogo.

It seems as if Le Corbusier had learned nothing from watching Pierre Chenal work. Instead of letting the montage and movement within the frame create interest, he sweeps his camera across a scene, tilting up and down, apparently unaware of the dangers of stroboscopic judder, which affects any panning shot if moved too fast. This is the exact opposite of the

FIG. 203 **Le Corbusier, panorama of seven overlapping photographs of the site of the proposed University City, Rio de Janeiro**
FLC Séquence 7407–7415

FIGS. 204–06 **Le Corbusier, photographs taken on the island of Paqueta, August 1936**
FLC Séquence 7337, 7318, 7323 → pp. 222–29

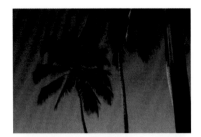

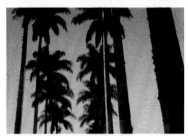

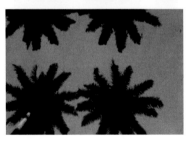

FIG. 207–09 **Le Corbusier, photographs in Rio de Janeiro, July 1936** FLC Séquence 7330, 7468, 7473 →pp. 234–35

advice given to amateur cinematographers in magazines such as *Le Cinéma Chez Soi*, which offered its readers basic advice on technique. Under the heading "Do not move your camera!" Lucien Pierron counseled:

> *The panning shot, there's your enemy! How many films ruined by a shaky camera! If you take twenty bad films, fifteen of them will have been ruined by this fault.... At any rate, let us pan the camera gently, very gently, so that the movement of the camera should be imperceptible.*[226]

Pierron pointed out that moving the camera risked creating a blurred image. In another article, the issue of economy was linked to the length of shots. Filmmakers were advised to take no more than 100 frames for a head shot (four seconds) and 200 for groups and landscapes, "but only, obviously, if the latter are animated." Le Corbusier panned like mad, with a rapidity and irregularity that produced both the blurred images and that sense of nausea that Pierron warned of.

More interesting than his movie sequences in Rio, however, were the photographs in which Le Corbusier captured a sequence of unusual and graphic images of tropical vegetation FIGS. 207–09.

In these views, Le Corbusier abstracts the botanical forms, almost as if preparing a decorative design, along the lines of the textbooks he studied when a student in La Chaux-de-Fonds. Sometimes, he turned the camera on its side, although it is not clear whether he did this to increase the sense of abstraction or simply to reframe the image.

As early as July–August 1936, he began to work in series. A group of nine photographs of the shadows projected onto a white wall by a line of palm trees show him exploring different ways of playing off figure and ground, on the margins of legibility FIGS. 230–31. This belongs to a kind of purely photographic exploration, depending on subtle differences of tone,

226 Lucien Pierron, "La prise de vues *Pathé-Baby*," *Le Cinéma Chez Soi*, 35 (Paris, 1929), 14–15.

contrast, and sharpness of detail. With the limited control he had of the Siemens B, it is natural that not all the effects come off precisely. These images, however, demonstrate a genuine curiosity about what could be achieved within the aesthetics of modernism with a photographic image.

Rio de Janeiro
July 12–August 14, 1936

Album 6

Brazil
On Le Corbusier's trip to Brazil in July and August 1936, he began by making film sequences (the *Graf Zeppelin*, views of Rio de Janeiro, the island of Paqueta, and the favela of Santa Teresa) but soon began to take photographs of the exotic vegetation and beautiful people of Rio.

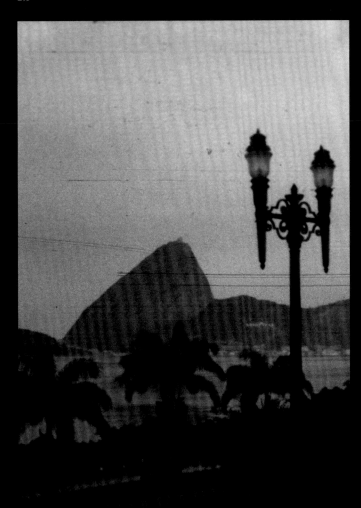

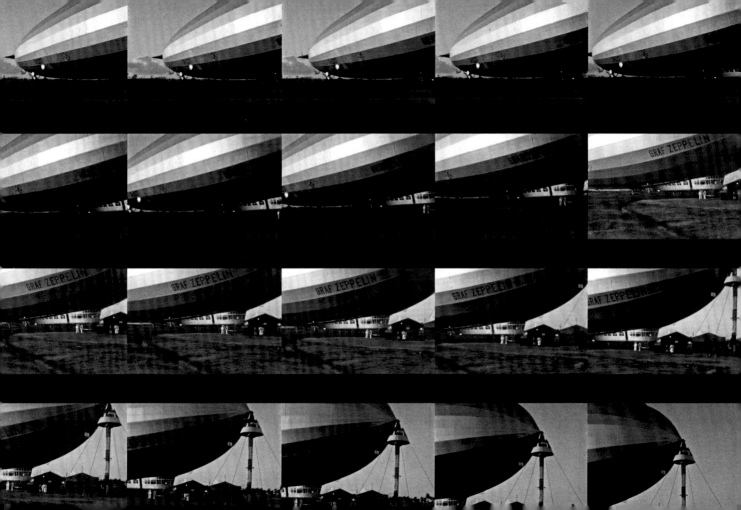

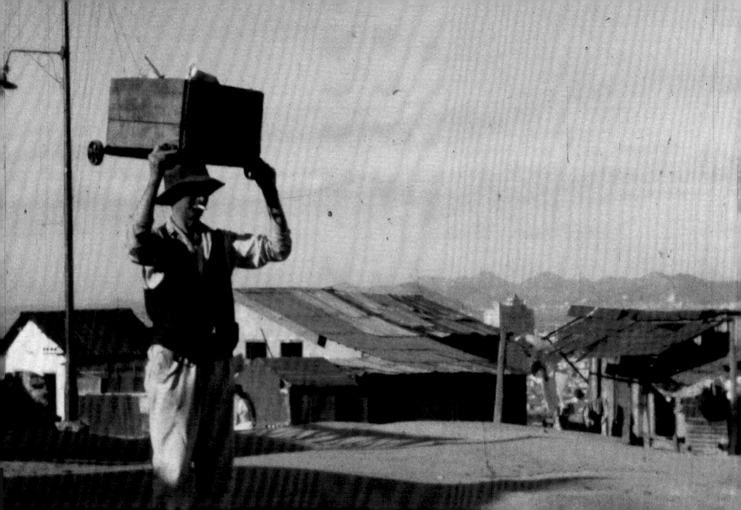

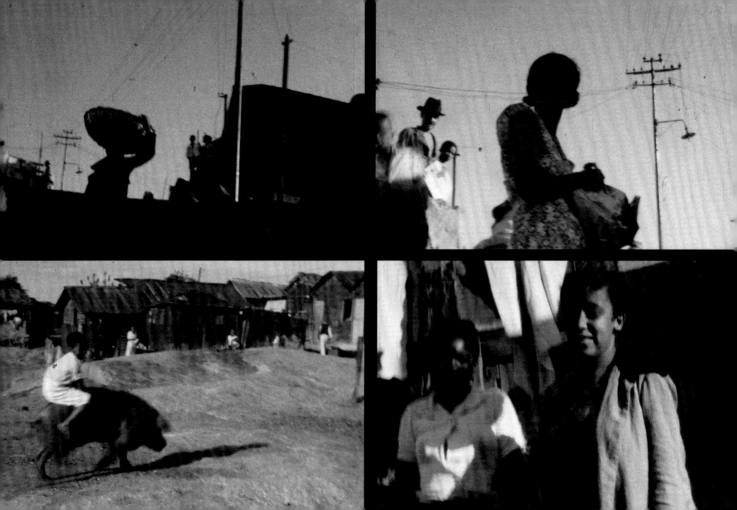

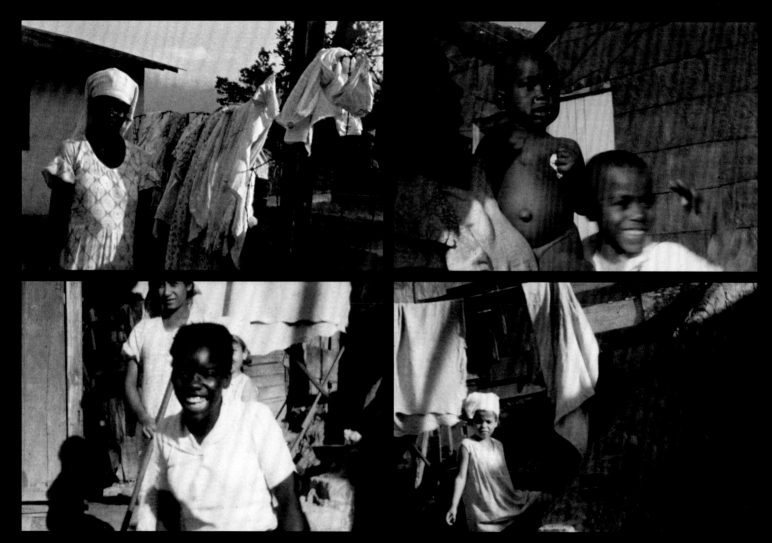

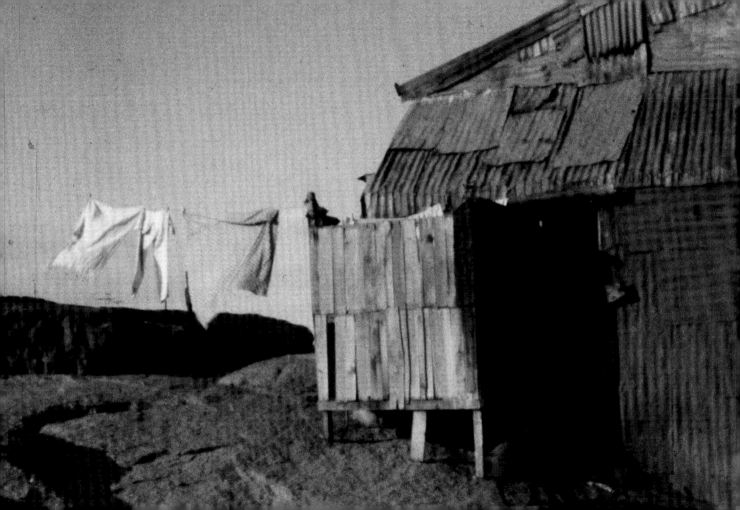

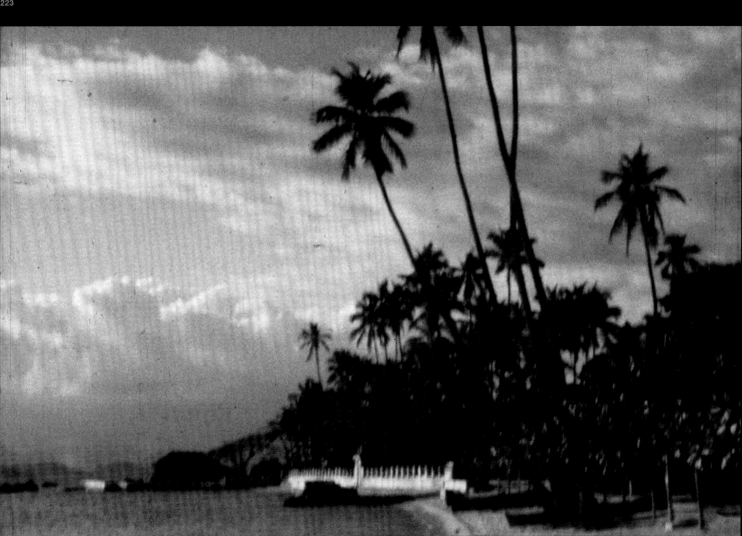

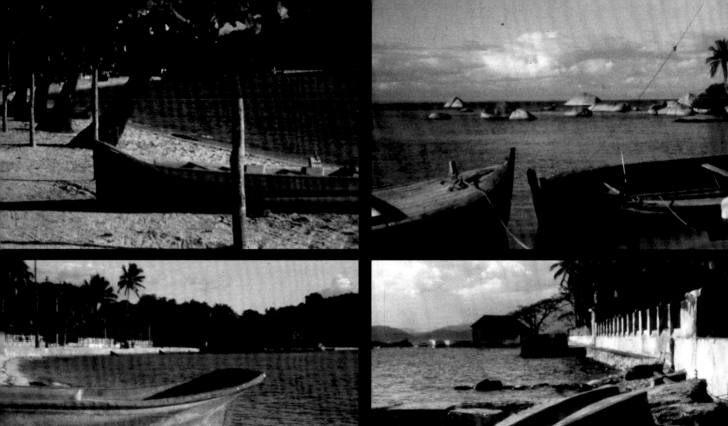

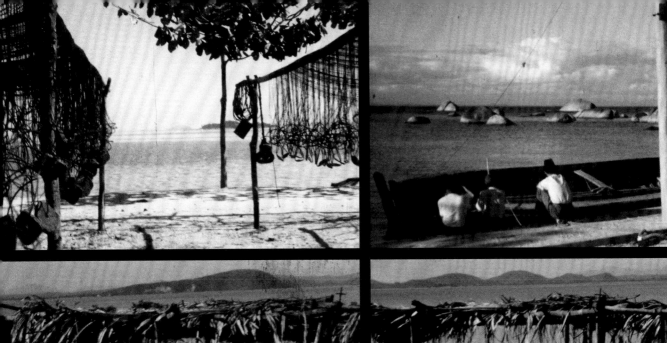
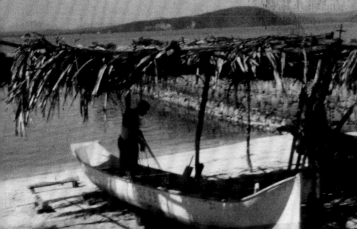
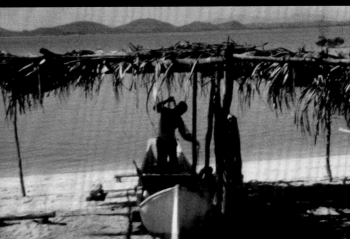

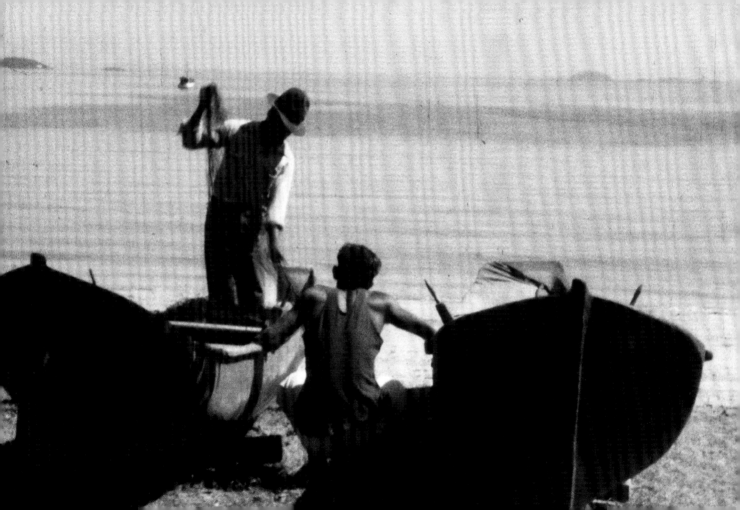

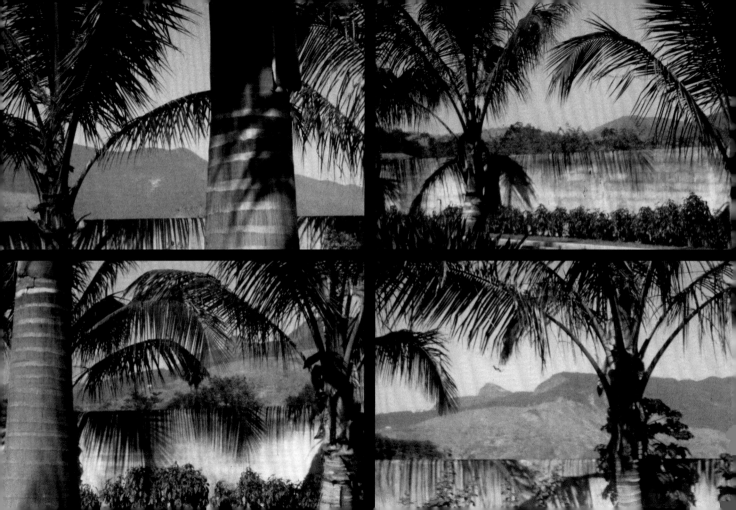

A Transatlantic Crossing

On August 14, 1936, Le Corbusier saw his Brazilian friends off at the quay, taking a number of rather blurred snaps of them on his Siemens B camera. His return voyage was on the Italian ocean liner *SS Conte Biancamano*, launched in 1925. After a period on the Genoa–New York run, she had been transferred to the South American route. For a brief period in 1935, she served as a troopship in the Italian campaign in Ethiopia.[227] The interior décor of the ship was carried out by the Florentine historicist architects, the Coppedè brothers, and the furniture was designed by the *Stile Liberty* (Art Nouveau) furniture designer Carlo Bugatti.

The curious can inspect the *Conte Biancamano* in reality, since a large section of the ship was saved from the scrapyard and installed in the National Museum of Science and Technology Leonardo da Vinci in Milan FIGS. 210–11.

Visitors to the museum can see the lounge, in its neo-Art Deco form redecorated after the war, and appreciate the scale of the promenade decks. But they are not offered a view of what interested Le Corbusier: the mechanical fittings of the working parts of the ship—the lifeboats, winches, gears, pulleys, cables, and ropes.

Le Corbusier made some notes about the ship on a scrap of paper:

A terrifying ship! Swimming pool on deck. Turkish bath (for sweating out toxins in the tropics, etc.), slides for rapid dives and climbing out via exercise racks— Badovici's system. Dining room with an opening roof; windows all round; open-air dancing like this [sketch] or like this [sketch].

This takes the biscuit! Conte Bianchamano [sic] August 17, 1936, crossing the Equator: in the smoking room they have lit the fire in the great Florentine chimney

FIG. 210 **Section of the *SS Conte Biancamano* in the National Museum of Science and Technology Leonardo da Vinci, Milan**

FIG. 211 **Section of the *SS Conte Biancamano* in the National Museum of Science and Technology Leonardo da Vinci, Milan**

227 In 1937, she was transferred to a Far Eastern route. After war service, in US colors as the *USS Hermitage*, the ship was refitted, remodeled, and relaunched as a luxury liner, under her original name, on the New York and South American routes.

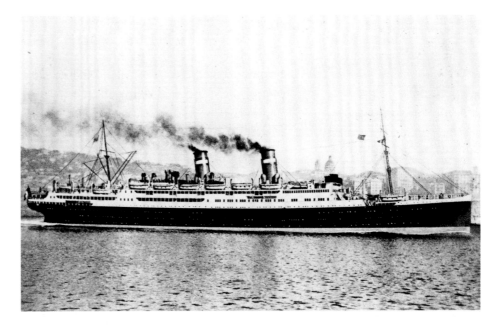

FIG. 212 *SS Conte Biancamano*, ballroom
with décor by the Coppedè brothers and
18th-century Persian carpet

FIG. 213 *SS Conte Biancamano*, in its livery
of the Società Italia Flotte Riunite

FIG. 214 *SS Conte Biancamano*, smoking room

Une architecture pure, nette, claire, propre, saine. — Contraste : les tapis, les coussins, les baldaquins, les papiers damassés, les meubles dorés et sculptés, les couleurs vieille-maronnié ou ballets russes ; tristesse morne de ce bazar d'occident.

« EMPRESS OF FRANCE » Canadian Pacific.

FIG. 215 **Le Corbusier-Saugnier, page from** *L'Art décoratif d'aujourd'hui*, **1925**

FIG. 216 **Le Corbusier-Saugnier, "Eyes that do not see,"** *L'Esprit Nouveau* 8, May 1921

piece!… Rest assured! It is only colored mica lit by electricity. We made them switch it off. It was physically unbearable.[228]

This description picks up many of the pleasures of sea travel, swimming, sauna, dining, and dancing. But, needless to say, there is no comment on the extravagant decoration of the interior. This is consistent with Le Corbusier's approach to ocean liners. These had been the first of the three modern phenomena addressed by the three articles "Eyes that do not see" in *L'Esprit Nouveau* (May 1921), reprinted in *Vers une architecture* (1923).[229] One of the illustrations FIG. 216 of an empty promenade deck on the *Empress of France* ocean liner was captioned "An architecture that is pure, crisp, clear, clean, sound. Contrast the carpets, cushions, canopies, damasked wallpaper, gilded and carved furniture, musty and Ballets Russes colors: the dreary dullness of our Western Bazaar." He went back on the attack in his book *L'Art décoratif d'aujourd'hui* (1925), which was part of his campaign against the decorative arts in the run-up to the Exposition Internationale des Arts Décoratifs et Industriels Modernes. Comparing an image similar to the one in FIG. 216 with the Art Deco staircase of the ocean liner *Paris*, he marveled at the functional clarity of the former and criticized the wasteful luxury of the latter FIG. 215.[230] This was also one of the comparisons he used in his lectures, managing to induce laughter in his audience by comparing the functional (good) with the decorative (bad).

During a lecture at the Sorbonne in June 1924, for example, after showing his audience a set of contrasts, including one similar to FIG. 216, he went on:

Just now, I showed you the ocean liner Paris, for example, which struck you as a remarkable thing, superb. Then, from the same ocean liner, I showed you the saloon, which certainly quenched your enthusiasm. It does seem extraordinary to find

228 FLC F2(17)267.
229 Le Corbusier-Saugnier, "Eyes that do not see: Liners," in Le Corbusier, J.-L. Cohen, and J. Goodman, *Toward an architecture* (Los Angeles: Getty Research Institute, 2007) [*Vers une architecture* (Paris: Cres, 1923)], 145–58, first published in *L'Esprit Nouveau* 8 (May 1921), 845–55.
230 Le Corbusier, *L'Art décoratif d'aujourd'hui* (Paris: Crès, 1925), 160.

231 Le Corbusier, "L'Esprit Nouveau en Architecture," in *Bulletin de L'Ordre de l'Étoile de l'Orient* 1 (3) (1925): 24–54; see also T. Benton, *The rhetoric of modernism: Le Corbusier as a lecturer* (Basel: Birkhäuser, 2009), 70.
232 Letter to Austin, October 1, 1936 (FLC R2(04)337), cited in A. Foscari, *Tumult and Order, La Malcontenta 1924–1939* (Zurich: Lars Müller Publishers, 2012).

at the heart of such a wonderful piece of work, so perfectly organized, something so completely at odds with it, such a lack of coherence, in fact such a contradiction: a total divergence between the general lines of the ship and its interior decoration. The former results from the scientific work of engineers; the latter from what are called specialist decorators.[231]

It is not surprising to see Le Corbusier, then, photographing the open spaces of the ship's promenade decks, mostly without people FIG. 217.

These photographs celebrate and exaggerate the open spaces, with a view turned toward the sea, which Le Corbusier thought of as equivalent to the balconies of his blocks of apartments in *La Ville Radieuse*, overlooking sports fields and open parkland. Always, in Le Corbusier's photographs, there is a hidden association with his architecture and urbanism.

So it is no surprise that the photographs Le Corbusier took on the *SS Conte Biancamano* in August 1936 would not be of the passengers playing deck games, or of the sumptuous ballroom or dining room, let alone the smoking room with its Florentine fireplace. Nor did he photograph the middle-class and aristocratic passengers with whom he mixed. For example, his Brazilian friend Bertie Landsberg, owner of Palladio's Villa Malcontenta on the Brenta Canal near Venice, was on board. In a letter sent to Mr. Austin of the Wadsworth Museum on his return to France, Le Corbusier explained:

He was my dining companion on board and we had some very pleasant discussions, along the same lines as those we had already had in the villa itself.[232]

Landsberg was a close friend of Count Giuseppe Volpi, who organized the conference in Rome at which Le Corbusier gave a lecture later in 1936. Instead, he took 744 photographs of elements of the ship's mechanical parts,

FIG. 217 **Le Corbusier, view of a promenade deck** FLC Séquence 8460

FIG. 218 **Le Corbusier, 16 mm photograph on the *SS Conte Biancamano*, August 1936** FLC Séquence 8069 → p. 287

FIG. 219 **Le Corbusier, *Sur le bateau*, 1933, 72 × 91.5 "sur le navire Afros aux Cyclades CIAM Athenes"** FLC 106; coll. particulière

233 Letter to his mother and
to Albert, September 10, 1936,
written from Le Piquey
(FLC R2(1)228).

with a few shots of the third-class passengers allowed up on deck in the bow of the ship →pp. 247–87.

In 1933, while touring the Greek islands on board the ship *Afros* with colleagues who had attended the CIAM Congress in Athens, Le Corbusier painted a picture in which similar elements are combined with human bodies. Machines for Le Corbusier are always symbolic, representing anthropomorphic metaphors of bones, muscles, and flesh. Here, Le Corbusier worked with the repertoire of forms developed in his paintings of 1929–33, based on the boats, ropes, and well-built women of the Bassin d'Arcachon, to which we will return later. Pride of place, however, is given to some heavy machinery, and it is this that forms the iconographny of his photographs on the *SS Conte Biancamano*. He made a couple of sketches of ropes and pulleys during the voyage, but most of his attention was devoted to the photographs FIGS. 220–21.

In a letter to his mother and brother, written after his return, he makes no mention of the 744 photographs he took during the voyage but claims to be making progress in painting:

I was worn out, after my work (huge) at Rio. On the boat (thirteen days), bad food and sleepless nights. Flat calm. Swimming pool all day long. A little painting (in progress).[233]

How can we make sense of these photographs? The first point to make is that images of machinery had formed a staple of Le Corbusier's rhetoric from the moment of his association with Amédée Ozenfant in 1918.

The theory of art behind the Purist art movement was that the world had been turned upside down by industrialization and its effects on transportation. It was a "machinist era," and only those sensitive to the age would acquire, so they claimed, a new understanding of the world and a

FIG. 220 **Le Corbusier, sketch, probably made on the *SS Conte Biancamano*, August 1936, Sketchbook C10, p. 73**

FIG. 221 **Le Corbusier, sketch probably made on the *SS Conte Biancamano*, August 1936, Sketchbook C10, p. 74**

new aesthetic. This was not their invention, but a belief shared by most avant-garde artists, architects, and designers in the 1920s.[234] It had an immediate effect on photography. Indeed photographers were in some cases among the first to express this "machine aesthetic."[235] In the heart of the "Photo-Secession" movement in the United States, in the circle around Alfred Stieglitz, his magazine *Camera Work*, and the 291 Gallery in New York, a movement began before the end of the First World War to abandon the soft focus and manipulated prints of art photography and to explore the precision and sharp focus of the plate camera, without abandoning the ambition to create art. Paul Strand was one of the first to create nearly abstract photographs of machines and effects of light and shade FIGS. 227–28. Soon, other photographers such as Edward Steichen and, a little later, Paul Outerbridge, Walker Evans, Margaret Bourke-White, and Anton Bruehl began to take photographs in which precision was combined with strong and semi-abstract graphic forms. The American photographers were well known in Europe, although Ozenfant and Le Corbusier did not reproduce the work of named "New Vision" photographers in the magazine *L'Esprit Nouveau*. Le Corbusier did have an eye for the telling detail, however, and the commercial photographs he and Ozenfant selected for *L'Esprit Nouveau* often have an abstract quality similar to those of the German and American photographers FIG. 229. The relationship between high realism and abstraction of form was typical of the "New Photography" and the modern art movement of the mid-1920s.

In Germany, a similar movement dedicated to expressing the "machine aesthetic" developed along two parallel lines. On the one hand were professional photographers who worked for commercial clients to advertise their wares and publicize their factories, or who used the power of the photographic close-up to produce books of details of natural or mechanical parts. The other group, more explicitly artistic, used their cameras to create

FIG. 222 **Le Corbusier, illustration from** *L'Art décoratif d'aujourd'hui,* **1925**
paste-up of page proofs, CCA

FIG. 223 **Le Corbusier, illustration from** *L'Art décoratif d'aujourd'hui,* **1925**
paste-up of page proofs, CCA

FIG. 224 **Le Corbusier, illustration from** *L'Art décoratif d'aujourd'hui,* **1925**

234 See T. Benton, "Building Utopia," in Christopher Wilk, *Modernism: Designing a New World* (London: V&A Publications, 2005), 149–73.
235 National Gallery of Canada and A. Thomas, *Modernist photographs* (Ottawa: National Gallery of Canada, 2007).

FIG. 225 **Anonymous photograph from the Reichsarchiv, cone and crater, illustrated in** *Foto-Auge*, ill. 42

FIG. 226 **Renger-Patzsch**, *Heterotrichum macrodum*, **illustrated in** *Foto-Auge*, ill. 50

abstract or near abstract images and collages. Many of them were associated with Russian Constructivism and the Bauhaus in Weimar (1919–25) and Dessau (1925–31). A cross-section of this European "New Vision" photography was put on display at an exhibition called *Film und Foto* held in Stuttgart in 1929, and was further publicized in a book by Franz Roh entitled *Foto-Auge* (1929).[236]

At this exhibition, anonymous photographs were mixed in with the work of well-known artists from both sides of the Atlantic, including Berenice Abbott, Herbert Bayer, Francis Bruguière, Anton Bruehl, Werner Gräff, André Kertész, Germaine Krull, László and Lucia Moholy-Nagy, Albert Renger-Patzsch, El Lissitzky, Rodchenko, Edward Steichen, and Edward Weston FIGS. 225–26, 230, 232. Le Corbusier's friend Willi Baumesiter exhibited photographs in the show, as did Sigfried Giedion and Fernand Léger's pupil Florence Henri. A traveling show of the exhibition also toured various European cities. It is extremely unlikely that Le Corbusier was unaware of this movement in photography, although he made a point of distancing himself from the German and Central European avant-garde.

Franz Roh's introduction to *Foto-Auge* is entitled "Mechanismus und Ausdruck" (Mechanism and Expression) and argues that photography has returned to its true potential after the aberration of trying to imitate the fine arts. Only as the technology of photography became simpler could the emphasis on "true visual culture" be opened to a wide popular base. With regard to "true visual culture," Roh differentiated between writing about the world—an indirect view—and the direct view offered by the camera lens. This is close to what Le Corbusier meant by *l'esprit de vérité*.[237]

In Marxist terms, photography could have a new role in giving the proletariat a medium of expression. Photography could therefore be seen as an emancipatory and critical art, and one of the characteristics of the "New Photography" was to use destabilizing and alienating methods to impose

236 G. Stotz, *Film und Foto* (New York: Arno Press, 1979) and F. Roh, *Foto-Auge: 76 Fotos der Zeit* (Tübingen: Wasmuth, 1973). See also W. Gräff, *Es kommt der neue Fotograf!* (New York: Arno Press, 1979) [Stuttgart: Akademischer Verlag, 1929].

237 See Le Corbusier, "Esprit de vérité," *Mouvement, Cinématographie, littérature, musique, publicité* 1 (1933): 10,11. Le Corbusier uses "l'esprit de vérité" here in a different sense to that of his earlier article "L'Esprit de vérité," *Architecture Vivante* 5 (17), in which he was referring to the functional realities of design.

FIG. 227 **László Moholy-Nagy, Parisian sewer, illustrated in** *Foto-Auge*, **ill. 38**

FIG. 228 **Paul Strand, Machine, Akeley Shop, New York, 1922**

FIG. 229 **Paul Strand, Automobile Wheel, New York, 1917**

FIG. 230 **Le Corbusier and Ozenfant, "Eyes that do not see,"** *L'Esprit Nouveau* 10

FIG. 231 **Page spread from** *Film und Foto*

FIG. 232 **Franz Roh,** *Foto-Auge*, **cover, 1929**

a "New Vision." Dramatic and strange angles of view, extreme contrasts, an emphasis on machines and raw materials, a flirtation with completely abstract images—all these could be seen as building blocks of a new, universal (and cosmopolitan) language of visual expression. Roh emphasizes that these characteristics can be understood only by comparison with movements in the fine arts, and indeed we can find links with Cubism, Constructivism, Dadaism, Surrealism, and abstract art.

Roh insisted also on the ability of the modern camera to capture things that were impossible for the human eye—high-speed action, X-ray vision, superimposed or collaged images, or reversed images that look like negatives. It is an important aspect of this approach that natural forms and machines were placed on an equal footing. They were both analyzed and abstracted by the camera to suggest a shared underlying geometry. It is for this reason that those arguing for a functionalist aesthetic often used the "organic" argument, claiming that nature strives toward a rational and functional perfection.[238] Many of the photographs and collages in *Foto-Auge* are based on the aesthetic of Dadaism and Surrealism, which did not interest Le Corbusier very much in general, but the emphasis on truth and on searching for ways to see the world in a new way fit closely with Le Corbusier's photographs of 1936–38.

Most of these photographs are carefully composed and have a "photographic aesthetic." By that I mean that Le Corbusier is less interested in trying to explain the objects he presents than he is in capturing a striking image of them, molded by light and shade.

A parallel movement in film, which was especially important in the last years of silent movies, looked for narrativeless means of representing reality. One of the key works here was Walther Ruttmann's *Berlin: Die Sinfonie der Grosstadt*, which was screened at the *Film und Foto* exhibition. Instead of using actors, narrative, and a plot (communicated through caption cards),

238 See H. Häring, "Wege zur Form," *Die Form* 1 (October 1925) and my commentary on this approach, T. Benton, "Modernism and Nature," in Wilk, *Modernism: Designing a New World* (London: V&A Publications, 2005), 311–39.

Ruttmann used the simple story line of a day in the life of the city to allow the film sequences to tell their own story. In a sense, Le Corbusier tried to do the same thing with the photographs on the *SS Conte Biancamano*, abstracting the workings of the ship to its essential components and representing the elements of the sea (cables, ropes, lifeboats), power (motors, winches), air (funnels), and finally the third-class passengers, allowed out onto the fo'c'sle to take the sea breeze. I have tried to represent this iconographic program in a single mosaic consisting of a little less than one tenth of the photographs he took FIG. 233.

FIG. 233 **Composition of 64 photographs taken with his 16 mm movie camera on the *SS Conte Biancamano*, August 1936**
→ p. 286

On the *SS Conte Biancamano*

August 14–27, 1936

Album 7

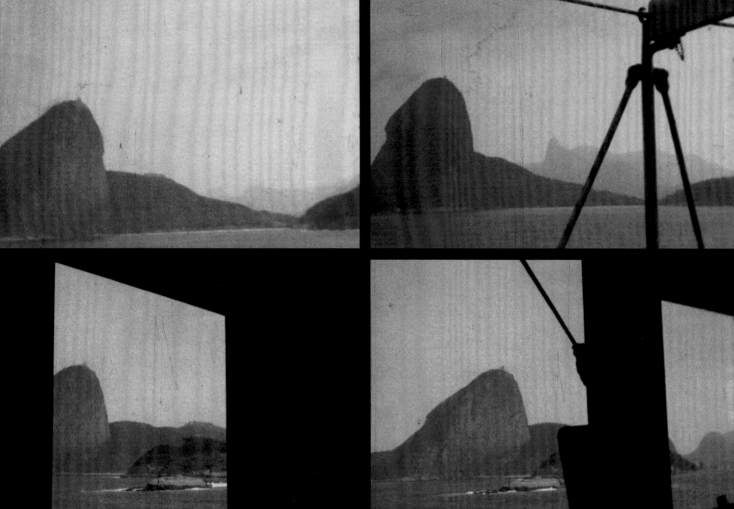

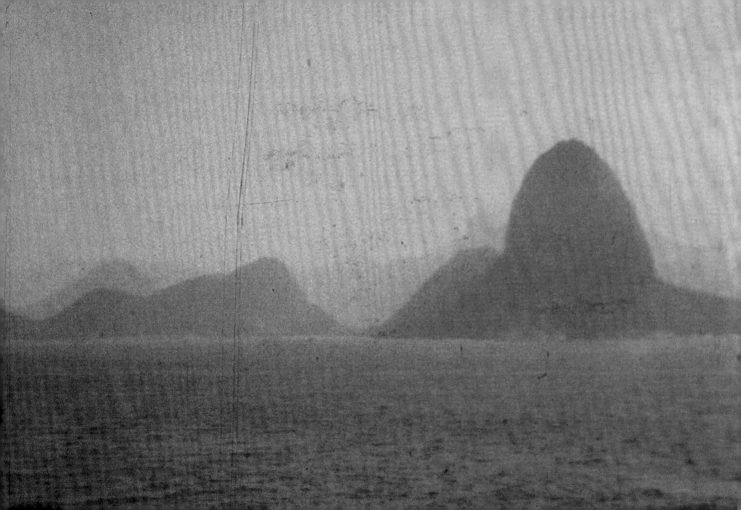

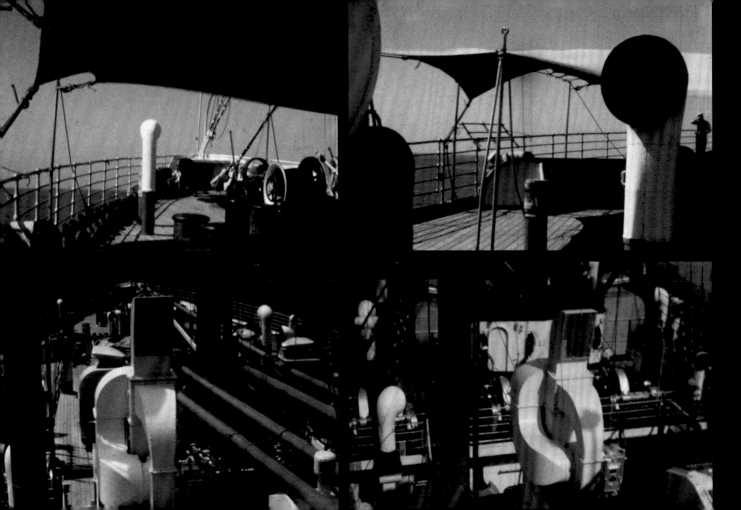

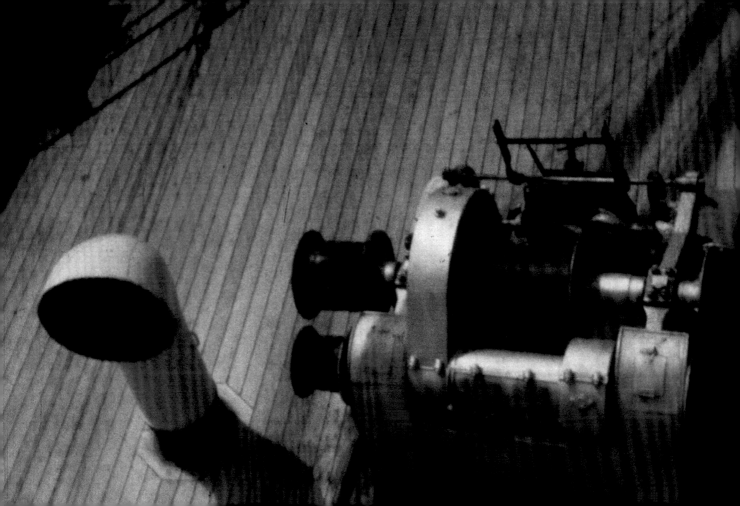

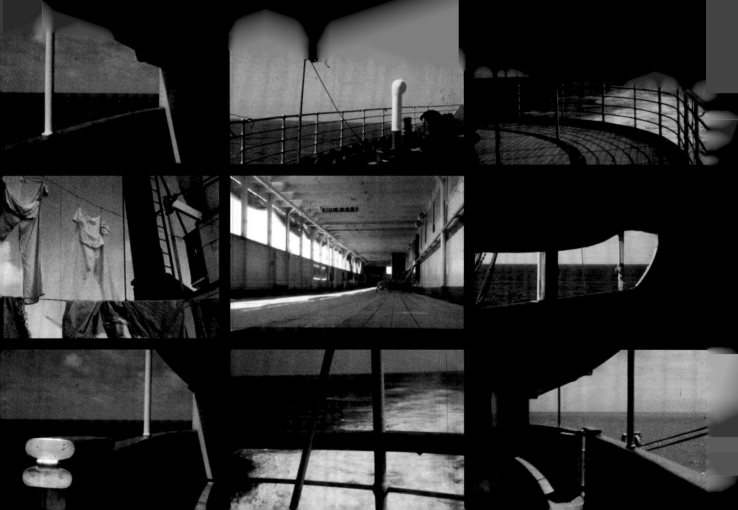

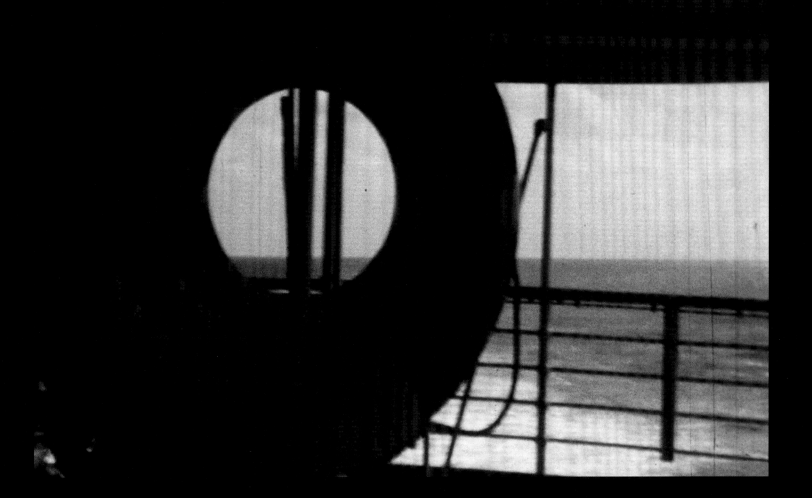

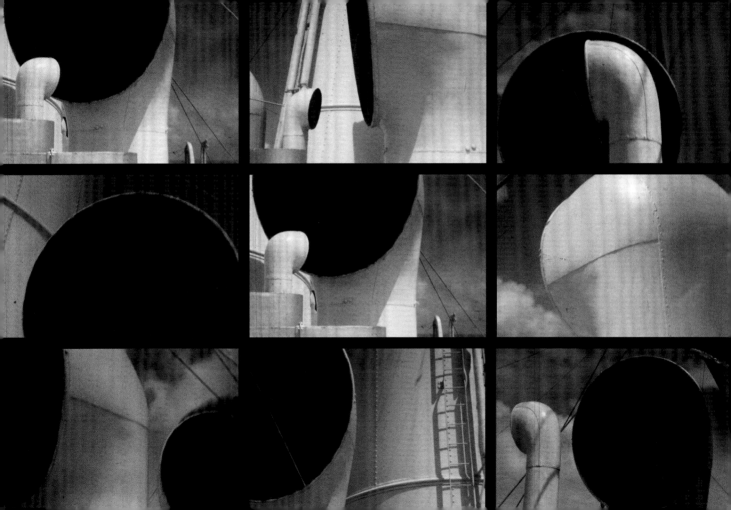

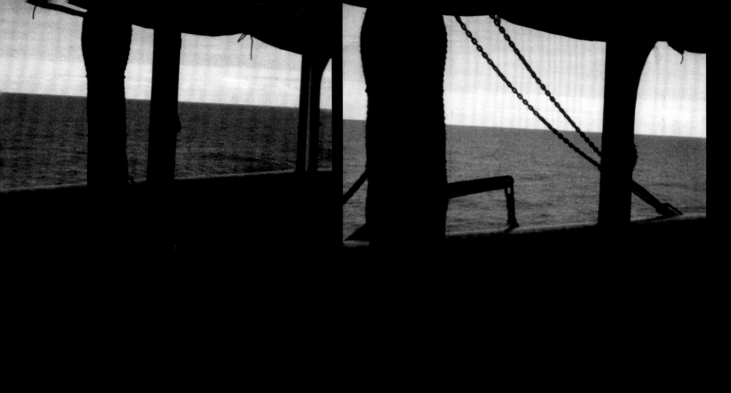

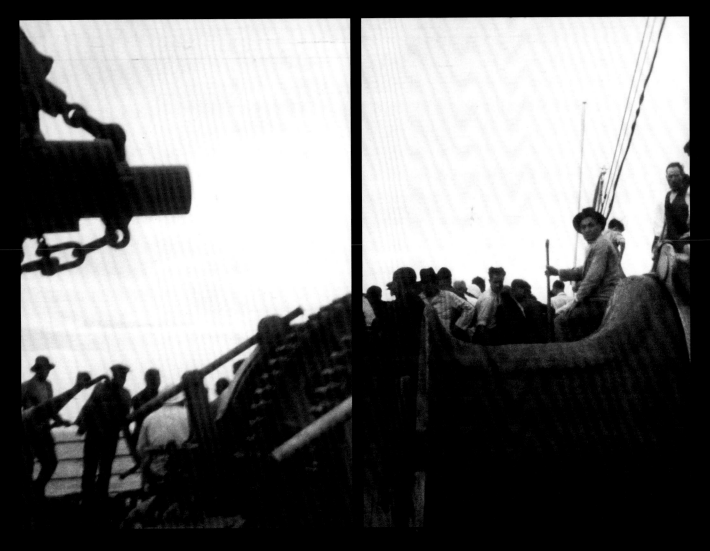

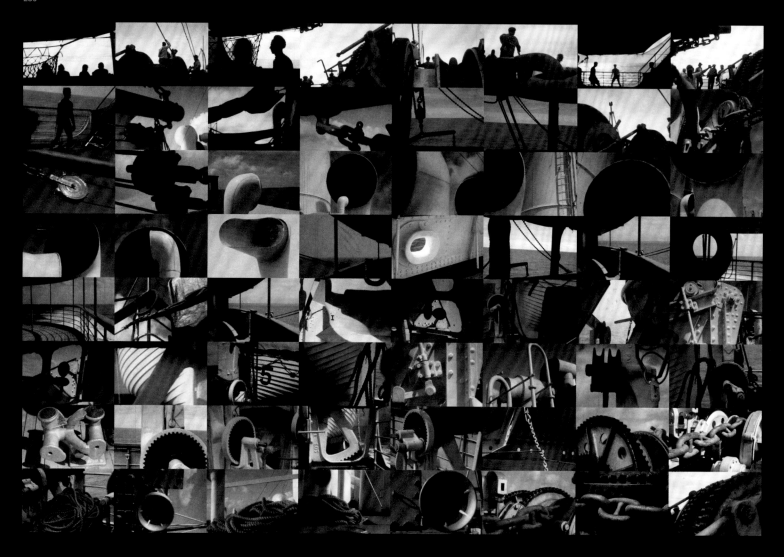

A Harbor on the Mediterranean

FIGS. 234–36 **Le Corbusier, photographs taken from his hotel, Villefranche, August 1936**
FLC Séquence 8575, 8932, 8869
→ pp. 292–93 bottom right, 294

On August 27, the *Conte Biancamano* berthed at Nice's harbor, at Villefranche, where Le Corbusier found Pierre Jeanneret and Yvonne waiting for him on the quay, in the company of Badovici and Madeleine Goinot. Pierre had driven Yvonne down from Paris in the Voisin. Yvonne had written to Badovici and Madeleine on August 21 hoping that they would join her to await Le Corbusier: "I would be happy if you came; we could have some fun."[239] The photographs Le Corbusier took in the port of Villefranche show him experimenting further with the dramatic compositional methods of the photography of the "New Vision."

Like all the exponents of the "New Photography," Le Corbusier knew how to allow the light to paint the subject, playing on the ambiguity between subject and form, between shadow and motif. A dozen photographs from the balcony of his hotel explore the possibilities of the diagonal, sometimes giving emphasis to the human dimension—people, boats, signs—and sometimes frankly making the black, white, and gray take command. For someone who never used this kind of effect in his drawings or paintings, these photographs represent new work, aesthetically speaking.

Stepping back, he incorporated the decorative grille of the balcony balustrade into his compositions →p. 295. Nearly twenty years after his harsh criticism of the decorative arts, these images reveal the secret pleasures of an admirer of Matisse and Picasso and perhaps of the decorative instincts of the youth trained at the École d'Art in La Chaux-de-Fonds.[240] Once again, he takes care to compose and find visual puns, aligning the wake of the motorboat to the angle of the railing.

The presence of the *USS Quincy* in the harbor excited Le Corbusier's interest and he made two turns around the ship in a hired boat, taking over 160 pictures of the ship.

239 FLC E1(5)21.
240 See A. Ozenfant and Le Corbusier, *Après le cubisme* (Paris: Éditions des Commentaires, 1918).

FIGS. 237–38 **Le Corbusier, photograph of the
USS Quincy in Villefranche harbor, August 1936**
FLC Séquence 08661, 08645 →pp. 298–99

FIG. 239 **Le Corbusier, photograph of nets
on the quayside, Villefranche, August 1936**
FLC Séquence 8596 →pp. 302–03

Many of these shots, taken from a rocking rowing boat, are unsharp, but even these show Le Corbusier's eye for dramatic silhouette. We also find the bold subdivision of the picture surface into geometric regions; note the square created by the bow of the ship in FIG. 237, an image that makes one think of the cutting edge of the south corner at Ronchamp.

At Villefranche, Le Corbusier discovered another sequence to explore. He was fascinated by the effects of transparency and the spatial illusions created by the diaphanous fishing nets laid out to dry on the quayside. He took nineteen shots of these and then returned later to take another twenty-three →pp. 302–03.

In this sequence Le Corbusier explores the way the nets seem to "stain" the quayside, almost like a watercolor wash, merging with the stone. He also plays with the tensed web of lines created by the raising of the nets on the stone bollards. He had not used many tensile structures in his work by 1936, but he would soon design the large tent for the Pavillon des Temps Nouveaux at the 1937 exhibition in Paris, which he later photographed both in construction in the summer of 1937 and during its demolition in January 1938. We also find some more informal views from a quayside café →pp. 296–97 and some picturesque photographs in the harbor town of Villefranche →pp. 300–01.

Villefranche

August 27–30, 1936

Album 8

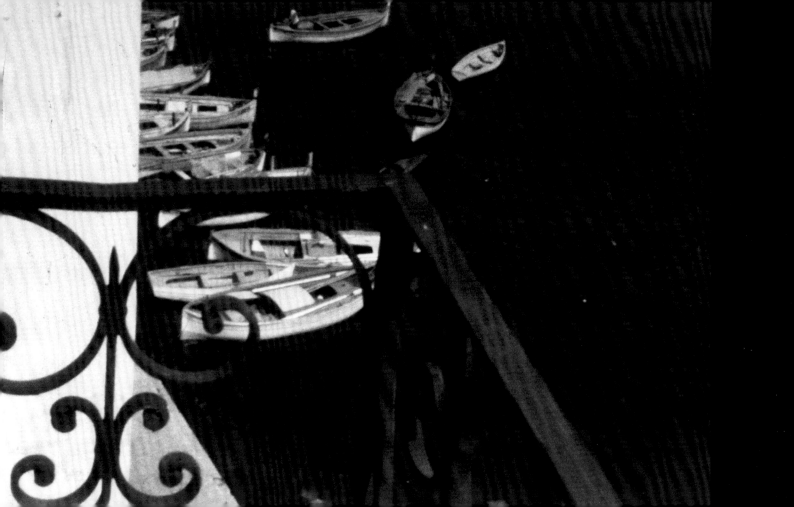

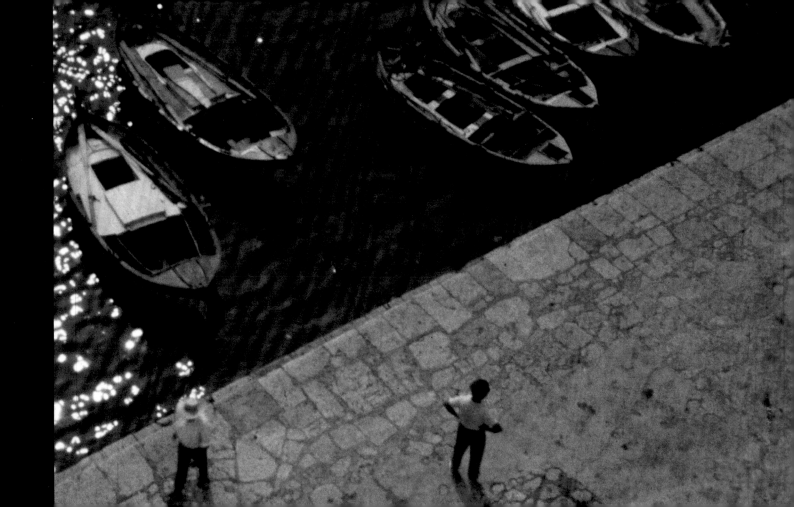

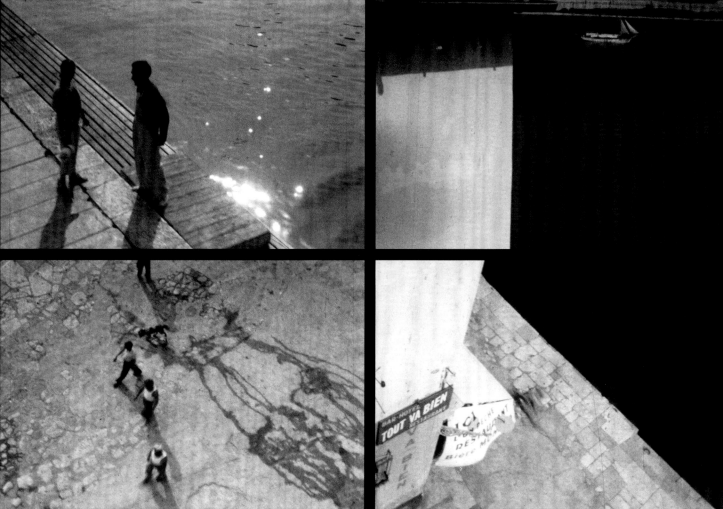

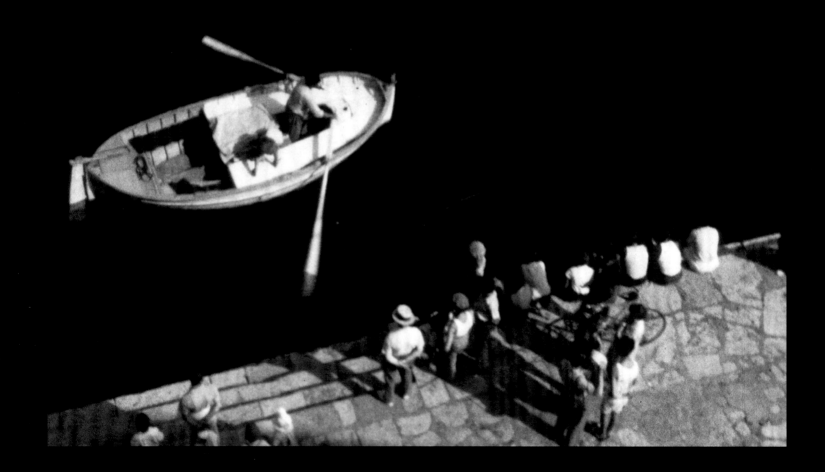

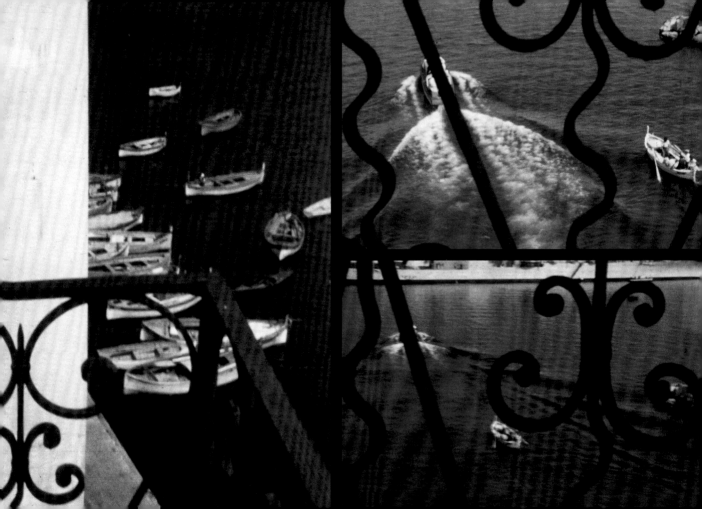

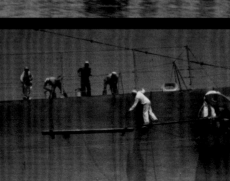

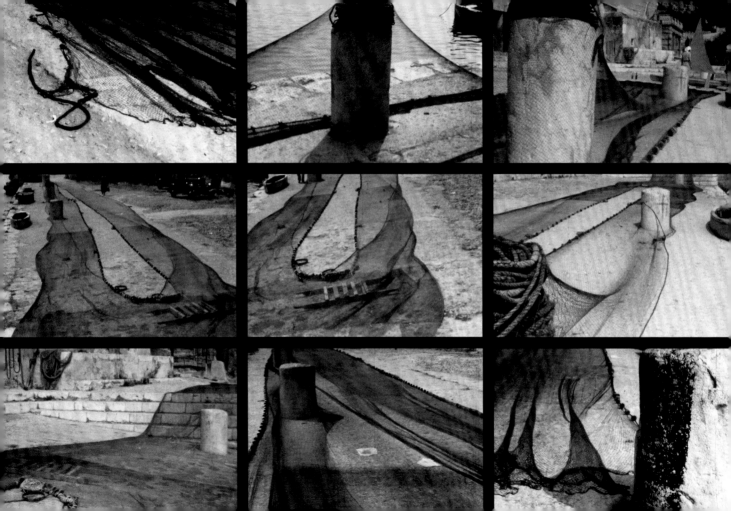

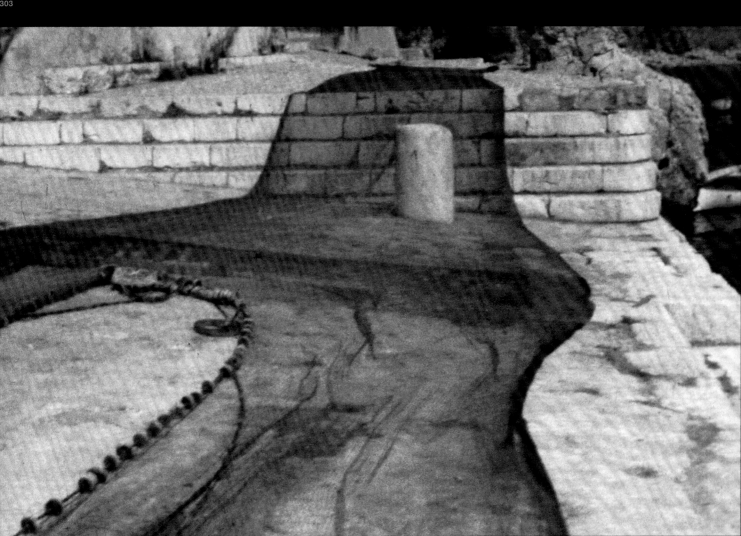

On the Beach

241 Among drawings of the bone, alone or with another subject, are drawings 5953, 6248, 4817-9, 4822-3, 4825-7, and 4830-2. For a discussion on setting *Léa* into the context of the paintings of this period, see C. Green, "The architect as artist," in *Le Corbusier: Architect of the Century* (London: Arts Council of Great Britain, 1987): 110–30.

"I am attracted to a natural order of things"

Opening words of *The Radiant City*, 1935

FIG. 240 **Le Corbusier, photographs of human imprints in the sand, Le Piquey, September 1936** → p. 333

FIG. 241 **Le Corbusier, sketch of tree, woman, chair, and coil of rope** FLC 3425

FIG. 242 **Le Corbusier, four photographs of motifs, in and around Le Piquey, corresponding to elements included in his paintings of 1928–32**

The majority of the photographs that Le Corbusier took between 1936 and 1938 are of natural subjects, seen in detail and fairly abstract. These photographs can roughly be divided into images of visual stimulation for his paintings and natural forms that seemed to him to have a more symbolic role, standing for the great ordering principles of nature. Many of the former are the photographic equivalents of the little sketches he made in his notebooks and sketchbooks as visual reminders and stimuli for his painting. There are hundreds of these. From 1928 on, he had been using natural objects in his paintings: bones, seashells, and flotsam found on the beach. He described these "objets à réaction poétique" (objects for stimulating the imagination) as his "CP (collection particulière)," his special collection. Many of them have been conserved in the archives of the Fondation Le Corbusier. Le Corbusier shot a film sequence of three bones, which resembles an airplane circling around a megalith FIGS. 245–47.

This bone was virtually a fetish for Le Corbusier, who drew it from every angle in thirteen drawings, as well as incorporating it into several important paintings, including his *Léa* (1932) FIGS. 243–44, 246.[241] Le Corbusier's paintings of 1928 to 1935 are full of observations made in and around Le Piquey, a small village on the long dune of sand planted with pine trees, separating the Arcachon Bay from the sea: boats, fishermen, oyster women, coils of rope, seashells, and nude women. In 1936, he revisited this iconography in his photographs. Working with a particular theme or motif—footprints, ripples, patterns of pebbles or shells—he would take dozens or hundreds of images, each one bringing a different emphasis of light and shade FIG. 240.

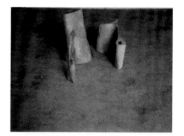

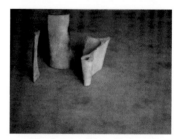

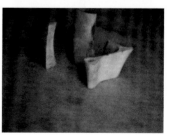

FIG. 243 **Le Corbusier, study for the painting** *Lea,* **1932** FLC 3602

FIG. 244 **Le Corbusier, drawing of bone and mussel, in preparation for** *Léa* FLC 4817

FIGS. 245–47 **Le Corbusier, frames from a film sequence of three bones on the floor of his atelier at 24 rue Nungesser et Coli**

FIG. 248 **Le Corbusier,** *Nature morte à la racine et au cordage jaune,* **1930**

FIG. 249 **X-ray photograph of a** *Nautilus pompilius* **shell,** *Wendingen,* **winter 1922–23, p. 17**

FIG. 250 **Diagram of the pulmonary system, published in** *Urbanisme,* **1925, p. 292**

FIG. 251 **Le Corbusier, the weather system under the heading "male and female,"** *The Radiant City,* **p. 77**

In other cases, he focused on objects seen lying around on the beach. Some of these photographs have documentary value, identifying elements in his drawings and paintings pp. 328–29. For example, in the back terrace of the Hotel Chanteclerc, where Le Corbusier and Yvonne stayed, there was a tree that often features in Le Corbusier's drawings and again in *Léa* FIGS. 242 bottom left and 243. He liked to transform the tree into the form of a woman's torso, and often drew a female nude beside it FIG. 241.

The horse-drawn lumber cart, logs of wood, and tree roots that appear in his painting *Le Bûcheron* (The Logger, 1931) also feature in many of his photographs. Countless details of "objets à réaction poétique" are photographed on the beach, half-embedded in sand →p. 328–29. These images draw together the iconogoraphy of Le Corbusier's art of the early 1930s: the graphic, semiabstract forms derived from the bric-a-brac of the seaside. He also photographed the fishermen's boats that appeared in his paintings.

The characteristic long and shallow boats of the Arcachon Bay lagoon, complete with their heavy coils of rope, constituted another favorite theme of his drawings and photographs FIG. 259. Once again, the "pinasses" became a sequence, with Le Corbusier exploring every angle in an effort to capture the sinuous curve of the prow in perspective. Le Corbusier's paintings meld natural, mechanical, and human forms. The hips and thighs of the nude in *La femme, cordage et bateau* (Woman, ropes, and boat) are like the expressive rocks at Ploumanac'h or Plougrescant in Brittany →p. 363.

These photographs were taken several years after the paintings in which he had begun to incorporate the "objets trouvés" into his work. Although we can find traces of anthropomorphic references in the shadows, Le Corbusier did not share the morbid introspection and oneiric fantasies of the Surrealists. He did, however, find hidden meanings in natural and mechanical forms. I do not accept Gorlin's suggestion that Le Corbusier's work was thoroughly permeated by Surrealism—an argument that, to me, does not

FIG. 252 **Charlotte Perriand, old acacia, 1933**
Charlotte Perriand Archive

FIG. 253 **Pierre Jeanneret, photograph of tiles, probably taken in Le Piquey, which he used in the photo mural in the Swiss Pavilion, 1934**
Charlotte Perriand Archive

seem to rest either on evidence of Le Corbusier's intentions or on any plausible deductions from the work.[242] The Beistegui apartment, whose Surrealist décor was largely the work of Charles de Beistegui's advisers, is the exception that proves the rule. There is no evidence that Le Corbusier read either *Minotaur* or *La Revolution Surrealiste*, and his only contribution to the former was to promote the work of his cousin Louis Soutter.[243] Le Corbusier was principally interested in the sensual pleasure to be derived from objects, but he was also developing in these years a personal mythology based on the cosmic forces of nature. We can trace the origins of these ideas to the early 1920s, when he began collecting seashells and other objects, which he saw as demonstrating a link between the geometry of natural forms and the universal laws of harmony. In 1923, he wrote to Hendrik Theodor Wijdeveld, the editor of the luxurious Amsterdam-based magazine *Wendingen*, praising him for the magnificent issue they had just produced featuring photographs and X-rays of seashells.[244] Le Corbusier claimed that he had been collecting shells for some time, but that he was particularly struck by the X-ray photographs, because they showed the shells' hidden structure, formed along the geometry of the golden section.

Le Corbusier clearly obtained a set of prints from Wijdeveld, because some of these photographs turn up later in his publications. For example, FIG. 249 appears over the heading of the chapter "L'heure du repos" (Free time) in his book *Urbanisme* (1923).[245] The end of this book, mostly filled with highly technical arguments about town planning, consists of a series of woodcuts of microorganisms, botanical sections, and diagrams of the respiratory system, which he says was suggested to him by his associate Pierre Jeanneret.[246] One of these diagrams, showing the pulmonary system FIG. 250, was reproduced again and again in his lectures and books, for example in *La Ville Radieuse* (p. 40). The fascination with natural objects as sources of inspiration for his paintings has a number of dimensions to it. On the one hand was a growing

242 See A. Gorlin, "The ghost in the machine: Surrealism in the work of Le Corbusier," *Perspecta* 18 (1982): 51–65. I do not agree with Gorlin's arguments. The Beistegui apartment, whose Surreallist décor was largely the work of Charles de Beistegui's advisers, is the exception that proves the rule.
243 *Minotaur* 9 (1936). (X1-13-32 (1-5))
244 Letter to Wijdeveld, January 8, 1923 (FLC R3(6)149).
245 Le Corbusier, *Urbanisme* (Paris: Éditions Vincent, Fréal & Cie, 1966), 190.
246 Ibid., pp. 288–93.

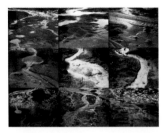

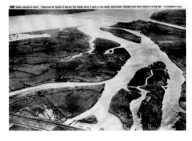

FIG. 254 **Le Corbusier photographs of sand and water** → p. 327

FIG. 255 **Photograph reproduced in Le Corbusier's book** *Aircraft*, **1935, ill. 120, with the caption: "Water returns to water. Dispersed as vapor in the air, the winds drive it back to the earth, and brook, tributary, and river return it to the sea."**

tendency among a number of artists, and especially his friend Fernand Léger, to turn toward nature for inspiration. This tendency was also found in Le Corbusier's own architecture. From 1929 on, he increasingly abandoned the use of pure white concrete forms and began to use rough stone walls, wood, and brick in his designs. This was also reflected in the work that his associate Pierre Jeanneret and his assistant Charlotte Perriand performed outside the work of Le Corbusier's atelier. Pierre and Charlotte became a couple in 1933 and spent most of their spare time together. They took photographs of vernacular architecture in the valleys of the Jura and of natural as well as mechanical objects FIGS. 252–53. Both Pierre and Charlotte were interested in photography and possessed good cameras, including a 6 × 6 cm Rolleiflex.

These photographs demonstrate a high level of technical and aesthetic sophistication. Whether Le Corbusier saw these photographs and was influenced by them is unclear, since relations between himself and his cousin Pierre, as well as with Charlotte Perriand, had become strained by 1936 and they had ceased spending much time together. What is clear is that there was, among those close to Le Corbusier at this time, an interest in photographing natural and mechanical forms and looking for abstract or near abstract relationships in the images. Le Corbusier, however, also had a particular approach to natural forms, seeking beyond the purely visual for a symbolic and cosmological significance.

He sketched out these ideas in some detail in his important book *La Ville Radieuse* (1935), some of it based on articles written in *Plans*, *Prélude*, and *L'Homme Réel* between 1931 and 1934.[247] On page 7 of his book, a diagram of the solar system is labeled laconically "système," and a whole section headed "Lois" spelled out the spirit of the laws of nature:

We have three spheres:
The dictator: the sun

247 Le Corbusier, *La ville radieuse, éléments d'une doctrine d'urbanisme pour l'équipement de la civilisation machiniste. Paris, Genève, Rio de Janeiro, São Paulo, Montevideo, Buenos-Aires, Alger, Moscou, Anvers, Barcelone, Stockholm, Nemours, Piacé* (Paris: L'Architecture d'Aujourd'hui, 1935).

FIG. 256 **Le Corbusier, sketch made from the plane piloted by Louis Durafour over the Sahara Desert, March 18, 1934, reproduced in** *Aircraft*, **1935**

FIG. 257 **Le Corbusier, sketch made from Louis Durafour's plane, March 19, 1933, over the Sahara,** Cahier 5, page 36, FLC 5014

Its companion, who twirls around us: the moon
Suddenly, the tempo of our daily actions is fixed:
By the 365 days of the solar year, the path of our bodies, our hearts and our mind.[248]

Le Corbusier went on to spell out his cosmic metaphors, the male and female (sun and moon), the dictatorship of the sun, and the law of water (the law of the meander), illustrated by sketches recalling his flights in South America and North Africa FIGS. 256–57. The great cosmic forces of sun and water, wind, earth, and fire governed human existence. All this was challenged and negated by man-made cities. Escaping the city to spend time in the country or by the sea was, for Le Corbusier, an opportunity to confront the fundamental laws of nature.

In the lectures he gave in Buenos Aires in 1929, Le Corbusier talked about his reaction to flying over the jungle and seeing the huge meanders of the rivers and the oxbows that remained after the meanders touched. In 1929, Le Corbusier interpreted this image as a metaphor of human decision-making in history. Men's understanding becomes increasingly convoluted, obstructing the natural processes of logic, until a moment of decision is reached and the Gordian knot is cut, allowing the metaphorical river of thought to flow more directly to the sea. In the 1930s, however, this aerial vision of the forces of nature shaping the world—wind, evaporation, rainfall, erosion—took on a more cosmic scale for Le Corbusier. In all of this, Le Corbusier was following his friend Dr. Pierre Winter, who had cowritten an article about preventive medicine entitled "Les grilles cosmiques de l'homme" in April 1931:

The earth, that is to say the [combination of] a centripetal influence (gravity), the ascending centrifugal influence (the sun), and a tangential lateral influence (the moon). The earth's influence is heavy and bears down on man from top to bottom. The sun's

248 Le Corbusier, *La ville radieuse* (Paris: L'Architecture d'Aujourd'hui, 1935), 7. This passage was eliminated from the English edition, Le Corbusier, *The Radiant City: Elements of a Doctrine of Urbanism to Be Used as a Basis of Our Machine-age Civilization* (New York: Orion Press, 1967).

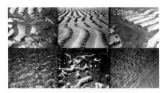

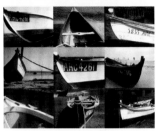

FIG. 258 **Le Corbusier, photographs of ripples of water and their imprint in the sand, Le Piquey, September 1936** →pp. 324–27

FIG. 259 **Le Corbusier, photographs of "pinasses," the fishing boats of the Bassin d'Arcachon lagoon, September 1936** →p. 320

FIG. 260 **Le Corbusier, photographs of boats at dusk, Bassin d'Arcachon, September 1936** →pp. 322–23

influence lightens him and draws him upward. The moon's influence softens him and displaces him sideways, working on the weak points where there is no bone, the joints.[249]

Le Corbusier took a number of photographs with his cine camera aimed at illustrating these cosmic forces FIGS. 254–55. More abstract and surprising, these images were clearly conceived as forming part of an almost cinematographic series. For this reason, I have combined them into groups, following the principle of the photo-mural created by Le Corbusier and Pierre Jeanneret on the curving wall of the assembly room at the Swiss Pavilion in the Cité Universitaire, Paris, in 1934 FIG. 258.

Each sequence was shot looking down at the sand immediately in front of him, and he managed to create an astonishingly varied range of effects from this perspective. Above and beyond the "photographic" effects of composition and play of black-and-white tones, all sense of scale has disappeared. We could be looking down on the desert, as Le Corbusier had done in an airplane piloted by Louis Durafour on March 18, 1933 when they flew from Algiers to Laghouat and Ghardaia FIGS. 256–57. In his book *Aircraft*, Le Corbusier makes the explicit connection between his observations of natural forces from the air and a sense of destiny:

> *With Durafour across the Atlas (Algiers—Ghardaia) March 18, 1933.*
> *The Earth: a bony structure (rocks) product of matter in fusion cooled on the surface and having undergone shrinkage, contraction, splitting and tearing apart, etc....*
> *And above:*
>
> *The immemorial play of water—water vapor. Rivers or erosion or infiltration....*
> *Annihilation of wealth or creation of wealth.*
> *Thus God, looking down on things from above, is assured of having delivered Earth to fate—to its fate.*[250]

249 P. Winter and M. Martiny, "Les grilles cosmiques de l'homme," *Plans* (April 1931): 43–44.
250 Le Corbusier, *Aircraft* (London: Studio, 1935), 116.

FIG. 261 **Le Corbusier, views of the fishermen and oyster women of the Bassin d'Arcachon, September 1936** → pp. 330–31

FIG. 262 **Le Corbusier, views of timber, bricks, and tiles used in the construction of oyster and mussel frames** → pp. 318–19

FIG. 263 **Le Corbusier, views of the pier in Le Piquey** → p. 321

In his photographs of sand, Le Corbusier is also trying to understand the way in which the sea, rising and falling with the tides and driven by the wind, molds the surface of the sand. This is both a highly architectural way of looking—searching for cause and effect—and also a reflection on nature and its cosmic system, at a tiny scale → pp. 324–27.

Among the many photographs of sand and water are a group that create an almost cinematographic effect FIG. 258. Le Corbusier stood with his feet in the shallows, photographing the water as it passed over the sand and receded, trying to understand the relationship between the ripples of water and the imprint left on the sand.

Le Corbusier did not only observe the forces of nature and inanimate objects. He loved the simple life and admired the men and women who worked the pine forests and oyster beds of Arcachon Bay. His book *Une Maison – Un Palais* (A House, A Palace, 1928) includes a long and moving description of the "honest people" who preserved the traditions of craftsmanship and retained a sense of authenticity in their lives.[251] A sketch of one of these huts, drawn by Amédée Ozenfant, not only appears in the book, but is given pride of place on the cover FIG. 265.

Many of Le Corbusier's photos record this threatened community and the rustic cabins they lived in. The visitors' book at the wooden Hotel Chanteclerc FIG. 268, where he often stayed, includes this inscription by him:

I like wooden houses because they are honest: both spiritually and in construction. Le Piquey is nearly finished! I knew it before the roads and the builders came. The lagoon, governed by the thirteen-hour rhythm of the tides—a truly cosmic rhythm—breeds constant diversity and infinite combinations. Now the houses have become "Basques" with false beams in painted cement and fake wood! ... I do believe that if the land had been in the hands of savages, the other half—the lagoon— would have been saved. Where the hell to find something true ...?[252]

251 Le Corbusier, *Une Maison – Un Palais* (Paris: Crès, 1928), 46.
252 Le Corbusier, note in the Livre d'or of the Hôtel Chanteclerc, September 1936 (FLC E2(8)109).

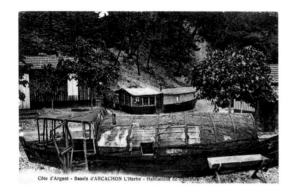

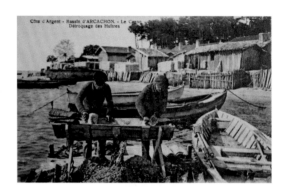

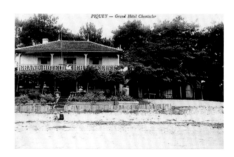

FIG. 264 **Postcard of boathouses constructed by the fishermen in the pine forests around Le Piquey** Le Corbusier's collection FLC L5(5)34

FIG. 265 **Le Corbusier, cover of *Une Maison – Un Palais*, 1928**

FIG. 266 **Postcard of men cleaning oysters, Bassin d'Arcachon** Le Corbusier's collection FLC L5(5)38

FIG. 267 **Le Corbusier, pen sketch of two women cleaning oysters on the beach, 21 × 31 cm** FLC 5997

FIG. 268 **Postcard of the Hotel Chanteclerc, where Le Corbusier and Yvonne stayed in Le Piquey**

FIG. 269 **Le Corbusier, sketch of a woman with a pile of plates and another woman preparing a meal, Hotel Chanteclerc, Le Piquey, 1933** FLC DE 2317

FIG. 270 **Madame Vidal buying the meat from the traveling butcher, Hotel Chanteclerc, Le Piquey, September 1936** FLC Séquence 31039

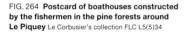

253 Letter to his mother, October 2 1936 (FLC R2(1)229).

Le Corbusier made several sketches and dozens of photographs in and around the Hotel Chanteclerc, where he appreciated the informal lifestyle and long, convivial meals with Yvonne and their friends →pp. 202–03. Badovici was genial, good company and kept Yvonne amused with his antics. Le Corbusier told his mother that Yvonne was "irritated by the sea, which does not agree with her."[253] But Badovici could be counted on to lighten the tone. There are photographs of them all dressing up with seaweed beards and ice-cream-cone noses, Yvonne with an enameled bowl on her head →pp. 200–01.

Another group of views in and around Le Piquey constitute a set of seascapes that recalls the work of the landscape painters that Le Corbusier knew from his early days in La Chaux-de-Fonds FIG. 260. A melancholy romanticism characterizes these pictures and sketches of the pinasses that worked the tidal waters of Arcachon Bay. These views are a million miles away from the robust and erotic flavor of his paintings of the period and give an interesting insight into his complex reactions to landscape. He also took a number of discreet shots of fishermen and oyster women, working or at rest, giving them a kind of heroic dignity FIG. 261.

If Le Corbusier mourned the loss of innocence of Arcachon Bay, his modernist eye was still sensitive to images of geometrical order and mechanical production, which he collected alongside images of the vernacular FIG. 262. The style of these photographs, their framing and composition, differ markedly from his other pictures in Le Piquey. He also interested himself in the constructions of the pier, apparently flimsy but well designed FIG. 263. Le Corbusier gives this feature a monumental scale and explores the spatial ambiguities around its wooden piles. These photographs demonstrate how, even with a camera with very few controls, Le Corbusier was able to manipulate photographic style to capture different effects.

FIG. 271 **Le Corbusier, preparatory sketch for the tapestry for Marie Cuttoli, 21 × 31.1, 1935** FLC 3042

FIG. 272 **Le Corbusier, sketch of rope and an anchor, Le Piquey** FLC Carnet B9 No. 600

Le Piquey, Bassin d'Arcachon
September 1936

Album 9

Le Piquey: Sand
During his vacation in Le Piquey, in the Bassin d'Arcachon in September 1936, Le Corbusier took a few panning shots of the sea but mostly concentrated on photographs of patterns in the sand, objects found on the beach, as well as the boats and the fishermen who worked them.

Le Piquey: Wood
Le Corbusier's rediscovery of natural materials in his own architecture is reflected in a number of sequences of photographs of wooden structures in and around Le Piquey and of the work of the lumberjacks in the pine forests of the Bassin d'Arcachon.

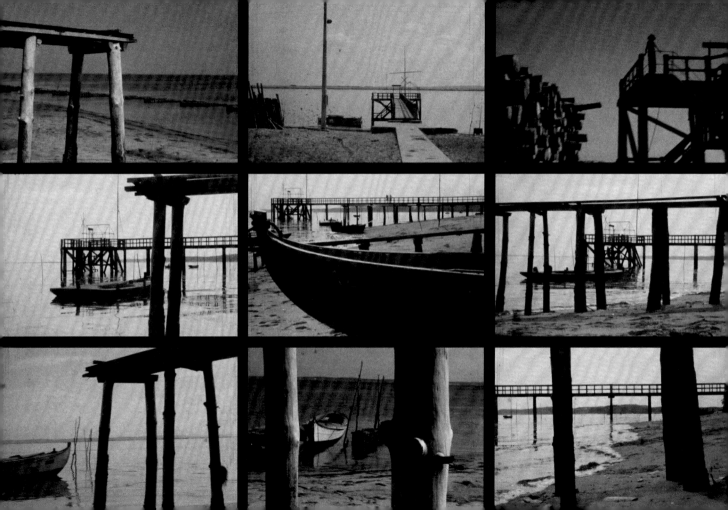

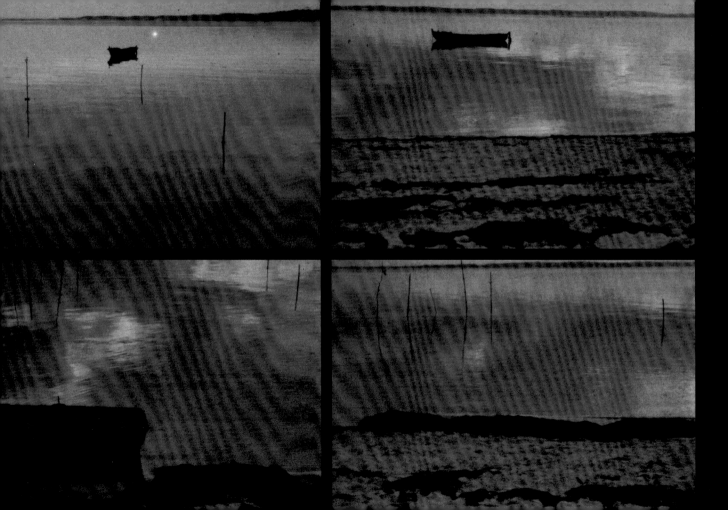

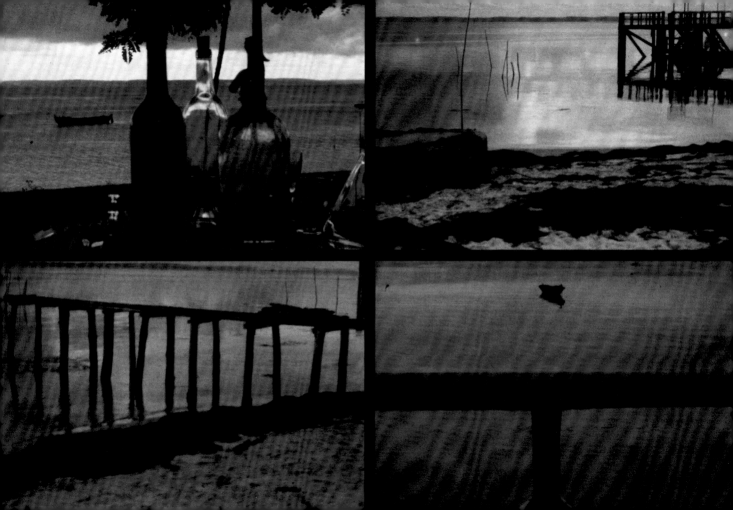

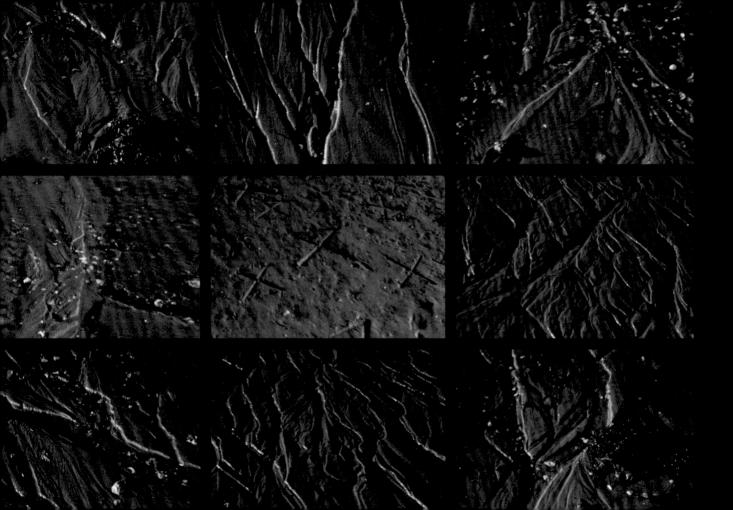

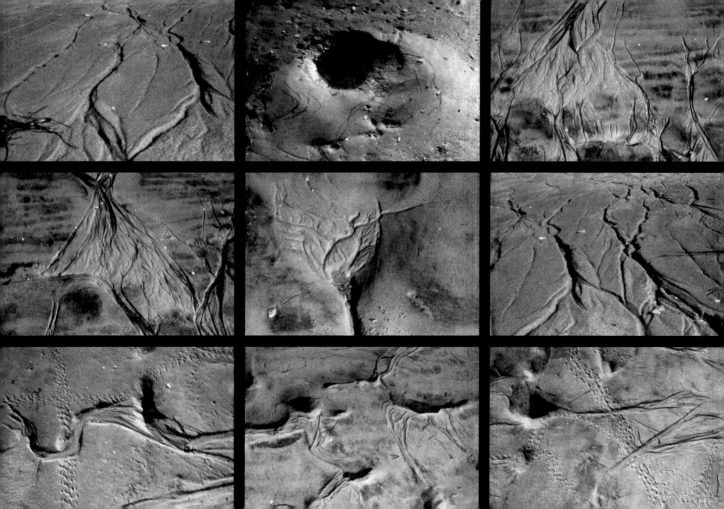

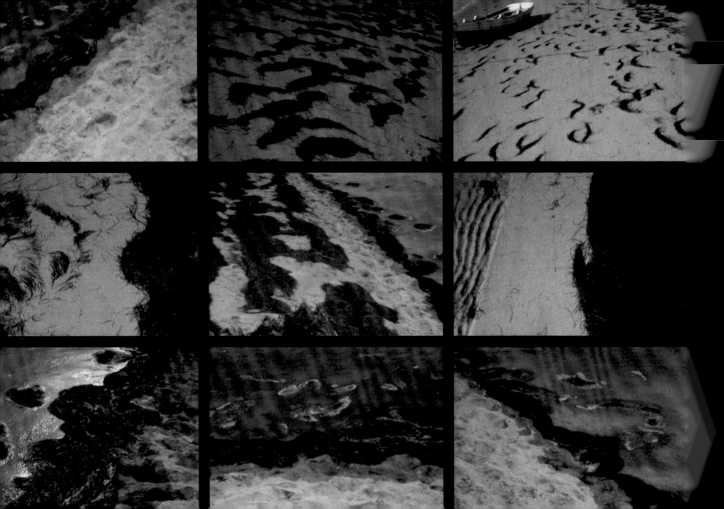

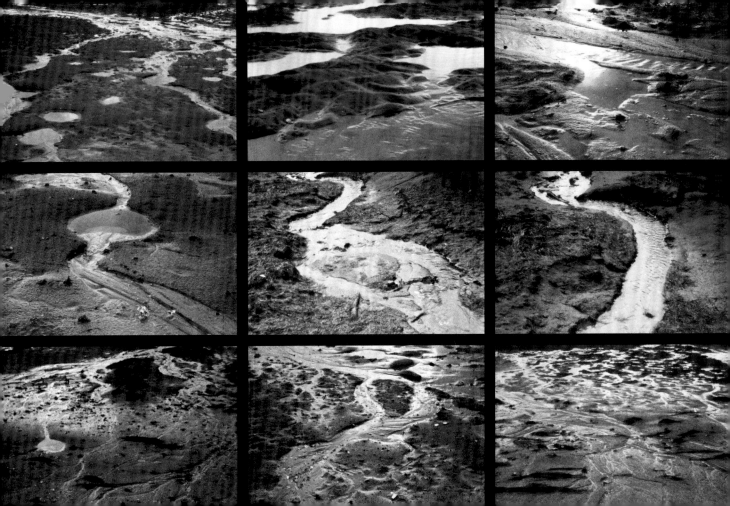

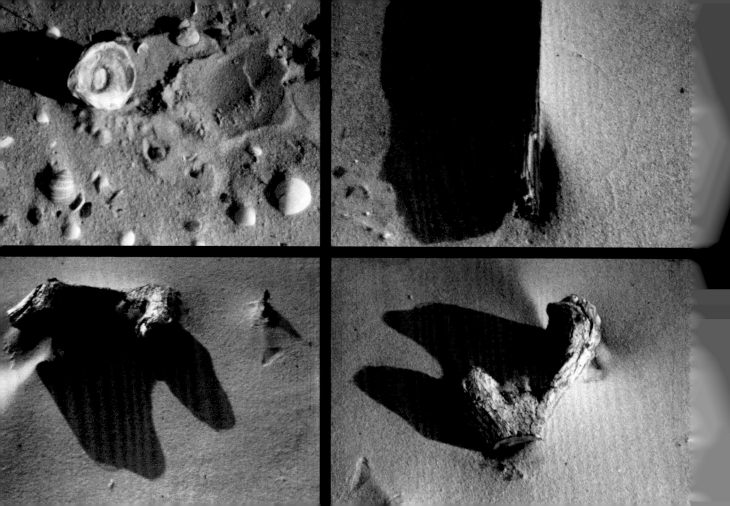

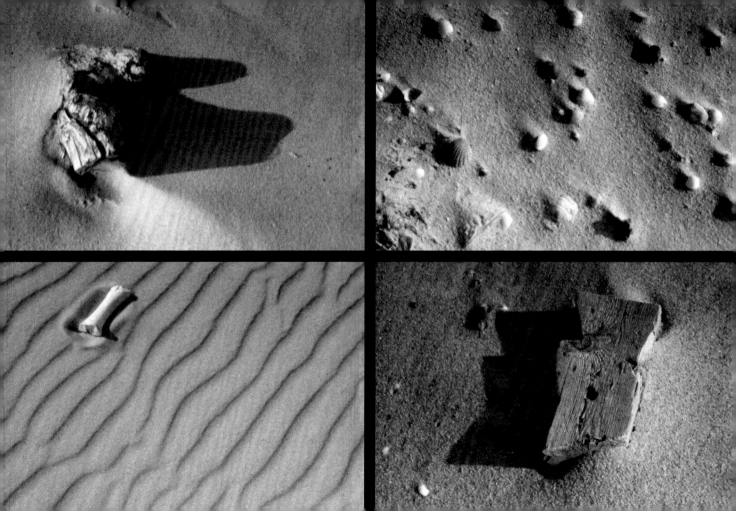

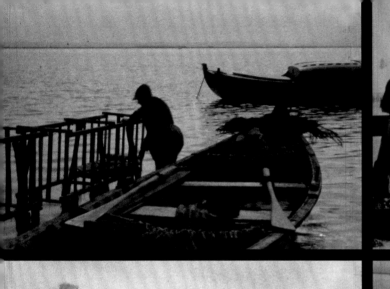
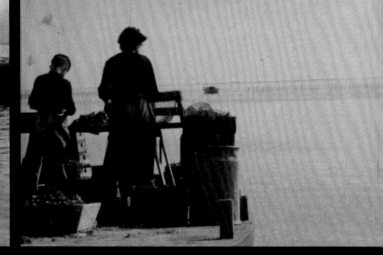
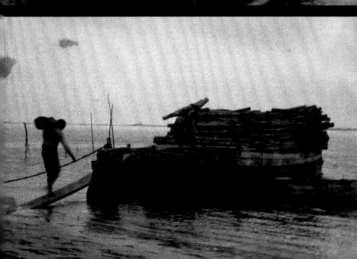
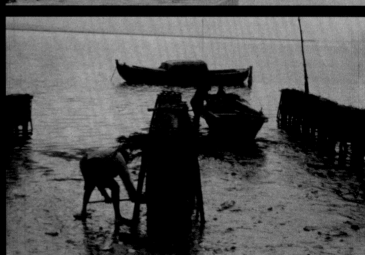

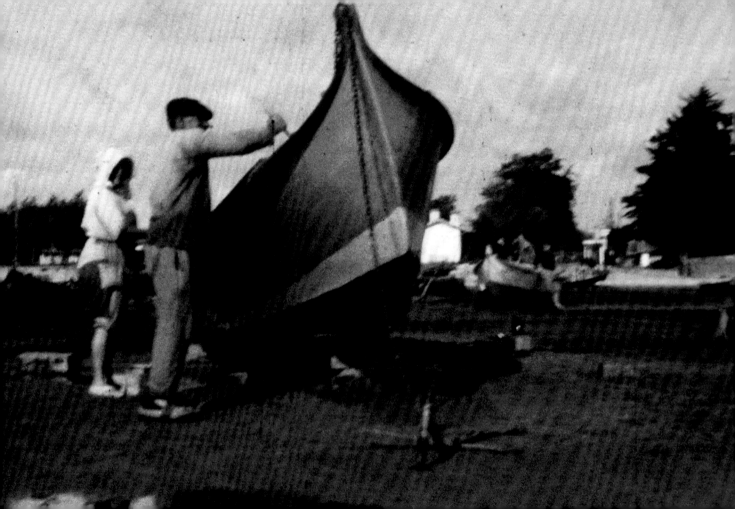

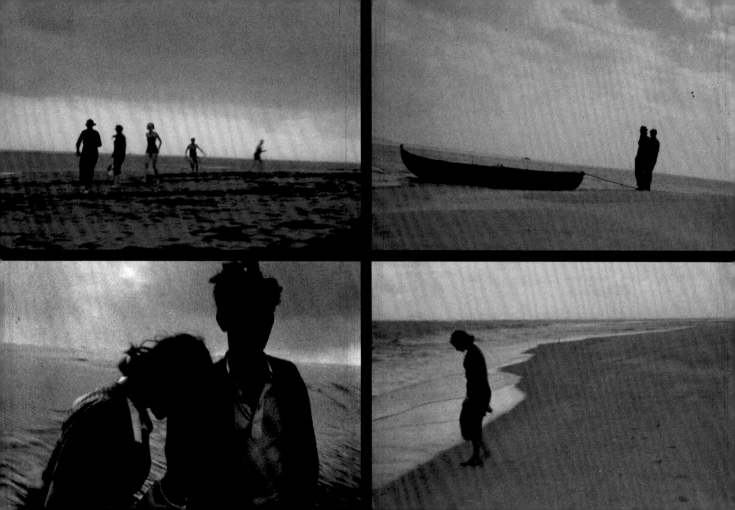

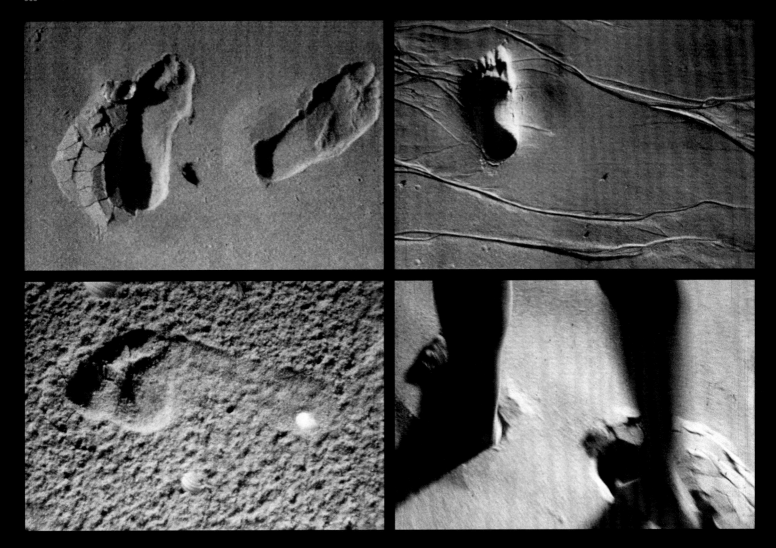

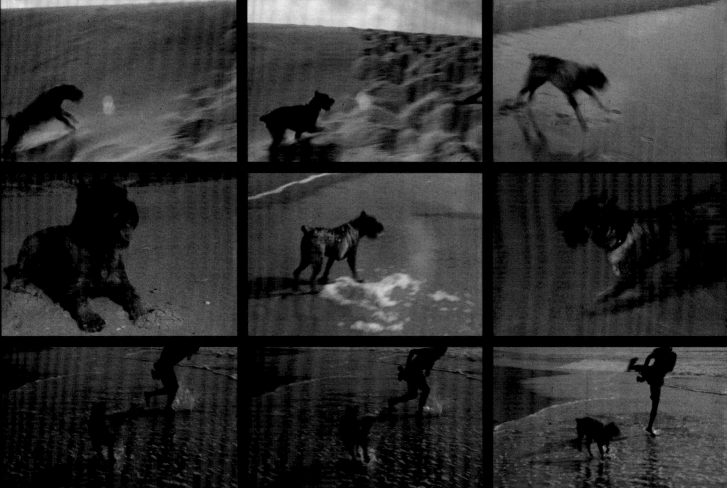

Stopover in Burgundy

On October 30, 1936, after a lightning trip to Rome (October 24) to give a lecture at an important conference, Le Corbusier joined his friends once again, this time in Vézelay, where Badovici had restored and modernized several houses, hoping to create an artists' colony in the venerable city. Le Corbusier had published a set of small square prints of the interior of one of these houses, describing it in glowing terms in the pages of *La Ville Radieuse*, captioning the photographs: "Why this astonishing freedom? Why this sweeping generosity? ... and this intimacy?"[254] FIGS. 273–74

It is not clear who the photographer of these pictures was, although the square format and the fact that they are now in the Charlotte Perriand archive indicates that they might have been taken by Pierre Jeanneret. Intriguingly, the elegant lady arranging flowers, maybe Eileen Gray FIG. 273, was erased from the photograph published in *La Ville Radieuse* FIG. 274. In 1936, Le Corbusier does not photograph the interior, but instead constructs a film sequence of Badovici and a friend (Pierre Guegen?), in hats and heavy overcoats, walking out of an upper-floor balcony onto a raised terrace. He also filmed Fernand Léger's recently completed fresco and took a number of photographs around the cathedral.

Among these photographs are some views of the medieval and Baroque buildings, in which there is a real sympathy for craftsmanship in stone, iron, and wood→pp. 340–41. Several carefully framed photographs of an old wooden cart are particularly interesting as evidence of Le Corbusier's love of vernacular and traditional craftsmanship→pp. 344–45. These are images of a kind Le Corbusier would never publish, reflecting as they do a taste he never proclaimed in public.

254 Le Corbusier, *The Radiant City: Elements of a Doctrine of Urbanism to Be Used as a Basis of Our Machine-age Civilization* (New York: Orion Press, 1967), 53–55.

FIGS. 273–74 **Photographs of Badovici's friends in his house at Vézelay (1934–35), published in *La Ville Radieuse***
Charlotte Perriand Archive

Vézelay

October 30–November 4, 1936

Album 10

Vézelay
At the end of October 1936, Le Corbusier visited Vézelay, where his friend Jean Badovici had converted some old stone houses. He made some film sequences of Badovici and a friend walking out onto the terrace of one of these houses, along with the large fresco that Fernand Léger had recently painted there.

On the Coast in Brittany

The strange and dramatic red rocks piled up and carved by sea and wind along the North Breton coastline had attracted artists and writers since the 19th century. For example, in the review *La photographie française* in 1900, an article on the rocks of Ploumanac'h by Édouard Lagache, and illustrated with his photographs, emphasizes the wild and fantastic beauty of the coastline FIG. 275.

He comments:

> *The ordinary visitor at Ploumanac'h stops, thunderstruck, gives up trying to understand, feels palpably uncomfortable ... before taking flight and forgetting post haste the more disconcerting aspects of the troubling things he has seen.*[255]

Lagache explains that the engineer Abdank had bought up a number of islands and plots of land in the area, in an effort to preserve the wild beauty of the landscape, and that a literary friend of his was even planning open-air theatrical performances. A tradition of identifiying anthropomorphic and fantastic shapes in these rocks was well established and nourished by the locals. Other sites, such as the troglodytic houses, the lighthouse precariously perched on the rocks, the house at Castel Meur, Plougrescant, squashed in between two huge rocks →pp. 355 top right, and the various chapels and shrines constituted the classic itinerary of the walking tour between Trégastel, Ploumanac'h, Perros-Guirec, and Plougrescant. Le Corbusier had visited Brittany since the 1920s, on one occasion with Fernand Léger, and collected a number of postcards of the area, including the bay of Saint Guirec, Ploumanac'h, where Le Corbusier had stayed on previous occasions.

255 E. Lagache, "Ploumanac'h," *La photographie française* (Paris: 1900): 209–13.

FIG. 275 **Edouard Lagache, "Ploumanac'h,"** *La photographie française*, **1900, pp. 210–11**

FIG. 276 **Postcards of the bay of Saint Guirec,
Ploumanac'h** Le Corbusier's collection, FLC L5(6)362

FIG. 277 **Postcard of a strange rock formation,
"le belier" (the ram), Ploumanac'h**
Le Corbusier's collection, FLC L5(6)366

FIG. 278 **Postcard of "le tricorne"
(Napoleon's hat), rock formation, Ploumanac'h**
Le Corbusier's collection, FLC L5(6)364

FIG. 279 **Eileen Agar, "Bum and thumb" rock,
Ploumanac'h, 1936** Tate Archive Photo Collection

FIG. 280 **Le Corbusier, three overlapping views
of the bay of Le Goufre from the upstairs room
of his bed-and-breakfast room, July 1937**
→ p. 353

FIG. 281 **Le Corbusier, two overlapping views
of the rocks near Plougrescant, July 1937**

These wild and spectacular rocks interested the Surrealists. The English artist Eileen Agar came through Brittany in the summer of 1936 with her husband and took a number of photographs with her newly acquired Rolleiflex camera. She had been introduced to photography by the English painter and photographer Paul Nash in 1935, when they shared a brief but passionate affair and took Surrealist pictures in and around the coastal town of Swanage. Agar's pictures at Ploumanac'h focus on the named rock formations, but find disturbing or erotic associations, following classic Surrealist principles. Her "bum and thumb" photograph is a witty "détournement" of this kind FIG. 279. Although Agar had taken up photography only the year before, she quickly adopted a near professional attention to composition, exposure, and presentation. She was aware from the start that her photographs were to be publishable or exhibitable products. Her work makes an interesting comparison with Le Corbusier's of a year later, because he was absolutely indifferent to the eventual uses to which his photographs might be put. His compositions are exercises in understanding and visual arrangement.

Le Corbusier's friendship with the Breton poet and critic Pierre Guéguen, born nearby at Perros-Guirec, probably helped him to make this choice for an extended convalescence after his painful bout of neuralgia early in 1937. Guéguen had sent him a friendly postcard from Tréguier while staying with the Sante family in September 1936 and passed on their best wishes.[256] In July 1937, Le Corbusier seems to have decided on Plougrescant rather than Ploumanac'h, staying in a cottage at Le Gouffre, on the northern tip of the Plougrescant promontory, further to the east of Ploumanac'h.

In his book *Une Maison – Un Palais* (1928), Le Corbusier had used images of the rocky coastline of Ploumanac'h to make an important statement about the relationship between wild nature and the artistic sign FIG. 282.

256 Postcard from Pierre Guéguen to Le Corbusier and Yvonne, September 8, 1936 (FLC E2(3)523).

FIG. 282 **Le Corbusier, illustration in**
***Une Maison – Un Palais* (1928), p. 23**

FIG. 283 **Le Corbusier, photograph of a**
rock formation at Plougrescant, July 1937
FLC Séquence 16102

*Let us accept La Palisse's dictum: the eye can make sense only of what it sees.
It does not see chaos, or, rather, it sees poorly in a chaotic or confused scene. It instantly
seeks out something that has a recognizable feature. Suddenly, we stop, impressed,
measuring, appreciating: we discern a geometrical form—rocks upright like menhirs,
the everlasting horizontal of the sea, the meander of the beaches. And through
the magic of relationships, we are transported into the land of dreams.*[257]

Finding order in chaos is a passable definition of the art of photography.
In the photographs he took during his convalescence in Brittany in July
1937, we find an intense analysis of what makes natural form memorable.
Unlike the postcards and the Surrealist photographers, Le Corbusier rarely
photographed the named rocks—Napoleon's hat, the witch, the rabbit, and
so on—which are pointed out by guides and signposts. Rather, he looked
for the dramatic moment where the vertical cuts across the line of the hori-
zon, or where a composition formed itself from the molding of rocks and
pebbles by the light FIG. 283.

Years later, in his *Poème de l'angle droit* (1955), Le Corbusier reproduced
in a drawing the dramatic sign of an upright man against the horizontal line
of the ocean. He also sketched a version of the upstanding rocks in Brittany.
In another sketch, he showed a hand drawing a vertical line, forming the
right angle with the horizon from which the poem derives its name. In all
these sketches is embedded the idea of the will of the artist, imposing his
idea on the chaos of nature.

Le Corbusier filmed various sweeping panoramas across the bay of
Le Goufre, for once avoiding the lurching swings and tilts of his typical
panning shots. He also took some overlapping shots, again as if mentally
combining them.

Not only did he overlap these views horizontally, as in FIG. 280, he also
took some that extended the view downward FIG. 281, enabling him to include

257 Le Corbusier, *Une Maison –
Un Palais* (Paris: Crès, 1928),
p. 22. This part of the book was
a transcription of a lecture.

a view of the sea and of rocks. These mental compositions have to be considered primarily as memory work, recording in two, three, or more shots an image that Le Corbusier had integrated as a whole.

In some cases he seems to have responded to a kind of biomorphic empathy, seeing in the rock formations the tension of forces of compression, almost like muscles, flesh, and bone FIGS. 284–85. Le Corbusier had been thoroughly convinced of the aesthetic theory of empathy in the early 1920s, believing that the eye transmits directly to the mind emotional stimuli from the forms it sees.

Another sequence turns around the dramatic clash of seawater and rocks FIG. 286. He took dozens of pictures of the water swirling around the rocks, apparently intrigued by the patterns assumed by the foam-flecked black water. This, too, in his mind, was probably part of the cosmic struggle of nature. Another group of photographs brought out the smooth, abstract qualities of bleached stones comparable to the sculptures of Henry Moore, which Le Corbusier had seen during his trip to London in September 1935.

The Plougrescant photographs must be considered in the context of Le Corbusier's convalescence after his illness. His attack of neuralgia was almost certainly a psychosomatic response to the unbearable tensions in his atelier. It was in 1937 that the twenty-seven-year close partnership with Pierre Jeanneret fragmented, as a result of growing political, personal, and architectural differences. All of Le Corbusier's grandiose projects for the Universal Paris exhibition of 1937 had come to nothing and he found himself sharply criticized by the young Socialists and Communists in his own studio, among them Jean Bossu and Charlotte Perriand. In the end, the Pavillon des Temps Nouveaux, Le Corbusier's only presence in the exhibition, got built only through Perriand's contacts with the Minister of Agriculture, who provided the site and imposed her as the site architect. This humiliation was more than Le Corbusier could bear, and a series of bitter

confrontations took place, spilling over into the French group of CIAM (Congrès Internationaux d'Architecture Moderne). Charlotte Perriand left the atelier and, although Pierre continued to work with him for a further four years, they barely spoke. Le Corbusier's immersion in the reassuring natural world of sea and stone during his long vacation in Brittany becomes more comprehensible in this context.

FIG. 286 **Le Corbusier, water and rocks, Plougrescant, Brittany, July 1937**
FLC Séquence 15199 →pp. 364–65

FIG. 287 **Le Corbusier, abstract forms in the rocks near Plougrescant, July 1937**
FLC Séquence 16323 →pp. 362–63

Plougrescant, Brittany

July 1937

Brittany: Stone
Recovering from illness in July 1937, Le Corbusier filmed the dramatic rocky coastline around the bay of Le Goufre, Plougrescant, Brittany. He also took hundreds of photographs of stones and pebbles on the shoreline.

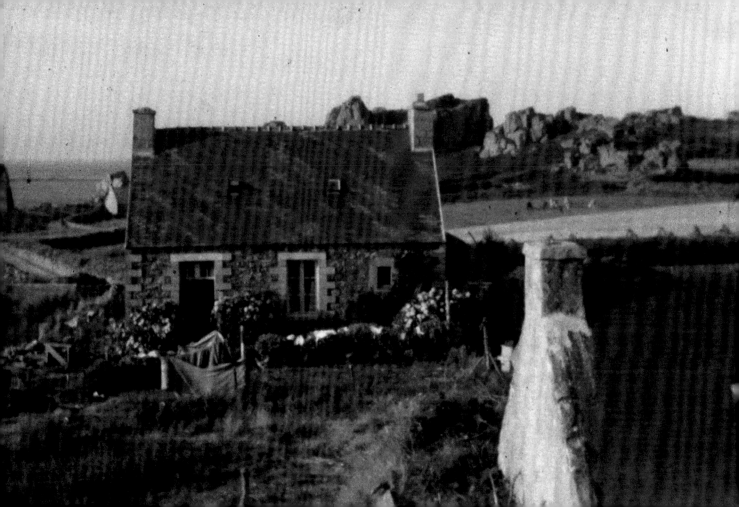

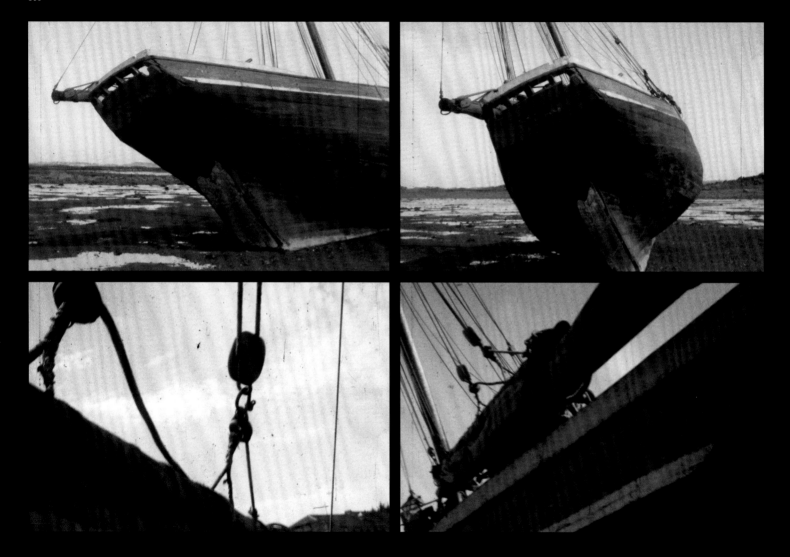

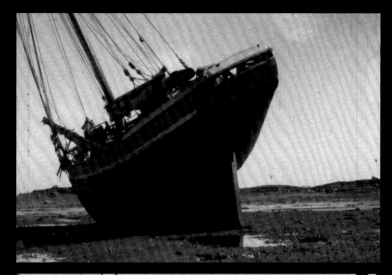

Le Corbusier made a first visit to Algiers in 1931, when he gave two lectures, on March 17 and 20. He gave three more lectures on February 28, March 6 and 8, 1933, when his visit to the city coincided with an important exhibition of modern architecture. He also gave an impromptu talk at the inauguration of this exhibition on February 25. In these lectures, which attracted large audiences, Le Corbusier tried to impose his line on the debates about the architectural and urban future of the city.[258] His controversial "Plan Obus" (1931–32)—which would have spared part of the Casbah from redevelopment by building a long, winding viaduct along the slopes above Algiers, with a motorway on top and thousands of apartments inside it—managed to divide the Algerian public and ensure that his urban proposals would never be accepted. Following his lecture tour in 1931, Le Corbusier decided to return, at the end of an epic drive in his famous Voisin automobile, in the company of Pierre Jeanneret (August 8 to September 9).

Passing through Spain and Morocco, the trip had as its aim the valley of the M'zab, 600 kilometers south of Algiers, passing through Laghouat to arrive in Ghardaia at the end of August.[259] On March 18, 1933, Le Corbusier again visited the M'zab, this time as a passenger of the pilot Louis Durafour, who flew him to Noumerate and then to Laghouat in his Caudron 286 for a brief visit.[260] Le Corbusier described the revelation of seeing the houses of the M'zab towns from the air, open and delightful in the interior but closed off to the street, an insight comparable to his first discovery of the Balkan and Turkish houses in 1911.

We imagined, since we cannot get access to the house interiors, that these houses were a dry crust of beaten earth, burnt up by the sun. The airplane reveals to us a miracle of wisdom, a knowledgeable and benevolent organization, a healthy biology

258 T. Benton, "La rhétorique de la vérité: Le Corbusier à Alger," in J.-L. Bonilo, *Le Corbusier Visions d'Alger* (Paris: Éditions de La Villette, 2012), 172–87.
259 A. Gerber, "L'Algérie de Le Corbusier: les voyages de 1931," thesis IV (EPEL, Lausanne, 1993), 149–94.
260 Ibid., pp. 179–88. This trip is described in Le Corbusier, *Aircraft* (London: Studio, 1935) and again in Le Corbusier, *Sur les 4 routes* (Paris: Gallimard, 1941), 122–25.

Pierre Jeanneret, photograph of ...sier during the road trip through Spain ... Africa by car, August to September
...lotte Perriand Archive

Le Corbusier, photograph on

FIG. 290 **Olive grove at Berianne, Algiers, April 1938** FLC Séquence 6185

FIG. 291 **Le Corbusier, photograph in a street in Beni-Isguen, showing the back of a man's head (Louis Durafour?)** FLC Séquence 6213

FIG. 292 **Le Corbusier, street in Ghardaia, April 1938** FLC Séquence 6229 → p. 375

FIG. 293 **Le Corbusier, sketch of Ghardaia with Beni-Isguen in the background, September 1931** FLC Cahier 12, No. 5230

FIG. 294 **Le Corbusier, sketch of a street in Ghardaia, March 1933** FLC Cahier 5, No. 5007

372

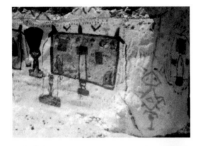

FIGS. 295–97 **Le Corbusier, wall painting and street scenes, Beni-Isguen, April 1938**
FLC Séquence 6319, 6277, 6281

a brilliant anatomy. The interiors of the houses open up like living seashells, with the aromatic greenery of their gardens. The elegant design of their arcades, in the heart of the land of thirst, tells of a real civilization.[261]

Note the association of house and garden with seashells. From 1920 on, one of his favorite slogans, describing how a house must suit its inhabitants, was "the house is a snail's shell." Although this visit seems not to have exceeded eight hours, he managed to make several sketches, many of which he later published in *La Ville Radieuse*. There was also a brief visit in the summer of 1936. In April 1938, called to Algiers to participate in a planning committee, he managed to squeeze in another lightning visit to the M'zab.[262] Le Corbusier appears to have left Paris for Port Vendre on Friday, April 17 and returned on May 7.[263] This time, he had his movie camera with him, and he took a number of pictures in Algiers, of the harbor, and the route to the plateau of Fort L'Empereur, above Algiers, as well as at Ghardaia and the M'zab. On the quay, he took the time to create a minisequence of nineteen photographs of voluptuous cast-iron bollards and anchors.

We know very little about the trip to the M'zab, except that it took place in the last few days of the visit and that it had rained heavily.[264] In fact some of his photographs show olive trees with standing water around the trunks FIG. 290.[265] On April 22, 1938, Le Corbusier wrote to his American friend Marguerite Tjader Harris from Algiers mentioning the desert at Ghardaia.[266] On his return, on May 8, 1938, he wrote to his mother and mentioned that the desert was "damp and flooded—an intense joy for the inhabitants but a miserable soaking for the tourists."[267] In his diary, he noted his expenses for the train journey to Marseilles and the names of contacts and meetings in Algiers. His lecture was on April 27. Le Corbusier seems to have been driven between Ghardaia and Laghouat, because there are roadside views of pilons and camels, but it is possible that Louis Durafour once again flew

261 Le Corbusier, *La ville radieuse, éléments d'une doctrine d'urbanisme pour l'équipement de la civilisation machiniste. Paris, Genève, Rio de Janeiro, São Paulo, Montevideo, Buenos-Aires, Alger, Moscou, Anvers, Barcelone, Stockholm, Nemours, Piacé* (Paris: L'Architecture d'Aujourd'hui, 1935), 230–31, cited by Gerber, op. cit., p. 182.
262 The trip was prefigured by a meeting with the Governor General of Algiers, reported to his mother on March 23, 1938 (FLC R2(1)151)
263 FLC F3(6)3, pp. 3v–10v.
264 Inspection of his diary shows that he had very few spare days (FLC F3(6)3)
265 Séquence 6164–6187. These seem to be in or near Berianne, between Laghouat and Ghardaia. I would like to thank Danièle Pauly for helping me to identify these images.
266 CCA 84 DR 1699.
267 FLC R2(01)248.

268 I would like to acknowledge the great assistance given by Alex Gerber in helping me identify the Algerian photographs. It was Alex who suggested to me the identification of Durafour.
269 P. Strand and J. A. Aldridge, *Living Egypt*, photographs by Paul Strand, text by James Aldridge (London: MacGibbon & Kee, 1969).

him to Ghardaia. There is no mention of Durafour in his diary, but for the entry corresponding to Wednesday April 22 he noted "7h airplane [Hotel] Aletti Mme Blanchet." I interpret this to mean that he was trying to fix up a flight on that day with a rendezvous at the Hotel Aletti, where he was staying. On Thursday, April 30, he wrote "2h start" and it is possible that this was the time of his departure for the airport at Maison Blanche. This would make sense in terms of the limited time available and also because, as Alex Gerber pointed out, there is a tantalizing glimpse of a man in a hat who looks rather like Durafour FIG. 291.[268]

These photographs are different to the beautiful sketches he made in 1931 and 1933 FIGS. 293–94, responding to the people and incident rather than an analysis of the architectural and urban dualities of the M'zab towns.

We have seen that a long-running theme for Le Corbusier was the contrast between the street, enclosed by walls, and the privacy of the houses behind. On his drawing of a street in Ghardaia, he noted: "The street is an enclosed path + irrigation channel." FIG. 294. Le Corbusier's curiosity about the storage and handling of water can be seen in a set of photographs of a young man standing next to some wall paintings FIG. 295 →p. 385.

The paintings seem to represent a cup of plenty and houses whose waterspouts nourish plants. The themes of ecology, a natural lifestyle, and a simple, direct style of expression seem to come together in these images.

He took a number of photographs of the closed streets of the sacred city of Beni-Isguen, unified by their brilliant limewashed walls and molded by violent light and shade. These views amount to yet another sequence, leading us through the streets of the city toward the mosque at its summit FIGS. 296–300 →pp. 380–81.

With a better technique and a proper camera, these photos could be compared with Paul Strand's wonderful views of Egypt in the 1960s.[269]

FIGS. 298–300 **Le Corbusier, views of a street in Beni-Isguen, April 1938** FLC Séquence 6301, 6352, 6359 →p. 381

M'zab and Algiers

April 17–May 7, 1938

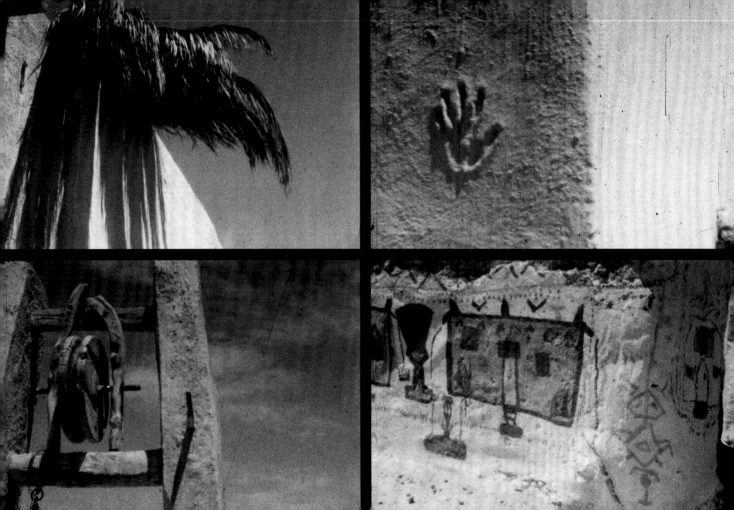

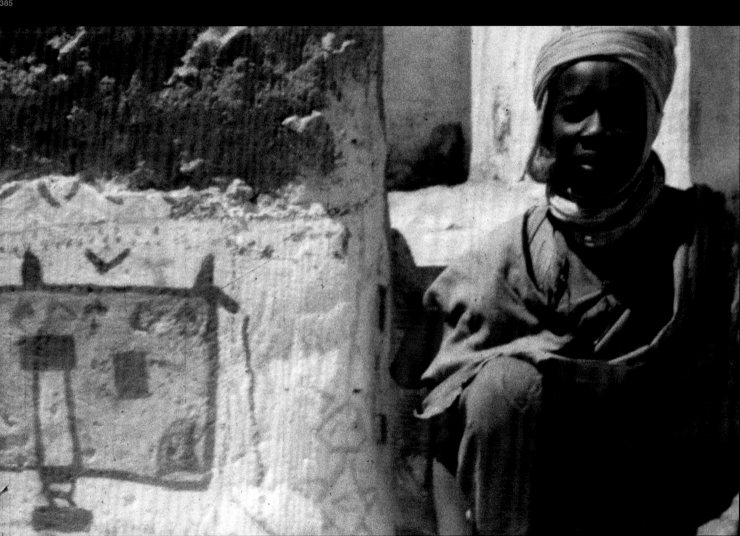

A Visit to E1027

FIGS. 291–303 **Le Corbusier, views of Jean Badovici's house, designed by Eileen Gray, April 1938** FLC Séquence 6729, 6863, 6881 → p. 392

We have noted Le Corbusier's close friendship with Jean Badovici, and the latter's generosity in making his home at Vézelay open to Le Corbusier and Yvonne. This friendship was to come under pressure, however, after the visit the couple made to Badovici's other house, the modernist villa largely designed by his companion of the late 1920s, Eileen Gray. Clinging to rocks on a narrow strip of land between the railway line and the Mediterranean, in the village of Roquebrune in the South of France, E1027 is one of the masterpieces of 20th-century modernism.[270] Gray paid for the site and supervised the construction, as a present to her friend, but soon after the house was completed, in 1929, she moved into another house nearby, apparently unable to put up with Badovici's infidelities and bohemian friends. In April 1938, Le Corbusier, just back from Algiers, was invited to stay at E1027, and he wrote a warm and admiring letter to Eileen Gray:

> *I was extremely sorry to have arrived too late, thus depriving myself of some time in your company. My wife says that you wanted to treat us to some gastronomic treats, among other things. I missed not only those, but also the pleasure of your company. I do hope that you will do us the honor of visiting us one of these days in Paris. I would be glad to tell you how much these days spent in your house have enabled me to appreciate the rare intelligence that has dictated its arrangements, inside and out, conferring to the modern furniture—the equipment—such a noble, charming, and intelligent aspect.*[271]

He took a number of photographs of the house, of the interior and from outside. In fact, these are the only photographs of modern architecture (apart from his mother's house and some glimpses of his own apartment) that Le Corbusier took with his movie camera. These photographs put

270 See P. Adam, *Eileen Gray* (London: Thames and Hudson, 2009) and C. Constant, "E.1027: the nonheroic modernism of Eileen Gray," *Journal of the Society of Architectural Historians* 53(3) (1994): 265–79.
271 Le Corbusier to Eileen Gray, April 28, 1938 from Roquebrune Cap Martin (FLC E2(3)479).

FIG. 304 **Le Corbusier, view of the mural he painted in the living room of E1027, April 1938** FLC Séquence 6673

FIG. 305 **Eileen Gray and Jean Badovici, living room of E1027, restored in 2010**

FIG. 306 **Le Corbusier, "sgraffitto" mural painted onto the external wall of the maid's bedroom, under the house, April 1938, restored in 2010**

on record Le Corbusier's close attention to Eileen Gray's house: its setting in the landscape, the ingenious wooden shutters fixed on external sliding rails to keep the sun's heat away from the windows, the canvas awning on the long balcony, and the sunbathing pit FIGS. 291–303 → pp. 392–93, 396–97.

Although Le Corbusier was later critical of aspects of the house and its furnishings, his letter acknowledged the outstanding quality of Gray's tubular steel furniture. But swinging the camera round 180 degrees would have shown one of two mural paintings he painted on this trip FIG. 304. Based on one of his paintings—*Figure devant une porte blanche*—shown in the exhibition of his paintings four months previously at the Kunsthaus Zürich, this rather brutal painting clashes with the delicate scale of Gray's interior. Le Corbusier argued that this three-quarter-high screen wall, which disguises a shower room, was a "dark corner" that needed brightening up, but this is hardly convincing.

In 1938, the walls of the living room were painted in a single color—white or off-white—as they had been since 1929 when the house was recorded for publication in a special issue of *L'Architecture Vivante*. In a recent restoration of the house, a polychromatic composition of blue, brown, black, and yellow panels was discovered in the underpainting and reconstructed. This scheme was clearly tried out and rejected by Eileen Gray and Badovici before the completion of the house in 1929, so Le Corbusier's painting would never have been seen in this context.

Another painterly intervention on this trip was the "sgraffitto" that Le Corbusier added to the wall underneath the house. This composition, the fruit of a long gestation in which Le Corbusier played with the superimposition of three nude figures (originally female), is less invasive and is certainly a much better picture FIG. 306.

There is no evidence that this composition has anything to do with Delacroix's painting *Les Femmes d'Alger* (1834), nor is there any reason to suppose

272 FLC E1(5)34.
273 See Badovici to
Le Corbusier, December 30,
1949 (FLC E1(5)96) and
Le Corbusier's reply January 1,
1950 (FLC E1(5)99).
274 B. Colomina, "War on
architecture: E.1027 – house
designed by Eileen Gray
at Cap Martin," *Assemblage* 20
(April, 1993), 28/29; S. Von
Moos, "Le Corbusier as painter,"
Oppositions 19/20 (1980):
88–105.

that Eileen Gray is symbolically represented in the painting, as the onetime owner of the villa, Madame Schelbert, claimed. That Le Corbusier did have a somewhat aggressive attitude to his mural painting can be confirmed from his letter to Badovici on August 19, 1939, inviting himself down to Roquebrune: "I have a furious desire to dirty the walls. Ten compositions are ready, enough to daub everything."[272] In 1939, Le Corbusier returned and added five more murals, including one at the other end of the living room. Badovici at first encouraged him in these undertakings but, in 1949, perhaps prompted by Eileen Gray, he furiously attacked Le Corbusier's vanity in defacing the interiors.[273] In return, Le Corbusier made some mocking references to certain aspects of the house and claimed that his paintings only improved the house. He went as far as to ask Badovici to pay for the materials he had used to restore the paintings after the war. This exchange took place at a moment when the friendship between the two men was disintegrating for other reasons. It was a sordid quarrel, and it is clear that Eileen Gray was horrified when she saw the painted work of the architect she greatly admired. Much has been written about these paintings, some of it oversensationalizing the "rape" of the house by Le Corbusier.[274]

What is of more concern to us here is that Le Corbusier took no less than 127 photographs with his movie camera of his black-and-white "sgraffitto" exploring different views and details FIGS. 307–09 → pp. 398–99.

He also took hundreds of photographs of his paintings in the atelier at 24 rue Nungesser et Coli, although many of these are so blurred and dark that they are almost illegible. This work of analyzing one's own production, typical of his architectural work, demonstrates both Le Corbusier's aesthetic curiosity and uncertainties about his pictorial production → pp. 400–01.

The photographs of E1027 at Roquebrune mark the end of Le Corbusier's adventure with his Siemens B movie camera.

FIGS. 307–09 **Le Corbusier, photograph of his "sgraffitto" painting, E1027, April 1938** FLC Séquence 6753, 6754, 6755

Roquebrune

April 1938

Conclusion

The two halves of this book are quite distinct. The first builds on the earlier work of Giuliano Gresleri and others on the voyage d'orient, without repeating their excellent results. What I have done, however is to cast doubt on some of the assumptions concerning the authorship of the photographs, by introducing some precision about the cameras that Jeanneret might have used. I have demonstrated that the 9 × 12 cm glass plates could not have been taken with the camera now in the collection of the Fondation Le Corbusier, and also that Jeanneret's first camera could not have been a Kodak Brownie. This led to a significant reevaluation of the arguments for the authorship of the photographs and Jeanneret's intentions in purchasing and using his cameras. By dating all the photographs, using information about the particular "fingerprint" of each camera triangulated with a knowledge of Jeannerets's movements, I have also been able to throw new light on some of the hypotheses concerning authorship. For example, it is not possible that Klipstein took all the 9 × 12 cm glass plates, because he was not present when a significant number of them were taken. The current data does not allow for certainty in identifying the authorship of the five negative formats taken during the period 1907 to 1917, but I believe that I have offered a reasonable judgment in attributing four of them to Jeanneret and one to Klipstein. More usefully perhaps, my attempt to situate Jeanneret's photography within the culture of amateur and semiprofessional photography of the time, along with an explanation of the material culture of photography— what you had to learn and do to take and develop a photograph at this time—should clarify the place of photography in Jeanneret's life at this time and counter his own attempts to play it down as insignificant. It is clear that for a short period, Jeanneret tried extremely hard to take professional-quality photos and invested a great deal of time and money in the attempt.

The second half of the book deals with the still photographs taken by Le Corbusier with a Siemens B 16 mm movie camera between 1936 and 1938. Identifying the make and model of the camera involved complicated detection and helps to underline the astonishing reticence in mentioning it, even in his letters to his mother after intensive filming of her and her house. Glimpses of these photographs have been seen in Jacques Barsac's book on the photography of Charlotte Perriand and in some other publications. But mine is the first detailed analysis of an extraordinarily rich period of visual composition.

How can we categorize Le Corbusier's photographs? In one sense, his whole photographic output, from 1906 to 1938, was a failure. Le Corbusier hardly mentions it and rarely published his own photographs. With some notable exceptions, particularly the pictures between April and May 1911, the technical quality of the negatives is mediocre. The technical possibilities of the 16 mm movie camera ensured that there was a limit to what could be achieved with the 1936–38 photographs. Why, then, take these images seriously? The arguments can be classified into biographical, architectural, aesthetic, and conceptual.

Le Corbusier's photographs provide an interesting commentary on his personal life. Among the early photographs are fascinating glimpses into his psychology. The picture of Le Corbusier and Klipstein on the veranda of a house at Kazanlük FIG. 51, or the many pictures of his family reveal his anxiety to keep his memories alive. Later, in the 1930s, his film and still images of his own apartment and his mother's house confirm his attachment to wife and mother →pp.189–92. The pictures of Yvonne offer revealing glimpses of a relationship that was being made difficult by her increasing dissatisfaction with her own appearance. I believe that part of Le Corbusier's enthusiasm for photography during his holidays with Yvonne in Le Piquey, Plougrescant, and Roquebrune results from an escape, on his part, into a

solitary activity. His images of himself, naked or nearly so, also bear witness to some kind of sexual frustration.

For only a brief period (April–May 1911) did the young Jeanneret seriously try to take expert architectural photographs. This is characteristic of the photographic culture of the time. Quite early in the history of photography, architecture became a specialized domain, rarely mentioned in photographic societies and magazines. The genre of travel photography was the one normally referred to in terms of places and buildings. Jeanneret's first photographs (1907–10) were aimed mostly at illustrating places rather than buildings, and the limitations imposed by his box camera, with its awkward 9×9 cm negatives, meant that this was necessarily the case. His principal aim seems to have been the accumulation of urban images that could be used in his proposed publication *La Construction des Villes* →pp. 58–61. With the purchase of his 9 × 12 cm plate camera, with its rising and cross fronts, he had the equipment capable of taking professional architectural photographs. And in Germany and Prague (April–May 1911), he took a certain number of faultless architectural photographs as good or better than those illustrating Schultze-Naumburg's *Kulturarbeiten* volumes →pp. 88–89. These required the use of a heavy tripod, adjustment of the rising front, focusing with a black cloth, and so on. Many of them can be admired as really excellent representations of architecture. His interest in representing street scenes continued, however, with his remarkable views of Prague →pp. 94–95. But once the voyage d'orient got under way, Jeanneret preferred to use the 6×9 cm roll-film negatives in handheld mode and took relatively few 9×12 cm glass plates. Even when he did, for example in the many cemeteries he photographed and in Istanbul, he tended to use the camera handheld →pp. 88–89. It is surprising how few high-quality architectural pictures he took in Istanbul or Athens, despite his fascination with the mosques and temples in both cities →pp. 98–99. It is clear that the reason for this increasing

impatience with photography was his commitment to drawing as a means of analyzing and recording buildings and places. The few photographs he took on the Acropolis, and their moody but mediocre quality, is further testimony to this transference of interest →p.136. The fact that he then bought a third cheap camera in Naples and used it for fairly casual note-taking (in Pompeii and in Rome) underlines this move →p. 148. It is surprising, then, that it was a handheld photograph taken with this camera in the Pantheon in Rome that features most prominently among his own photographs selected for publication (in his book *Urbanisme* →p.149). It seems that, like most amateur photographers of this time, Jeanneret considered architectural photography to be a difficult and technical practice best left to the professionals. This was certainly the case from the moment that Le Corbusier began to work with good professional architectural photographers in Paris, from 1922 on, and probably explains why he seems to have taken few pictures after 1919. His 1930s' photographs with the Siemens B ignore buildings almost entirely, except as background to his family. The exception is Eileen Gray's E1027, where he picked out a number of architectural features that interested him, as well as photographs of the garden, Yvonne, Badovici and Madeleine, and his recently completed wall paintings →p. 389.

We can only guess at Le Corbusier's theoretical opinions on photography. It is extremely unlikely that he considered it an art, although he spent a lifetime perfecting ways of using photographs to maximum effect in his publications. Most of his photographs are closer in kind to his sketches: aides-mémoires intended to capture the setting, some detail and some significant features. From the early days on, he often worked in series, taking a group of photographs of the same or similar subjects. The set of photographs of vernacular houses in Hungary, Bulgaria, and Serbia →pp. 126–27 or the group of photographs in Pompeii FIGS. 127, 131, 133 are of this kind, and we can see how he refined his compositional technique as he took these images.

Working in series became an obsession in the 1930s with his movie camera. How far this was simply the product of having a very large number of photographs on each roll of 16 mm film is not clear. But the lexicon of mechanical imagery on the *Conte Biancamano* →p. 246, or the hundreds of compositions of sand or mud in Le Piquey →p. 316 or rocks at Plougrescant →p. 352, reflect something else: a methodical analysis of form and an attempt to understand the cause and effect of natural forces. These images, taken together in sets, provide an astonishingly rich play of light and shade, and a balance of figure and ground. One measure of a specifically photographic aesthetic is when effects of light and shade or shades of gray become more important than the iconographic content of an image. This is certainly the case in a number of Le Corbusier's photographs in the 1930s in which semi-abstract form takes over from representation. These images reveal a hitherto undreamt-of interest, on Le Corbusier's part, in the "New Photography" of the 1920s in Germany and Central Europe. The Villefranche photographs in particular reveal a sophisticated aesthetic in the mode of what László Moholy-Nagy called the "New Vision." →p. 290 Nothing in Le Corbusier's published output or private correspondence gives us a clue of this secret taste for a modern photographic aesthetic.

The mystery surrounding the 1930s' photographs, taken with an expensive camera never mentioned by Le Corbusier in his correspondence or in his diary, indicates either that he did not consider photography as sufficiently important aesthetically to be publicly acknowledged or that he simply did not want this activity known. One reason may be the psychological one mentioned earlier, but another may also derive from his professional situation. Fêted everywhere as lecturer and expert but simultaneously starved of work and increasingly at odds with his cousin Pierre Jeanneret, Le Corbusier was passing through a period of reevaluation in the 1930s. Photography allowed him to explore his increasing interest in the hidden

power of nature—the cosmic forces of sun and moon, wind, rain, and tides and their relationship with gender and with the emotions. His photographs illustrate perfectly the complex, not to say contradictory, theories and convictions written into his important book *La Ville Radieuse* (1935). In turn, they prepare the road for the expressive, organic quality of the postwar architecture. Above all, Le Corbusier's intensive exploration of expressive photography between 1936 and 1938 helps to explain his surprising choice of Lucien Hervé in 1949 as his preferred photographer. Lucien Hervé, a Hungarian artist and photographer well steeped in the traditions of the "New Photography," preferred to photograph textures and dramatic compositions of light and shade, using his 6 × 6 cm Rolleiflex camera, rather than the precise wide-angle views normally required by architects.

If Le Corbusier photographer is unlikely to displace Le Corbusier architect in the canon, his photographic work commands respect for its astonishing versatility, perception, and imagination. His experiments in filmmaking, with their jerky, swooping pans, confirm his amateur status as a movie cameraman and confirm that he had no conception of film montage. The still photographs, however, have a quality and care in composition and framing that owe nothing to chance and merit close scrutiny.

Appendix 1: Photographic Expenses of Jeanneret and Klipstein

Based on a letter to Klipstein, December 18, 1911 (E2(6)144), FIGS. 79–80. This page of accounts lists purchases of photographic materials by Jeanneret and Klipstein between May and November 1911. I have interpreted the figures in terms of the cost per photograph (see pp. 101–02). Glass plates were sold in boxes of 12 or 6. 6 × 9 cm roll film was also sold in rolls of 12 or 6 frames.

	Place	Item	Costs	Unit Costs	No. of Negatives	Costs for Each Frame	Total Costs
Klipstein	Prague	1 roll film	1.80	1.80	12	0.15	
		black cloth	0.80	0.80			
	Vienna	3 boxes of glass plates	10.80	3.60	36	0.30	
		4 roll films	8.00	2.00	48	0.17	
		1 filter	9.00	9.00			
	Bucharest	4 roll films	8.00	2.00	48	0.17	
							38.40 francs
Jeanneret	Dresden	1 box of glass plates	1.90	1.90	6	0.32	
		development	2.00	2.00			
	Prague	repairs	4.00	4.00			
		1 box of glass plates	3.60	3.60	12	0.30	
	Vienna	development	2.90	2.90			
	Bucharest	development	1.05	1.05			
		pack films	5.00	5.00	12	0.42	
	Pera (Istanbul)	3 roll films (6 per roll)	3.18	1.06	18	0.18	
		2 roll films (6 per roll)	2.12	1.06	12	0.18	
		development	3.60				
		development	0.64				
		2 pack films	9.96	4.48	24	0.41	
		magnesium	1.91				
		2 roll films (6 per roll)	2.12	1.06	12	0.18	
		plates	12.29	3.06	48	0.26	
		2 roll films (6 per roll)	2.12	1.06	12	0.18	
		development	5.08				
		3 roll films	6.00	2.00	36	0.17	

Place	Item	Costs	Unit Costs	No. of Negatives	Costs for Each Frame	Total Costs
Athens	repairs	0.50				
	photos of Mount Athos enlargement and mailing	2.20				
	development	4.90				
Naples	2 roll films	4.60	2.30	24	0.19	
	2 roll films	4.60	2.30	24	0.19	
Rome	2 roll films	4.60	2.30	24	0.19	
	2 roll films	4.60	2.30	24	0.19	
Florence	3 roll films (6 per roll)	3.45	1.15	18	0.19	
La Chaux-de-Fonds	development	11.40				
	development	2.00				
						112.30 francs

Films Purchased	Glass Plates	Pack Film	Roll Film	Total Frames	Total Costs (in Francs)
Klipstein film purchases	36	–	108	144	38.40
Jeanneret film purchases	66	36	204	306	112.30
Total film purchases	102	36	312	450	150.70

Appendix 2: Le Corbusier's 16 mm Films

Hypothetical analysis of the reel of 16 mm film conserved in the Fondation Le Corbusier, breaking it down into 18 reels and relating them, where possible, with the identifications in Le Corbusier's hand on the original boxes. Length is measured in minutes, seconds, and frames.

Reel	Date	Length	No. of Frames	Total Frames	Emulsion Nos.	Content	LC Descriptions on Box
1	July 1936	01:23	13	2088	61015	24 Nungesser et Coli (his apartment) (film); mother at 24NC; bones; Stade sport scene; LC in studio	24 Nungesser et Coli; peinture; été 36 tableau cordage T100 film (avec pied); sport stade Jean Bouin; 3 os Trois os. Film; Corbu sur voute et pelouse luzerne
2	July 1936	01:28	15	2215	61022	Film of 24NC; film of paintings; stills of paintings	24 N. C. Tableaux 2
3	July 1936	01:19	2	1977		24NC film roof garden; film of dining room; Pinceau, Yvonne	Le Corbusier; 24 Nungesser et Coli; Tableaux; jardin; Atelier
4	July 1936	01:18	19	1945		24NC film of stairs and roof garden	24 N. C. Tableaux (aucune inscription)
5	July 1936	01:17	19	1944	61022	Zeppelin and Pernambouco	Pernambouc; Hotel Gloria
6	July 1936	01:16	12	1912	61022	Brazil (starts with film of Rio)	Rio; Le Corbusier; Très mauvais Zeppelin; Favella et Piqueta (sic); Vue de Rio depuis bateau seulement; Hotel Gloria [Box covers two films]
7	August 1936	01:17	12	1937		Brazil Conte Biancamano, Villefranche	Tropiques; Tropiques Equateur mer intérieur pa[quebot ?]
8	August 1936	01:20	13	1989	61023	Paintings 24NC; film Vevey in summer with mother + film of LC on parapet	
9	Sept 1936	01:17	12	1937		Le Piquey with Yvonne, Badovici and Mad, photos of café, Yvonne and Badovici on the beach film of boy and Pinceau on beach; shells and objects on beach; wood; fishermen; Hotel Chanteclerc; dogs	
10	Sept 1936?	01:06	2	1652	H56917	Le Piquey; pan of pier to sea; Piquey horse riding; film of sea	Piquey; Mer lumière forte
11	Sept–Oct 1936	01:19	6	1957	H5602	Le Piquey; Albert at La Roche; 24N and riot Parc des Princes, Le Lac approx. October 8, 1936, film of mother and house and lake; portrait mother	Sept 1936; Le Lac; Fenêtre; maman coiffée; maman cheveux; (fixes); émeute parc des Princes; fixes; toit Albert; toit La Roche; Piquey (fixe); Le Lac maman octobre 1936 cheveux; (fixes) émeutes Parc des Princes; fixes toit Albert; toit La Roche; Piquey (fixe)Piquey; Maman Le Lac [octobre 36]
12	Oct 1936	01:20	20	1996	HS602	Le Lac; 1936 October; portrait mother	Le Lac; 1936 octobre portrait; maman; maman + Corbu seul/lac
13	Oct 30–Nov 4, 1936	01:11	5	1756		Vézelay at Badovici's house, Léger's fresco, film of people, church, trees etc.	Vézelay Noël 36; Noël 1936; Vézelay+ Pinceau Fresque; Sombre excellent Léger Brouillard à la Bado Fin
14	Dec 1936	01:06	14	1640		Film Vevey; Le Lac in snow; mother	Le Lac décembre 36 Lumière douce; Le Lac décembre 1936 avec Neige fraiche + 4 fixes maman + Pinceau Bois de Boulogne futais p. Urb Le Corbusier Ceci a été coupé
15	July 1937	01:08	1	1701	CH5649	First image is of Le Lac. Gravel works Nov 1937, Brittany Plougrescant; clowns in street; boats and sailing boat	
16	July 1937	01:10	18	1744	FH5691	Brittany	Plougrescant Bretagne 1937. Piacé Bézard et sa mère; Zoo Paris et maman 24NC
17	Jan 1938	00:03	71		H56917	1937 Pavillon des Temps Nouveaux; paintings 24NC	1937 Pavillon TN + Bretagne
18	Jan to May 1938	00:50	18	1247		paintings 24NC; Algiers; E1027; paintings 24NC	Cap Martin villa + 1 peinture salon +; Scraffitti + Alger Laghouat.; Gardaïa; Ossature Pav Tps Nouveaux janvier 38; Alger = mon chantier dns La Marine = Brise soleil; effets de photos de tableaux et dessins Corbusier
		00:25	8	609		Comic commercial film: the golfers	
				35460 frames in all			

Works Cited

"Les nouveaux appareils Eastman." *La Photo-Revue Suisse* 1(1): 32 (January 1897).

Picture taking with the No. 3 and No. 3A folding Brownie cameras (meniscus lens). Rochester, N.Y.: Eastman Kodak Company, 1913.

"In the Shop Window." *Amateur Photographer* 533 (December 12, 1928).

The Focal encyclopedia of photography. New York: Macmillan, 1960.

Adam, P. *Eileen Gray*. London: Thames and Hudson, 2009.

Barsac, J., A. Pacquement, et al. *Charlotte Perriand et la photographie l'œil en eventail*. Milan: 5 Continents, 2011

Benton, T. "From Jeanneret to Le Corbusier: rusting iron, bricks and coal and the modern Utopia." *Massilia* 2 (2003): 28–39.

Benton, T. "Building Utopia." In C. Wilk, *Modernism: Designing a New World*. London: V&A Publications, 2005.

Benton, T. "Modernism and Nature." In C. Wilk, *Modernism: Designing a New World*. London: V&A Publications, 2005.

Benton, T. *The rhetoric of modernism: Le Corbusier as a lecturer*. Basel/Boston MA: Birkhäuser, 2009.

Bourdieu, P. *Photography: A Middle-brow Art*. Stanford, Calif.: Stanford University Press, 1990.

Brooks, H. A. *Le Corbusier's Formative Years: Charles-Edouard Jeanneret at La Chaux-de-Fonds*. Chicago: University of Chicago Press, 1997.

Brunel, G. *Georges Brunel,... Formulaire des nouveautés photographique... Appareils, accessoires, produits, formules et procédés, la photographie scientifique et artistique*. Paris: J.-B. Baillière et fils, 1896.

Buckland, Michael. *Emanuel Goldberg and his Knowledge Machine*. Westport: Libraries Unlimited, 2006.

Child Bayley, R. *The complete photographer*. London: Methuen & Co., 1907.

Clouzot, H. "La ville radieuse." *Beaux-Arts* (Nov. 22, 1935): 3.

Collignon, M. *Le Parthénon: l'histoire, l'architecture et la sculpture*. Paris: Hachette Br., 1914.

Colomina, B. "War on Architecture: E.1027 – house designed by Eileen Gray at Cap Martin." *Assemblage* 20 (April 1993): 28–29.

Constant, C. "E.1027: The Non-heroic Modernism of Eileen Gray." *Journal of the Society of Architectural Historians* 53(3) (1994): 265–79.

Denis, M. "De Gauguin et de Van Gogh au Classicisme." *L'Occident* 90 (May 1909).

Dillaye, F. *La théorie, la pratique et l'art en photographie: l'art en photographie avec le procédé au gélatino-bromure d'argent*. Paris: J. Tallandier, 1904.

Dillaye, F. *Les nouveautés photographiques: complément annuel à la théorie, la pratique et l'art en photographie: année 1905–1912*. Paris, Tallandier, 1905.

Dumont, M.-J. *Lettres à ses maîtres II, Lettres à Charles L'Éplattenier*. Paris: Éditions du Linteau, 2006.

Easton, E. W., C. Chéroux, et al. *Snapshot: Painters and Photography, Bonnard to Vuillard*. New Haven: Yale University Press; London, 2012.

Edwards, E. *The camera as historian: amateur photographers and historical imagination, 1885–1918*. Durham, NC: Duke University Press, 2012.

Ford, C. *The Story of Popular Photography*. London: Century in association with the National Museum of Photography Film and Television, 1976.

Gilbert, G. *Collecting photographica: the images and equipment of the first hundred years of photography*. New York, Hawthorn Books, 1976.

Göllner, P. *Ernemann Cameras: die Geschichte des Dresdener Photo-Kino-Werks: mit einem Katalog der wichtigsten Produkte*. Hückelhoven: Wittig, 1995.

Gorlin, A. "The ghost in the machine: Surrealism in the work of Le Corbusier." *Perspecta* 18 (1982): 51–65.

Gräff, W. *Es kommt der neue Fotograf!* New York: Arno Press, 1979 [Stuttgart: Akademischer Verlag, 1929].

Green, C. "The architect as artist." *Le Corbusier: Architect of the Century*. London: Arts Council of Great Britain (1987): 110–30.

Gresleri, G. "L'Oriente di Jeanneret." *Parametro* 1 (1986): 6–64.

Gresleri, G. "Viaggio e scoperta, descrizione e trascirzione = travelling and discovering, description and transcription." *Casabella* 51, no. 531–32 (1987): 8–17.

Gresleri, G. (ed.). *Les voyages d'Allemagne, Carnets; Voyage d'Orient, Carnets*. Milan: Electa, 2000.

Gresleri, G., G. Gobbi, and P. Sica. *Le Corbusier. Il viaggio in Toscana (1907)*. Florence, 1987.

Günter, R. "Architektur-Fotografie in gesellschaftlichen Zusammenhang." *Marburger Jahrbuch für Kunstwissenschaft* 20 (1981): 123–37.

Häring, H. "Wege zur Form." *Die Form* 1 (Oct. 1925).

Jeanneret, C.-E. and C. Schnoor. *La Construction des Villes*. Zurich: GTA, 2008.

Lagache, E. "Ploumanac'h." *La photographie française* (1900): 209–13.

Le Corbusier "L'Esprit de vérité." *L'Architecture Vivante* 5(17) (1927).

Le Corbusier. *Une Maison – Un Palais*. Paris: Crès, 1928.

Le Corbusier. "L'Esprit de vérité." *Mouvement. Cinématographie. Littérature. Musique. Publicité* 1 (monthly review). Paris (1933): 10, 11.

Le Corbusier *La ville radieuse, éléments d'une doctrine d'urbanisme pour l'équipement de la civilisation machiniste. Paris, Genève, Rio de Janeiro, São Paulo, Montevideo, Buenos-Aires, Alger, Moscou, Anvers, Barcelone, Stockholm, Nemours, Piacé*. Paris: L'Architecture d'Aujourd'hui, 1935.

Le Corbusier and A. Maurois. *Des Canons, des munitions? Merci! Des logis... S. V. P. Monographie du «Pavillon des temps nouveaux» à l'Exposition internationale "Art et technique" de Paris 1937*. Paris: L'Architecture d'Aujourd'hui Rel. 1938.

Le Corbusier. *Modulor 2; La parole est aux usagers*. Paris: Architecture d'Aujourd'hui, 1983 [1st edition 1955].

Le Corbusier. *L'Atelier de la recherche patiente*. Paris: Vincent, 1960.

Le Corbusier. *Le Voyage d'Orient*, Paris: Minuit, 1966.

Le Corbusier. *Urbanisme*. Paris: Éditions Vincent, Fréal & Cie, 1966.

Le Corbusier. *The radiant city; elements of a doctrine of urbanism to be used as a basis of our machine-age civilization*. New York: Orion Press, 1967.

Le Corbusier. *Le Corbusier, viaggio in Oriente: gli inediti di Charles Edouard Jeanneret fotografo e scrittore*, 2nd ed. Venice/Paris: Marsilio/Fondation Le Corbusier, 1985.

Le Corbusier. *Voyage d'Orient*. (6 carnets in 5 vols. with transcriptions). Milan: Electa, 1987.

Le Corbusier, C. R. d. Santos, et al. *Le Corbusier e o Brasil*. São Paulo: Tessela-Projeto, 1987.

Le Corbusier. *Voyage d'Orient sketchbooks*. New York/Milan: Rizzoli/Electa, 1988.

Le Corbusier and M. Emery. *La construction des villes: genèse et devenir d'un ouvrage écrit de 1910 à 1915 et laissé inachevé par Charles Edouard Jeanneret-Gris, dit Le Corbusier*. Lausanne: Éditions L'Age d'homme, 1992.

Le Corbusier (Ch.-E. Jeanneret) and G. Gresleri, *Le Corbusier: les voyages d'Allemagne: Carnets*, 5 vols. Milan/Paris: Electa/Fondation Le Corbusier, 1994.

Le Corbusier and G. Gresleri. *Le Corbusier: les voyages d'Allemagne: carnets*. Milan/Paris: Electa/Fondation Le Corbusier, 1994.

Le Corbusier and Giuliano Gresleri. *Viaggio in Oriente. Charles-Edouard Jeanneret fotografo e scrittore*. Venice: Marsilio-FLC, 1995, 2nd edition.

Le Corbusier. *Les voyages d'Allemagne: carnets; Voyage d'Orient: carnets*. Milan/Paris: Electa/Fondation Le Corbusier, 2000.

Le Corbusier and I. Zaknic. *Journey to the East*. Cambridge, Mass.: MIT Press, 2007.

Le Corbusier, J.-L. Cohen, et al. *Toward an architecture*. Los Angeles, Calif.: Getty Research Institute, 2007 [Vers une architecture, Paris: Cres, 1923].

Le Corbusier, S. v. Moos, et al. *Le Corbusier: the art of architecture*. Weil am Rhein: Vitra Design Museum, 2007.

Le Corbusier, R. Baudouï, et al. (2011) *Correspondance Tome I: Lettres à la famille, 1900–1925 édition établie, annotée et présentée par Rémi Baudouï et Arnaud Dercelles*. Paris: Infolio/Fondation Le Corbusier, 2011.

Lefevre Gallery and E. Vuillard. *Vuillard et son Kodak*. London, 1972.

Lejeune, J.-F. "Schinkel, Sitte, and Loos: The 'Body in the visible.'" Charles C. Bohl and Jean-François Lejeune (eds.), *Sitte, Hegemann and the Metropolis*. London: Routledge, 2009.

Lossau, J. *Der Filmkamera-Katalog: 16 mm, 9,5 mm, 8 mm, Single-8, Super-8, Doppel-Super-8. The Complete Catalog of Movie Cameras*. Hamburg: atoll medien, 2003.

Lothrop, E. S. and International Museum of Photography at George Eastman House. *A century of cameras from the collection of the International Museum of Photography at George Eastman House.* New York: Dobbs Ferry/Morgan & Morgan, 1982.

Martin-Sabon, F. *La Photographie des monuments et des oeuvres d'art.* Paris, 1903.

Mazza, B. *Le Corbusier e la fotografia: la vérité blanche.* Florence: Florence University Press, 2002.

McKeown, J. M. and J. C. McKeown. Price guide to antique and classic cameras. Grantsburg, WI: Centennial Photo Service, 1985.

Moore, R. A. "Alchemical and mythical themes in the Poem of the Right Angle 1947–1965." *Oppositions* 19/20 (winter/spring, 1980).

Moravánsky, A. "The optical construction of urban space: Hermann Maertens, Camillo Sitte and the theories of 'aesthetic perception.'" *The Journal of Architecture* 17(5) (2012): 655–66.

Naegele, D. "Le Corbusier seeing things: ambiguity and illusion in the representation of modern architecture." *Dissertation in Architecture, 1996* (University of Pennsylvania 1996).

Naegele, D. "Object, Image, Aura: Le Corbusier and the Architecture of Photography." *Harvard Design Journal* 6 (fall 1998): 1–6.

National Gallery of Canada and A. Thomas, *Modernist photographs.* Ottawa: National Gallery of Canada, 2007.

Neblette, C. B., F. W. Brehm, et al. *Elementary Photography for Club and Home Use.* New York: Macmillan, 1936.

Officer, L. H. "Exchange Rates." In S. B. Carter, S. S. Gartner, M. Haines et al., *Historical Statistics of the United States, Millenial Edition.* New York: Cambridge University Press, 2002.

Ozenfant, A. and Le Corbusier. *Après le cubisme.* Paris: Éditions des Commentaires, 1918.

Piotrowski, A. "Le Corbusier and the Representational Function of Photography." In A. Higgott and T. Wray, *Camera constructs; Photography, architecture and the modern city.* Farnham: Ashgate (2012): 35–45.

Posthumus, N. *Inquiry into the history of prices in Holland.* Leiden: Brill, 1946.

Rabaça, A. "Documental language and abstraction in the photographs of Le Corbusier." *Jornal dos Arquitectos,* 2012.

Renan, E., H. Bellery-Desfontaines, et al. *Prière sur l'Acropole compositions de H. Bellery-Desfontaines gravées par Eugène Froment.* Paris: E. Pelletan, 1899.

Roh, F. *Foto-Auge: 76 Fotos der Zeit.* Tübingen: Wasmuth, 1973.

Sabatino, M. *Pride in modesty: modernist architecture and the vernacular tradition in Italy.* Toronto: University of Toronto Press, 2010.

Schubert, L. "Jeanneret, the City, and Photography." In S. Von Moos and A. Ruegg, *Le Corbusier before Le Corbusier.* New Haven/London: Yale University Press, 2002.

Schubert, L. and Centro Internazionale di Studi di Architettura "Andrea Palladio" di Vicenza. *La villa Jeanneret-Perret di Le Corbusier, 1912: la prima opera autonoma.* Venice/Vicenza: Marsilio; Centro Internazionale di Studi di Architettura Andrea Palladio, 2006.

Schultze-Naumburg, P. *Kulturarbeiten.* Munich: G.D.W. Callwey, 1902.

Schultze-Naumburg, P. *Kulturarbeiten.* Munich: G.D.W. Callwey, 1904.

Schultze-Naumburg, P. *Kulturarbeiten.* Munich: Callwey im Kunstwart-Verlag, 1906.

Schwindrazheim, O. "Die Poesie der alten deutschen Stadt." *Deutsche Camera-Almanach. Ein Jahrbuch* VIII (1912): 133–42.

Sitte, C. *City Planning According to Artistic Principles [Der Städtebaunach seinen künstlerischen Grundsätzen vermehrt um "Grossstadt-grün"].* New York: Rizzoli, 1889.

Sitte, C. *Der Städtebau nach seinen künstlerischen Grundsätzen vermehrt um "Grossstadt-grün."* Braunschweig: F. Vieweg & Sohn, 1983.

Sitte, C. and C. T. Stewart. *The Art of Building Cities: City Building According to its Artistic Fundamentals.* New York: Reinhold Publishing Corporation, 1945.

Spechtenhauser, K. and A. Rüegg. *Maison Blanche: Charles-Edouard Jeanneret/Le Corbusier.* Basel/London: Birkhäuser, 2007.

Stotz, G. *Film und Foto.* New York: Arno Press, 1979.

Strand, P. and J. A. Aldridge. *Living Egypt,* photographs by Paul Strand, text by James Aldridge. London: MacGibbon & Kee, 1969.

Von Moos, S. "Le Corbusier as painter." *Oppositions* 19/20 (1980): 88–105.

Winter, P. and M. Martiny. "Les grilles cosmiques de l'homme." *Plans* 4 (April 1931): 49.

Worringer, W. *Abstraktion und Einfühlung. Ein Beitrag zur Stilpsychologie.* Neuwied: Heuser, 1907.

Worringer, W. and H. Kramer. *Worringer, Abstraction and Empathy: A Contribution to the Psychology of Style.* Chicago: Elephant, 1997.

Zannier, I. (1988) *L'occhio della fotografia: protagonisti, tecniche e stili dell'"invenzione maravigliosa."* Roma: Nuova Italia Scientifica, 1988.

Zimmermann, E. "Die Fotografie auf des Dresdner Kunstausstellung." *Deutsche Kunst und Dekoration* XIV (April–Sept. 1904): 675–87.

Biographies

Tim Benton was trained at Cambridge University and the Courtauld Institute of Art. He has taught at the Open University, Milton Keynes, since 1970. He has published widely on the history of architecture and design, notably on the interwar period, specializing in the work of Le Corbusier. He currently teaches a doctoral class at the École Polytechnique Fédérale de Lausanne. His books include *The Villas of Le Corbusier 1920–1930* (1984, 1987, and 2007 in French and English editions) and *The Rhetoric of Modernism: Le Corbusier as a Lecturer* (2007–08 in English and French editions). He has worked on a number of large exhibitions as curator and contributor to the catalogs, notably *Thirties: British Art and Design Before the War*, Hayward Gallery, 1980, *Art and Power: Europe under the Dictators 1930–45*, South Bank Centre, 1995, *Art Deco 1910–1939*, V&A, 2003, *Modernism; designing a new world 1914–1939*, V&A, 2003, and *Le Corbusier and the Power of Photography*, La Chaux-de-Fonds, 2012. His book *Le Corbusier conférencier* was awarded the Grand Prix de l'Architecture by the French Académie d'Architecture in 2008.

Le Corbusier (1887–1965) was born Charles-Édouard Jeanneret in the Swiss watchmaking town of La Chaux-de-Fonds. Entering the local art school at the age of sixteen, he was fortunate to come under the inspirational guidance of Charles L'Éplattenier, who was determined to transform the school from a training college for watch engravers into an art academy forming painters, sculptors, and architects. L'Éplattenier persuaded Jeanneret that he should become an architect and encouraged him to travel. For ten years (1907–16), Jeanneret traveled to Italy, Austria, Germany, France and took a long trip in 1911 (the "voyage d'orient") through the Balkans to Istanbul , Mount Athos, Athens, Pompeii, Rome, Florence, and Pisa. It was during these *wanderjahre* that he first began taking photographs. He had already begun designing houses in La Chaux-de-Fonds (1906–17) and, by the time he emigrated permanently to Paris in 1917, had built six houses and adapted the design of a cinema. He had also worked as an architectural assistant with two of the most influential architects of the time: the Perret brothers in Paris (1908–09) and Peter Behrens in Berlin (1910–11). Influenced by these masters and by his travels, he moved a long way from the Arts and Crafts regionalism of L'Éplattenier to a deep understanding of classical architecture and a fascination with reinforced concrete as a means of construction.

In Paris, a friend set him up in business, manufacturing cement blocks and designing industrial buildings for a construction company. Only one of these projects was built (a water tower near Bordeaux) and by 1923 Jeanneret's companies were in receivership and he became a declared bankrupt. But long before then, he had achieved an international reputation, with a new friend, Amédée Ozenfant, as a painter and joint editor of the magazine *L'Esprit Nouveau* (1920–25). Soon after meeting Ozenfant in 1917, they formed an art movement–Purism–mounted an exhibition, and published a manifesto, in 1918. *L'Esprit Nouveau* published articles on politics, economics, cinema, literature, music, and art and it was here, under the pseudonym Le Corbusier that Jeanneret published the articles on architecture that would be grouped together in 1923 in the book *Vers une Architecture*, as well as three

other books. *Vers une Architecture*, one of the most widely published and translated books on architecture of the twentieth century, and probably the most influential, established Le Corbusier's reputation on an international basis. By the time the magazine folded, in 1925, Le Corbusier had also built six houses or artists' studios in the white, Purist style that had achieved significant publicity in international publications.

From 1925 to 1933, Le Corbusier developed his architectural career, in collaboration with his cousin Pierre Jeanneret, with whom he had established a professional partnership in 1922. By 1929, in addition to his famous villas– Villas Cook, Church, Baizeau, Stein-de Monzie, Savoye–many of them for American clients, Le Corbusier had contributed two houses to the international housing settlement on the Weissenhof outside Stuttgart, in 1927, and adapted a rooftop apartment for the Spanish aristocrat Charles de Beistegui. Between 1929 and 1933, he designed and built a ministry building in Moscow, the Swiss student hostel in the University City in Paris, an apartment block in Boulogne (in which he installed himself in a penthouse studio), two buildings and a concrete barge for the Salvation Army in Paris, and a block of apartments in Geneva. He had also played a leading role in founding the pressure group for the international modern movement in architecture, the CIAM (1928) (Congrès Internationaux d'Architecture Moderne), contributing to each of its conferences and to the CIRPAC planning groups in Paris. His unsuccessful projects for the League of Nations (1927) and Palace of Soviets (1931–32) had become *causes célèbres* that had provided a rallying ground for the international modern architecture movement. Already in 1929, however, Le Corbusier had abandoned many of the founding dogmas of the modern movement, including his own Five Points for a New Architecture (1927) and had begun to search for a closer link with organic form and the rediscovery of the materials of his first works: stone, wood, brick, and the use of a pitched roof.

In 1930, Le Corbusier married his sweetheart, Yvonne Gallis, and adopted French citizenship, under the name of Le Corbusier. From 1926 on, his art developed from the geometric forms of his Purist period to a more sensuous and organic style, focusing on the natural forms of seashells, driftwood, ropes, and boats, usually in relation to the female form. Following the successes of the early thirties, Le Corbusier suffered a drought of commissions and a succession of frustrating refusals. His public career flourished, however, with invitations to lecture in South America (1929 and 1936), the United States (1935), and most countries in Europe. His situation in 1936, when he began taking photographs again, was a paradoxical one: a famous, not to say notorious, international figure with almost no work. His books, and especially the series of *Oeuvre complète* (from 1929 on), were eagerly consulted by young architects all over the world. Between the summers of 1936 and 1938, Le Corbusier experimented with a 16 mm movie camera, taking 120 sequences of film and around 6,000 photographs. His last public display in the 1930s, the Pavillon des Temps Nouveaux at the 1937 exhibition in Paris, was an unhappy collaboration with left-leaning assistants in his studio who did not share his political views, and it marked the beginning of the end of his partnership with his cousin Pierre Jeanneret.

After a miserable war, in which he briefly dabbled with the Vichy government, Le Corbusier reinvented himself in the postwar period, casting most of his followers into confusion with a sequence of highly expressive buildings (notably the Maisons Jaoul in Paris, the chapel of Notre Dame du Haut, Ronchamp, and the capital city of the Punjab, Chandigarh). He took on Lucien Hervé, a young Hungarian artist, as his semiofficial photographer and it was Hervé who provided some of the most striking images of the postwar architecture. It is likely that Le Corbusier's photographs of 1936–38, in which he experimented with the aesthetic of the New Photography, prepared him for this surprising choice, since Hervé was not known as a professional architectural photographer.

Acknowledgments

My first debt is to Lada Umstätter for inviting me to contribute a room and a catalog essay to the exhibition Construire l'image: Le Corbusier et la photographie (La Chaux-de-Fonds, October–December 2012). This was the origin of this research and I am grateful to Sophie Vantieghem for her assistance and to all the members of the exhibition committee for their reactions and advice. Giuliano Gresleri's wonderful book on the Voyage d'Orient was another point of departure, and I cherish conversations with him about photography. The work of Giovanni Fanelli and Barbara Mazza was also inspirational and it has been a pleasure discussing Le Corbusier's photographs with both of them. Many of the ideas for the exhibition and book were explored with my doctoral class at the École Polytechnique Fédéral de Lausanne. Michel Richard, Director of the Fondation Le Corbusier, gave me full support in accessing the material and producing the high-resolution scan of the 16 mm film that was essential for the work. Claude Prelorenzo's work on the 16 mm films was a motivating factor. Arnaud Dercelles, Delphine Studer, and Isabelle Godineau supported the research in the highly professional manner any researcher of Corbusiana has come to expect. Carlos Lopez, at the Bibliothèque de la Ville La Chaux-de-Fonds, was endlessly helpful in allowing me to inspect the original glass plates and celluloid negatives in their collection. I am grateful to Phyllis Lambert and Maristella Casciato at the Centre Canadien d'Architecture, Montreal, for allowing me to consult the set of copies of Jeanneret's photographs. The librarians at the CCA generously supported the project in making available important material in the collection. Much of the work was done in the library of the College of Environmental Design, University of California, Berkeley, and in the Library of Congress and the National Gallery of Art, Washington, D.C. I am particularly grateful to Professor Elizabeth Cropper and her staff at the Center for Advanced Study in the Visual Arts, Washington, D.C., for affording me a period of uninterrupted work as associate scholar from November to December 2012. The staff of these wonderful institutions provided expert assistance and I am grateful for their help and in particular to the Department of Photographs and Prints in the Library of Congress. Lindsay Harris introduced me to the photograph collection at the NGA, and Andrea Gibbs helped me source images in the Department of Image Collections in the library at the NGA. Many people stimulated, criticized, and enriched this work in its evolution, in particular Jean-Louis Cohen, Bruno Hubert, Josep Quetglas, Łukasz Stanek, and Stanislaus von Moos. Veronique Boone gave me an understanding of Le Corbusier's relationship with Pierre Chenal. Jacqueline Jeanneret provided me with precious insights into Pierre Jeanneret's photography. François Penz and Marco Iuliano organized a conference at the CRASSH institute in Cambridge in May 2012, providing a rich context in which to explore the finer points of architectural photography. Alex Gerber and Danièle Pauly helped me identify images of the M'zab, while Anat Falbel, Margareth Da Silva Pereira, Daniela Ortiz dos Santos, and Hugo Segawa did the same for Brazil. To Jos Erdkamp I am beholden for his unrivaled expertise in early Kodak cameras.

Helena de Anta, Danko Szabó, and all the staff at Lars Müller Publishers worked intensively to produce this book to time and to the highest standards. I am particularly grateful to Lars, whose belief in the material made it possible. Caroline Maniaque was endlessly encouraging and provided much-needed criticism. This book is dedicated to her.

LC FOTO
Le Corbusier Secret Photographer

Copyediting and proofreading: Danko Szabó
Design: Integral Lars Müller / Lars Müller and Sebastian Fehr
Typesetting: Integral Lars Müller / Esther Butterworth
Lithography: Ast & Fischer, Wabern, Switzerland
Paper: Hello Fat Matt, 1.1, 135 g/m²
Printing and binding: Kösel, Altusried-Krugzell, Germany

© 2013 Lars Müller Publishers and Tim Benton

Lars Müller Publishers
Zürich, Switzerland
www.lars-mueller-publishers.com

ISBN 978-3-03778-344-3

Printed in Germany